THE LANDSCAPE OF ERNEST LAMARQUE

Caitlin Press Inc.
8100 Alderwood Road,
Halfmoon Bay, BC V0N 1Y1
www.caitlin-press.com

Edited by Patricia Wolfe
Text and cover design by Vici Johnstone
Front cover image: Lamarque and Joe Poole. 1-30-r, Whyte Museum of the Canadian Rockies. Back cover image: Fort McKay. LaE.09.07, Whyte Museum of the Canadian Rockies.

Printed in Canada
Caitlin Press Inc. acknowledges financial support from the Government of Canada and the Canada Council for the Arts, and from the Province of British Columbia through the British Columbia Arts Council and the Book Publisher's Tax Credit.
Library and Archives Canada Cataloguing in Publication

Sherwood, Jay, 1947-, author
 The landscape of Ernest Lamarque : artist, surveyor and Renaissance man, 1879-1970 / Jay Sherwood.

Includes bibliographical references and index.
ISBN 978-1-987915-01-3 (paperback)

 1. Lamarque, Ernest, 1879-1970. 2. Surveyors—British Columbia—Biography. 3. Artists—British Columbia—Biography. 4. Photographers—British Columbia—Biography. 5. Canada, Western—Surveys—History. 6. British Columbia—Biography. 7. Canada, Western—Biography.
I. Title.

TA533.L34S54 2016 526.9092 C2015-908141-6

The Landscape of
Ernest Lamarque

SURVEYOR, ARTIST AND
RENAISSANCE MAN, 1879-1970

JAY SHERWOOD

CAITLIN PRESS

Contents

Introduction

Ernest Charles William Lamarque lived the life of a Victorian adventurer. Born in England in July 1879, he was the youngest of the three children of George and Mary Lamarque. Both his father and grandfather occupied senior government positions as Surveyor of Taxes. Lamarque's mother died in late March 1881, possibly in childbirth, and the 1881 census in April recorded that he was residing with his grandfather. In the 1891 census, Ernest was living with his father, who died later that year. He was then raised by aunts and uncles and sent to boarding school.

While Lamarque's older brother pursued a professional career, Ernest left England in the summer of 1896, shortly after his seventeenth birthday, seeking adventure. He travelled to the United States, where he joined a school friend who had gone to his uncle's farm in Toledo, Ohio. During the following months the two young men worked their way north and west until they reached Winnipeg in January 1897. Lamarque's friend found employment in the city while Ernest worked at temporary jobs until he obtained a position as a clerk with the Hudson's Bay Company. Lamarque spent seven years with the HBC in Saskatchewan, Alberta, British Columbia and the Northwest Territories.

Then he decided to become a surveyor. During his apprenticeship in the years before World War I, Lamarque worked on the BC–Yukon boundary survey, the D.A. Thomas coal railway and other significant ventures in remote places in British Columbia and Alberta. Although Lamarque's formal education ended at sixteen, he was able to complete his apprenticeship and pass his final examination, becoming BCLS #185 in 1915.

The 1920s was a quiet period in Lamarque's career but in the 1930s he surveyed on many important projects, including the Big Bend Highway and the preliminary Alaska Highway. He is best known for his reconnaissance work on the Bedaux Expedition, locating a route across northern British Columbia from Fort St. John to Dease Lake. During World War II he surveyed several airfields in northern British Columbia and the Yukon.

Opposite: Charles Bedaux hired the famous Hollywood cinematographer, Floyd Crosby, to film and photograph his 1934 expedition. Crosby took at least one individual photograph of each person on the adventure. This is his picture of Ernest Lamarque. PA173879, Library and Archives Canada.

Most of Lamarque's work did not have the technical challenges that Frank Swannell's triangulation surveying did. But he was a competent surveyor who was selected for many significant projects. For Lamarque, the work that he did was only part of the adventure. He enjoyed recording the country he saw and the people he met. He wrote several short articles that were published in newspapers and magazines, so his adventures reached a widespread audience. Some of these articles are included in sidebars in this book. He kept diaries for some of his surveying and in later years wrote a memoir. Lamarque's memoir was never published as a book, but copies are housed in the national archives in Ottawa, along with archives in British Columbia and Alberta. He also wrote a manuscript about his experiences on the Bedaux Expedition. Lamarque was a voluminous, lifelong correspondent and some of his exchange of letters with people are preserved in different archives. Many of these letters included sketches.

Lamarque took photographs throughout his surveying career. He also made watercolour paintings and drew sketches. Although he had no formal training, Lamarque must have been interested in art from an early age. His oldest surviving sketches date to his time at Île à la Crosse, when he drew some of the Métis who lived in the area. His earliest watercolour painting, from 1903, is of the Hudson's Bay post and landscape at Île à la Crosse. Lamarque's artwork is largely descriptive and intended to bring the viewer into the landscape that he saw. Like his letters, many of his writings and reports included sketches.

Most of Lamarque's artwork is housed at the Whyte Museum of the Canadian Rockies in Banff, but there are also paintings at the National Art Gallery in Ottawa, Library and Archives Canada, the Royal BC Museum, the Glenbow Museum and in private collections. Lamarque had a connection with the Vancouver Art Gallery (which opened in October 1931) for many years. From May to July 1932, the VAG hosted an All-Canadian Exhibition whose "aim is to gather from all parts of Canada a collection of pictures and sculptures that shall be representative of all that is best in Canadian art." A majority of the Group of Seven had paintings displayed. There were a large number of BC artists represented, and Lamarque's 1905 painting of Fort St. John was selected. That October the gallery held its first annual BC Artists' Exhibition. It displayed one or two works by many of the province's artists and included one of Lamarque's watercolour paintings of the Athabasca River. In 1936 he had a solo show of twenty-four pieces of art. Over the years, the VAG selected artwork by Lamarque for nine of its annual BC Artists' Exhibitions.

Lamarque's material is significant both for the projects in which he was involved and the landscape that he documented. The cumulative and varied

record of Ernest Lamarque shows what it was like to work and travel through remote regions of western Canada from the late 19th to the mid-20th century.

Author's note: Lamarque's memoir is the foundation for several parts of this book, and the sections where it is used extensively are set in block quotes. Whenever Lamarque's diaries or more detailed accounts are available, I have used them as the basis for the writing. I have supplemented Lamarque's writing with research and have included this in the narrative wherever possible. Usually this material corroborates Lamarque's writings. Sometimes it provides more detail or context to the projects in which he was involved.

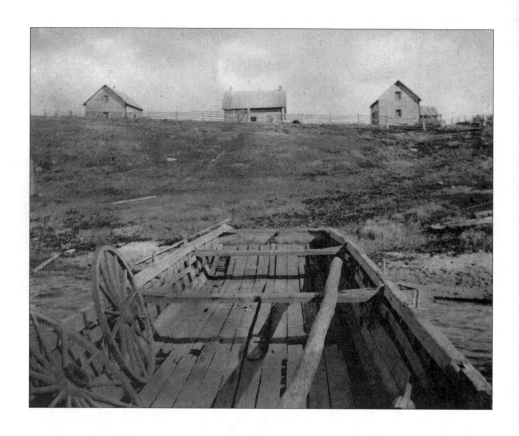

HBC Green Lake, 1900. Green Lake was a Hudson's Bay Company post in the southern end of the English River district. In the latter part of the 19th century it became the main access route to Île à la Crosse and the other posts in the district. When Lamarque worked in the English River district, Green Lake and the adjoining area was part of Treaty 6. The remainder of the English River district became part of Treaty 10 in the early 20th century. 9-8-1, Whyte Museum of the Canadian Rockies.

1 | Hudson's Bay Company Clerk, 1897–1906

1897–1900 | ÎLE À LA CROSSE

In June 1897, at Winnipeg, seventeen-year-old Ernest Lamarque signed a three-year contract as a clerk with the Hudson's Bay Company and was posted to Île à la Crosse, headquarters of the English River district in present-day northwestern Saskatchewan. (At that time it was part of the Northwest Territories.) Since the late 18th century, there had been trading posts at Île à la Crosse Lake, traditionally called Sakitawak, meaning "big opening where the waters meet." The community of Île à la Crosse, the second-oldest in Saskatchewan, is now a National Historic Site. The area had a productive fur trade and occupied an important geographical location along the divide between the Hudson Bay and Arctic Ocean watersheds. The lake is on the headwaters of the Churchill River (also known as the English River or Missinippi by First Nations people). Flowing out of the lake, the Churchill makes a journey of over 1500 km across Saskatchewan and Manitoba, before emptying into Hudson Bay. To the northwest of Île à la Crosse, waterways connect to Little Buffalo, Buffalo and La Loche lakes. (The first two are today called the Peter Pond lakes.) From the northwest end of La Loche, the famous 19 km Methye Portage (also called Portage la Loche) led to the Clearwater River and access to the Athabasca and Mackenzie River region, which drains into the Arctic Ocean.

Initially the Hudson's Bay Company reached Île à la Crosse through the Churchill River. The area was also on the trade route from Montreal used by the North West Company and in the late 18th and early 19th century the two companies competed for the fur trade around Île à la Crosse. After the merger of the North West Company with the Hudson's Bay Company in 1821, Île à la Crosse remained the headquarters of the English River district throughout the 19th century. It was one of the company's main posts, because of its fur production and its connection to the more remote region to the northwest. By the 1870s, the annual brigade trips to Hudson Bay ceased and the southern route through Green Lake became the main access.

Some of the fur company employees married local First Nations women, mainly Cree, and their offspring were the beginning of the Métis community at

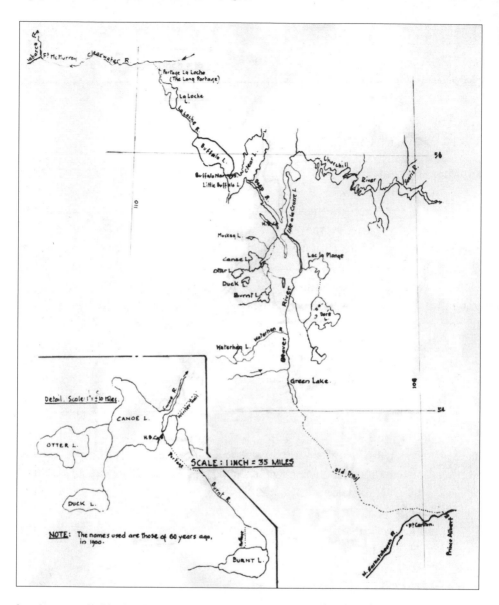

Lamarque made this sketch map of the English River district. M-81-1-memoirs2, Whyte Museum of the Canadian Rockies.

the lake. By the time Lamarque worked at Île à la Crosse, there was a well-established Métis community around the lake and many of the Métis were employed by the Hudson's Bay Company. First Nations people, primarily Cree, lived throughout the English River district. During his three years in the area, Lamarque met and worked with several well-known people. Almost all of the Métis that Lamarque mentioned are documented in the Métis National Council's "Historic

Online Database" on the internet. Lamarque's record provides many important details about life in the Île à la Crosse region at the close of the 19th century. In addition to his memoir, he wrote several short articles; sketched some of the people; made a few paintings; and took photographs that are among the earliest pictorial record of the area and its people. The Hudson's Bay Company post journals for those years exist, and they provide documentation of Lamarque's work in the English River district.

C.C. Chipman was then the Fur Trade Commissioner for the Hudson's Bay Company. He asked me if I would care to go north for the Company, to Isle a la Crosse. Of course I was delighted with the idea and so in mid-June I left Winnipeg for Prince Albert, which was the terminus of the railway in the direction to which I was going. Chipman told me that Chief Trader William Cornwallis King† was in charge of the English River district with headquarters at Isle a la Crosse and "you will find him a very worthy man"...

I left Winnipeg for the north late in the afternoon of the 15th of June 1897... The Rev. and Mrs. Beale—married that day—were going to Saskatoon and there was a gay party of friends to see them off. The German Consul, a Mr. Hespler, was, like myself, en route for Prince Albert. It was a glorious summer evening as the train sped westward across the prairies, dotted with prosperous looking farms and many sloughs from which the wildfowl flew away as the train passed. I could see old buffalo trails and, here and there, the remains of very primitive buildings with sod roofs which had been used by the first

† William Cornwallis King was a famous Hudson's Bay Company factor who eventually became a Chief Trader. Born in 1845, King began employment with the company as a teenager and worked for it for about forty years. He was in charge of the post at Île à la Crosse from 1894 to 1899. Lamarque wrote this description of King:

"He, like all these old-time officers and employees of the Hudson's Bay Company, men who had been with the Company when it yet controlled the whole vast regions of Rupert's Land, were in very truth true and faithful servants of the Company and looked upon the 'Free Traders' who were steadily encroaching on what they thought of as the Company's territory with extreme ill favour.

"I remember that there was a long plank walk at Isle a la Crosse which stretched from the Big House to a gateway at the fence by the lake. On summer evenings, Cornwallis King, resplendent in his shepherd's plaid Norfolk suit, his billy-cot hat at a rakish angle, would march up and down on this long wooden walk, the king of all he surveyed. The freemen were in the village; the Mission at the point and the Company's flag blew out in the summer breeze from the flagpole at the fort, significant of its power and prestige."

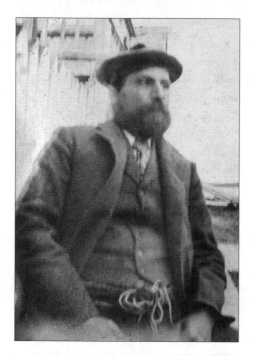

Alexander Lariviere. 9-9-2, Whyte Museum of the Canadian Rockies.

settlers. It all looked very attractive and exciting to me from my comfortable seat in a rear Pullman car...

We were at Regina in the morning, and there we left the main line for the branch running north to Prince Albert. Apart from this branch line and those between Calgary and [Fort] Macleod and Calgary and Edmonton, there was hardly another branch west of Manitoba, which province, even then, had quite a network of them. After breakfast at the Palmer House in Regina we boarded a mixed train—principally freight, with two or more passenger coaches at the rear—for the north.

Up to and beyond Lumsden the terrain was attractive, undulating and semi-wooded, but from there, nearly to Saskatoon, it was a more or less flat, bald prairie. We stopped at a place called Craig, for lunch, and reached Saskatoon in mid-afternoon where we stopped for tea... The Beales got off there. He was to be stationed at Battleford, 100 miles [160 km] or more to the west across the prairie, which he would have to reach by buckboard or wagon, camping out en route...

We reached Prince Albert in the evening and I put up at the old Queen's Hotel. The next morning it was pouring with rain. I walked down to the offices of the Hudson's Bay Company by the bank of the North Saskatchewan River to meet my chief, Cornwallis King. When I arrived he was helping the manager of the store and the accountant to arrange tins about the floor of the office to catch the rain which descended through various parts of the roof. He told me that we would start off on the morrow for Green Lake, but he did not tell me, as he might have done, to have a mosquito bar made for my bed, en route.

The next morning we crossed the river on the ferry in the pouring rain. King's wife was with him and they rode in a buckboard which he drove. I rode with his teamster, Robbie Gardiner, who was

driving the covered wagon... After a somewhat uninteresting journey over a generally rough road, with plenty of corduroy across the muskegs, we reached the southerly end of Green Lake about noon on the 22nd. I slept in the back of the wagon, but the mosquitoes allowed little sleep. In the daytime the bulldog flies... were a horrible plague for the horses. We hung boughs of foliage about their harness to try and protect them as much as possible, but they suffered much and their flanks and chests were streaked with blood. These dreadful flies were abroad from sunrise to sunset. We usually, indeed, always, started very early, before sun-up, and I remember that one morning when I was walking ahead of the teams, that with the first sight of the sun, there was the first bulldog...

There was much covered cargo on the beach at Green Lake, brought there by the freighters from Prince Albert, waiting to be checked and loaded on to the two bateaux which had but just arrived from Isle a la Crosse, the head post of the district. My first job with the Company, then, was to help Mr. King attend to this. The wind was from the north, against us, so the crews tracked the boats along the fine, open beaches most of the way and we reached the Hudson's Bay post at the lower end of the lake by sundown. This post was situated right at the northeasterly end of the lake, which has a length of some 18 miles [29 km] and a general width of about half a mile [800 m]. The water in the summertime is full of a green algae, hence the name. The shores were then densely wooded and I saw no sign of any habitations. George Drever was in charge of the post. He had been in the service for about 20 years, at Forts Pelly or Ellice, in or near the region of the Qu'Apelle Lakes. He had been there during the '85 rebellion [Riel Rebellion], and had some interesting tales to tell of those stirring times... He was a sturdy bearded man and his accounts, on which I was set to work, were in a very backward and befuddled state. I stayed there for just a month, while Cornwallis King made the return journey to Prince Albert. I note, from an old diary, the following: "Had nothing much to do during this time. Drever spends his day smoking, reading and telling yarns; he is a jolly fellow. He has had an addition to his family, another girl." [Drever was in charge of the post at Green Lake from 1893 to 1900. After forty years of employment with the HBC, he retired in 1910.]

With the return of King and his wife, we started off for Isle a la Crosse, 120 miles [192 km] away to the north. The route was by a

little river by which the waters of the lake drain to the Beaver River, a stream that rises far to the west in the vicinity of Lac La Biche, and flowing easterly, turns abruptly to the north at the confluence of this small stream to flow northerly for 100 miles [160 km] to Lake Isle a la Crosse.

While I was at Green Lake, I met some of the Waterhen Lake Indians, who, so Drever said, were yet pagans and "the most honest natives in the country." They were fine, bold looking people, their hair done in plaits, the ends stuck into empty cartridge cases. There was no fur to trade, of course, in the summer season, so they brought in dried meat and dried fish. There were some horses and cattle there, so the sled dogs had to be kept in corrals, for they would have made short work of any colts or calves that might have been about.

We took passage in the same two bateaux by which we had traversed the lake, for, by this time, they had been to Isle a la Crosse and back again for another load. These long, flat scows could accommodate 100 pieces, or about 5 tons of miscellaneous cargo and were propelled by long 14 foot [4.25 m] sweeps, the oarsmen rising to a standing position and then pulling back to a sitting one. There were six to eight oarsmen in a boat and, of course, a steersman. One of the men would, when necessary, stand in the bow with a long pole, usually where the river was shallow or rapid. The river, where we entered it, was not a very large stream, despite the fact that it was there quite 250 miles [400 km] from its source. It had, however, received no large tributaries. Indeed, the Waterhen River, which entered it some 30 miles [50 km] from Green Lake post, was probably the largest. For most of the distance to Lake Isle a la Crosse, the Beaver River has a width of from 100 to 200 feet [30 to 60 m] with a gentle current except in the several miles of rapids which occur about midway. The boatmen were all rather wild, hardy looking fellows; mostly French or Scotch Crees. In the rapids they were often in and out of the water, shoving the heavily laden boats that scraped over rocks and shallows. A boat was holed in the Grand Rapid and had to be unloaded. The stream was hemmed in by the forest, the banks generally low and uninteresting. The crews wore gaudy cotton handkerchiefs tied round or over their heads, their long dark hair hanging low over their shoulders. The songs of the old-time voyageurs were absent, and except for an occasional shout or word of command from a steersman, it was a silent brigade

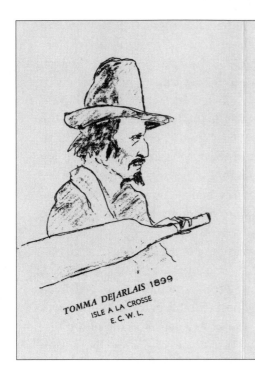

TOMMA DEJARLAIS, VETERAN STEERSMAN AND GUIDE FOR THE BOAT BRIGADES OF THE HUDSON BAY COMPANY FROM ISLE A LA CROSSE TO YORK FACTORY ON THE HUDSON BAY.

From a drawing that I made of him at Isle a la crosse in 1899.

This voyage took the whole summer to complete, down stream all the way to the Factory, about 1,000 miles distance. Down the formidable Churchill River with its many bad and dangerous rapids till the stream going to Cumberland House and the North Saskatchewan was reached, and so down that stream to its mouth in Lake Winnipeg. Across the Northerly part of the Lake to Playgreen Lake and Norway House, and thus via the Nelson and Hayes Rivers to the Factory.

Awakened by the Guide's call, of Wapun (Cree for dawn) the crew rose from their various bivouacs along the bank, and toiled for an hour until the cook had their breakfast ready, bacon, bannuk, dried venison, pemican, perhaps fish, all washed down with plenty of strong tea.

In rowing the boats with their long 14 foot oars, each man was at the opposite side of his boat to his rowlock. Standing well forward at the commencement of the pull, he swung backward to a sitting position at the end. On a fine calm day, one could hear the sound of the sweeps four or five miles away across the lake. At York Factory, the oars were more or less neglected for tracking lines. Those immensely strong, thin, light cod lines were those by which the boats were to be hauled back to their destination. The crew with the lines tied to their portage straps, which they placed around their bodies to take off their bodies the strain of hauling the heavily laden boats. Think of it! Isle a La Crosse, 1,000 miles distant and having to track or haul the boats thereto against the current. Certainly the approach of Autumn and the gradual lessening of the river's volume, and the advantage of the numerous and sometimes powerful eddies which were found near the shore. Sometimes they were so strong that depending on the configuration of the shore, and the power of the out stream current, the crews might almost have to run to keep abreast of their boats. Here the men with poles would keep the craft off the shoals, and the steersman would skilfully slip the boat into the rushing stream at the point at the head of the eddy. Shades of Governor Simpson! These men were worthy descendants of his crews and the Canoes du nord.

All this was before the C.P.R. WAS BUILT ACROSS Canada in 1885, and the branch lines completed from Regina to Prince Albert and Calgary to Edmonton, both in 1891.

Lamarque produced this card describing Tomma Dejarlais and the old brigade trips from Île à la Crosse to Hudson Bay. M81-19, Whyte Museum of the Canadian Rockies.

that swept down river. At night time, round the camp fire, the man detailed as cook made enough bannock for the following day, mixing the dough in the top of a 100 pound [45 kg] flour bag. Their food was bannock and bacon—coarse sow-belly—with perhaps some dried fruit and beans with plenty of sugared tea.

As on the journey from Prince Albert to Green Lake, we travelled from dawn to dusk. The cry of the Cree guide—"wapan," it is dawn—waking the crews from their slumbers, so we covered, quite easily, despite delays in the rapids, the distance to Isle a la Crosse in three or four days.

Both the North West and Hudson's Bay Companies had establishments at Isle a la Crosse very early in the 19th century. They were keen competitors and sometimes antagonists. The Hudson's Bay Company had their fort in a bay some five miles [8 km] from the mouth of the river, across the lake, the Nor'Westers [North West Company] near the mouth of the river. Midway in the lake is a long narrow island with a fine sandy shore on which the H.B.C. men and

the Nor'Westers used to play the game of lacrosse, thus the name of the lake. When I arrived there in the summer of '97 the establishment was yet quite an imposing one and, as the head post of the English River district, of some importance in the fur trade. There were six or seven buildings within a partly stockaded enclosure, all well white-washed and with the Company's flag flying from the flagpole at the main entrance in honour of the officer-in-charge of the district. To the southwest, along the shores of the bay, were the scattered log dwellings of many of the boatmen and of others, all of whom were discharged servants of the Company and generally known by the name of freemen—because they were no longer bound in service to the Company. See image LaE.0907, page 100–101

On the point, at the southwesterly end of the bay, was the Roman Catholic mission, in charge, at that time, of Father Rapet—a church, a small school and quarters for the few Sisters and Brothers who lived there. This mission had probably been established before, or about the middle of the 19th century. See image R1150.5A, page 109 bottom

The fur trading firm of Wright, Tupper and McCallum had a store in that part of the bay where the freemen dwelt... In their employ was an ex-Mounted Policeman, a well-educated Nova Scotian who was reported to have trained for the Bar. His name was Flynn Harris, latterly a well-known character in the Athabasca and Mackenzie River regions, and who was, for many years, Indian Agent at Fort Simpson.[†]

A tall, handsome young man named [Alfred] Fugl, an Anglo-Dane, who had been with the Company for seven years, was in charge at Isle a la Crosse during the absence of Mr. King... Cornwallis King, who was a medium-sized man with a greying beard, lived with his wife at the big house at the fort. He had brought in with him from Prince Albert an old-time employee of the Company, Bobby Thompson. He and Thompson had arrived together at York Factory on the westerly coast of Hudson Bay in 1862, and Bobby had gone north to the Mackenzie and Liard River country and been stationed at old Fort Halkett at the confluence of the Smith River with the Liard, far above Hell's Gate in a turbulent and dangerous section of the river, and many the yarn he could spin of that wild stream, known to the

† In correspondence with R.M. Patterson in the 1960s, Lamarque recalled that Flynn Harris would occasionally come to the post in the evening to play cribbage. He also wrote that, "I yet have a fringed moosehide coat, cut like a Northwest Mounted Police jacket, which Harris' first wife made for me at Isle a la Crosse."

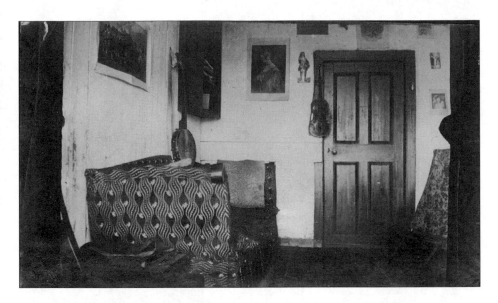

Clerk's quarters at Île à la Crosse, 1898. This is a rare, early photograph of the interior of a Hudson's Bay post, showing furnishings, musical instruments and pictures on the wall. 9-14, Whyte Museum of the Canadian Rockies.

old voyageurs as Le Courant Fort. Thompson acted as cook for the Kings, but Fugl and I, who lived in one of the houses by the main gate, had one of the freemen from the village to do ours.

The Hudson's Bay Company post journal for July 23, 1897, recorded: "The bateaux arrive from Green Lake with Mrs. and Mr. King and Mr. Lamarque as passenger." Lamarque's relationship with HBC personnel had a stormy beginning. On July 31, the post journalist noted: "Mr. Lamarque lost my cap & the priest lent me his. Wind north, blowing hard, my cap was lost overboard between the fort and the mission."

When Fugl went away to take charge of the outpost of Souris River, about 120 miles [192 km] down the Churchill River, I went to live in the Big House with the Kings. This was a large house—I think there were eight bedrooms upstairs—and it had been built, I understood, by Chief Factor Fortescue who had been in charge of the district and had a large family. It was said that he had a piano there, the transportation of which, into that country, must have been a formidable one.

Lamarque's initial mentor was Magloire Maurice, a veteran HBC employee who was born at Portage la Loche and worked at several posts in the district.

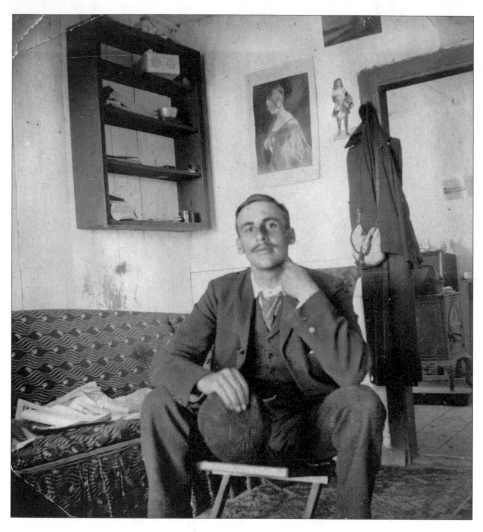

S.E. Davis in the clerk's quarters at Île à la Crosse. 10-7, Whyte Museum of the Canadian Rockies.

Maurice was conversant in the local Cree and Dene languages and could also speak French and English. He and his brother, François, taught Lamarque the Cree language, introduced him to the geography of the area, helped him learn the fur trade and instructed him in the skills needed to survive in the rugged environment.

> There were two servants of the Company who lived just without the fort enclosure. With one of these, Magloire Maurice, I was sent by canoe to visit the outpost of Canoe Lake, about 40 miles [64 km] to the southwest. Magloire and I left very early in the morning and paddling

all day, reached the lake in the evening. This, I am sure, was probably the hardest and longest day's work that I had ever done. The Canoe River was a quiet stream, except in the rapids, a turbulent piece of water over a mile in length [1.6 km] which we avoided by a portage nearly as long. We rested at Canoe Lake the next day, when I met many of the natives, and on the next, returned to the fort, a comparatively easy paddle downstream. King, I knew, was sending me there to trade in the fall. There were less than a dozen Indian cabins situated on a small plateau at the south-westerly end of the lake. The Company had a single room cabin there, about 20 feet [6 m] square. It had a bunk in it, a chair and a table and there was

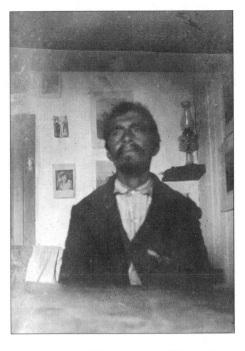

Joseph Halcrow (Halcro) was a Métis who lived at Île à la Crosse. In the 1891 census his occupation is listed as blacksmith. His son, Samuel, died at Vimy Ridge. 9-1-1, Whyte Museum of the Canadian Rockies.

a large, open fireplace. There were two windows of glass, one facing east and the other south. About 30 feet [9 m] away was a small windowless cabin which was used as a store. The cabin was on the northerly side of the small plateau, about 30 feet from where the bank dropped abruptly to the lake shore. There was no shelter whatever from the north winds which howled across the lake.

The post journal for August 26 recorded that Lamarque and Magloire had gone to inspect the Canoe Lake post and noted their return two days later, bringing five ducks for food. On August 30, the two men set off to visit Buffalo Narrows. The post journal for September 2 stated: "Magloire and Lamarque returned from the Narrows about noon, made a fair trip, strong head wind on return trip. Wind SE, fine day. Everything quiet at Buffalo Narrows but few furs so far."

Canoe arriving at Île à la Crosse, LaE.09.01-2, Whyte Museum of the Canadian Rockies.

A few days later Magloire and I went to the post at Buffalo Narrows, again about a 40 mile paddle. The small outpost of Buffalo Narrows was at the narrow neck of water which lies between Big Buffalo Lake and Little Buffalo Lake; the latter, again, by a narrows, extending into Clear and Island Lakes. These four large lakes, all of which lie to the north of Isle a la Crosse, are the headwaters of the Churchill River, which flows out of Lake Isle a la Crosse from the northerly end of one of its many arms. Between Isle a la Crosse and Buffalo Lakes there is a twenty mile [32 km] stretch of water, averaging about half a mile [800 m] in width, called Deep River. There is no perceptible current therein though the movement is, of course, to the south.

On our way back we were stormbound at the southerly entrance thereto. For two days, the lake beyond was a turbulent mass of seething waters, too rough for us to venture out on in our small birch canoe. Magloire, who was a French Cree, could talk and understand English well, and an old voyageur, had many an interesting tale to tell. He had never been to York Factory on Hudson Bay with the brigades, but there were freemen at Isle a la Crosse who had, and so had several of the Cree at Canoe Lake. It was a whole season's journey from Isle a la Crosse to the Bay and back, and there were many portages to be made

to avoid the numerous rapids on the Churchill and Nelson rivers. The crews arose at dawn, travelled for two or three hours, had breakfast, then on again with perhaps two more halts for meals, to camp in the late evening. The pay was small, the work hard and the food consisted of bannock, bacon, fish, dried meat, tea—not much more.

By the end of September, the equinoctial gales, there almost invariably from the east or northeast—in general, from the Bay—had stripped the trees of practically all their foliage, and in bleak wintry weather two of the freemen and I left with a boat load of supplies for Canoe Lake. With the trading goods carried into the little store the boatmen immediately started on their return journey.

The HBC post journal recorded Lamarque's activities: "September 30—S.E. wind strong. Baptiste Laliberte[†] and Lamarque started with a few trading goods to meet the Cree at Canoe Lake." "October 5—Laliberte and Lamarque return from Canoe Lake with a few furs." The following day "Lamarque started for Canoe Lake with supplies for fall trade."

In late October and early November, the post journal noted the first returns of furs from the Canoe Lake district. "October 29—Francis Collinson arrived from Canoe Lake with Mr. Lamarque's furs, not so bad for a commencement." "November 4—François Maurice from Canoe Lake with a bundle of furs from Lamarque."

By mid-November, winter weather had started and there was enough snow on the ground to utilize a sled and dog team. The post journal record for November 12 stated: "About 9 o'clock this morning Lamarque arrived from Canoe Lake along with François Maurice. After getting a few supplies put together he left about 2:30 p.m., taking a sled and a train of dogs."

Some of the Cree had already left for their hunting grounds, but one or more stayed all winter. François Maurice, a brother of Magloire, lived in a cabin not far from mine and that winter he acted as my interpreter and travelling companion. He could speak English and indeed had accompanied the Tyrell brothers on their exploratory journey through the Barren Lands from the northeast of Lake Athabasca to

† Baptiste Laliberte was a Métis who worked for the Hudson's Bay Company in the English River district for many years. He began as a general servant, then was an interpreter and a trader. In 1895 he became a post master. This was a position that ranked between interpreter and clerk and was usually given to aboriginal or Métis men that the HBC valued for their hard work and skills. In 1899 the HBC promoted Laliberte to clerk in the Cumberland district. He worked there for two years before returning to Île à la Crosse at the same position.

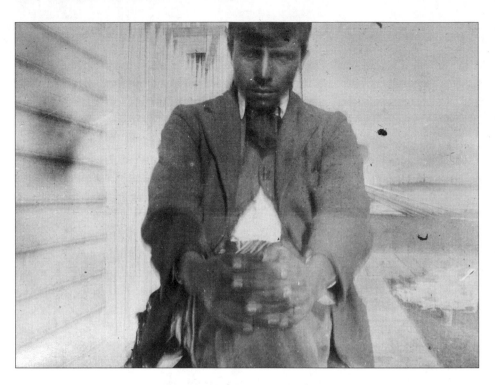

Joseph Desjarlais at Île à la Crosse in 1898. 9-10-1, Whyte Museum of the Canadian Rockies.

Chesterfield Inlet and Hudson Bay. [Joseph and James Tyrell travelled through that area on a Geological Survey of Canada expedition in 1893. François was hired both for his canoeing skills and because he could speak the Cree and Chipewyan language.]. He was a very powerful man and had an enormous appetite. We travelled several hundred miles together that winter, visiting the various Cree families at their hunting lodges to trade their furs. I had a train of four dogs, and though, of course, at first it was all new to me, I soon acquired some ability therefor. Sometimes we had to camp out—bivouac under the shelter of a tree—but usually we made some native tipi for the night. On an average we would make about thirty miles [50 km] in a day, depending on the state of the trail. We always tried to make some Indian encampment by nightfall for it saved a lot of work after a long day's travel. It took a full hour to make a good bivouac—clear away the snow, cut spruce or balsam brush for a bed and enough wood to keep the fire going for most of the night. We usually left about 5 o'clock in the morning, which in mid-winter would be two hours

before the dawn. After travelling for two or three hours we would boil the kettle, eat a frugal meal, usually of bannock and bacon, washed down with sweetened tea, then on for a similar period, have another snack and on once more to halt for the night in mid-afternoon to make camp in the waning light.

A well-ordered Indian tipi is a pleasant place in which to spend the night, especially when there is plenty of room and the aroma of newly placed balsam boughs fills the air. The first five or six feet [1.5 to 1.8 m] above the ground is usually free of smoke, and if there should be an occasional whiff the smell of wood smoke is quite pleasant. To lie with one's head near the covering of the lodge and feet to the fire is quite remarkably relaxing after a long day on the trail. All these Cree at Canoe Lake were Roman Catholics, and every night the head man in a lodge would recite family prayers, all kneeling around with their backs to the fire. After our arrival and before we had a meal, a bowl of snow water in which to wash was handed round, to the visitors first and then to the others, so the water was not too clean for those who came last. Fine whitefish were then plentiful in most of the lakes and streams. They averaged three pounds [1.4 kg] in weight and were caught in great quantities in the fall and cached for use in winter. Our sled dogs got two apiece each day when travelling; one when idle. The fish, of course, were kept in a frozen condition, and were usually excellent eating. Should there be too long a period of warm weather, however, after they were caught and cached they were not so palatable; or as an old trader remarked to me, "they have an acquired taste."

I went into the fort at Christmas. It was only about 20 miles [32 km] away by the winter portage trail, which did not follow the river until near its mouth. Fugl was there from Souris River and Baptiste Laliberte from Buffalo Narrows, and the accountant, John George McTavish Christie, who had been out on furlough. We feasted sumptuously for a couple of days for Bobbie Thompson was an excellent cook.

The post journal for December 24 noted Lamarque's arrival from Canoe Lake along with the Cree, and it also recorded his departure on December 28.

We all sat down to breakfast at two o'clock in the morning. Our sleds were packed and we were soon on our way to our various outposts. We were all more or less dressed alike, in blanket or cloth capots, with long stockings pulled up over our trousers, or with

fringed leggings coming above the knees. We all wore many-coloured l'assomption belts [a type of colourful sash originally used by the French Canadians that later became part of the Métis costume] and had plenty of duffle inside our moccasins. Fugl... had some trouble with his dogs. He had a magnificent team. Whiskey, the leader was coal black; Londee the second, practically white; Chocolate came next, the name sufficiently describing the colour, and old Bristhaire was the steer dog next to the sled. Young Lariviere was with Fugl. They got away to the accompaniment of much snarling and growling, crowding my dogs back from the gate as they swept through and out on to the dim surface of the lake, from which, presently, came a distant hail, "See you in June." The sound of bells had died away as François and I, the last to go, turned towards the village and through it on our journey back to Canoe Lake. It was but a few minutes past three, four long hours before the dawn, nearer five. There were no lights in the village, none at the mission, and not one at the fort we had so recently left.

TÊTE NOIR

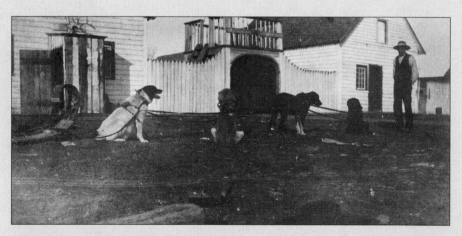

Lamarque's dogs at Île à la Crosse in 1899. Tête Noir, the white dog with the black head, is on the left. The man is Petit Vincent Daigneault. 9-10-2, Whyte Museum of the Canadian Rockies.

DURING THE LONG days of summer, Tête Noir, who was half wolf, lazed near the shore of the lake, waxing fat on the numerous fish from the nets. When I first knew him—and we worked together in winter—he was past his prime as a sled dog, but, even so, there was not a keener animal in the country and for the three years that we followed the winter trails together he was my best dog and companion.

Tête Noir had a black head, as, indeed, his name would imply. A white body and legs and his tail, which he carried after the manner of a wolf, was half black and half white. In winter time, when he was working, he weighed about 80 pounds [36 kg].

Sometimes on a moonlight night in the fall of the year, before we went to the outpost, I have heard him commence to howl—often little more than a whimper—and then pause, waiting for the response from the dogs in the village across the bay. If this was not speedily forthcoming, he would howl and howl, continuing to do so till the others took up the cry, when, satisfied, he would sleep.

Tête Noir was splendid in any position in the train, though I rarely, unless the ice was uncertain—when his sagacity there was of value—had him foregoer or steer dog, for in either position he was so keen and worked so strenuously that he was unduly hard on himself.

Though so fierce a fighter that most dogs avoided battle with him, he would take food from my hand like a child, and in our many bivouacs on bitter winter's nights, he would often sleep on the spruce boughs by my side.

The third year, Tête Noir and I did not go out to the outpost but stayed at the head post of the district till spring, making only a few journeys together, that last winter of 1899–1900, two of which were to a lake 120 miles [192 km] to the south, to get news of the Boer War, for even in those days there was a monthly mail to this lake to the south. The old dog was still very keen and when on one or two occasions I took him out of the train and let him run behind the sled, he was not happy about it.

I went south to civilization in the summer and before going I expressed the hope that, as he belonged to the Hudson's Bay Company, he would be suitably cared for and pensioned off.

Some years later I met the officer who took charge of the post soon after I left, and he told me that the old dog had been cared for and had not done any more work; that he had died a year or so after my departure and was buried in the grounds of the fort.

January was usually a very cold month, when the natives did little hunting or trapping. New Year's Day was one of feasting and the Cree, who mostly stayed in their cabins by the lake till after the first of the year, all paid me a visit and accepted such hospitality as I was able to offer. My cabin would then be crowded with men, women and children eating bannock and bacon grease with lots of sweetened tea.

During the winter, the post journal recorded trips from Canoe Lake bringing in furs from that post. François Maurice came with a load of furs on January 8, 1898, and returned to Canoe Lake two days later. In late January, Maurice returned again with "furs, quite a little bit." A week later Maurice came in with more furs. On February 7, "Petit Vincent left for Canoe Lake with 6 bags flour for Mr. Lamarque's trade" and on the evening of the following day he returned "with 2 bags of Mr. Lamarque's furs—$31.40 in all." On February 21, Lamarque brought in a bundle of furs and took back some supplies. A week

later "Lamarque from Canoe Lake with his furs to date, consisting of 1 beaver, 3 red foxes, 1 silver fox, 1 marten, 2 ermine." The post journal entry for March 7 recorded: "Mr. Lamarque arrived from Canoe Lake with about 310 lb. [135 kg] furs, including 2 fine silver foxes, quite an acquisition to our small month—fixed him up ready to return him tomorrow morning for another onslaught." Four days later Vincent went to Canoe Lake with eight bags of flour for Lamarque's trade.

> The region around Canoe Lake was undulating and forested. In March some of the Cree pitched off to where they had killed game. It was the best month in which to hunt moose—a season of high winds and milder weather, when the snow was often soft and almost soundless on which to travel, the creaking of trees and the noise of the wind smothering any sound made by the hunter. The chief, Raphael Pewabiskoose [Iron], was a small tough man of about 50 years of age and a mighty hunter. He had killed five moose in one day, within a radius of three or four miles [4.8 to 6.4 km], and had pitched off from his usual hunting location to the vicinity of his kills. I paid him a visit there and spent a couple of days in his lodge, 50 or 60 miles [80 to 96 km] from the lake. The weather was mild and the equinoctial gales roared through the forest. His dogs, I remember, were very hungry, and occasionally they came into the tipi during the night looking for food, leaving the entrance flap askew and the snow blowing in. Every now and then some occupant would rise on an elbow and shout "marche," and the dogs would withdraw, but they were soon back again.

The March 18 post journal stated: "Lamarque on his last trip to visit the Indian camp collected a few skins but did not send them in. He unfortunately cut his leg with an ax on his most recent trip, but was to start out again on Monday morning."

> I was in to Isle a la Crosse again for Easter. Many of the Indians went in too and attended mass at the mission. During the spring I covered much of the country I had in winter, but by water, travelling in a birch canoe with an Indian, for I now knew enough Cree to dispense with the services of François. We covered much country by water and portage, and at the beginning of June I returned to Isle a la Crosse for the summer.

The Outpost

ON A SMALL eminence above the lake shore stood the single-roomed log cabin which, with another, very much smaller, windowless log building, constituted the outpost of the Hudson's Bay Company at Canoe Lake.

The edge of the forest was nowhere within two hundred feet [60 m] of the buildings which were, therefore, unsheltered from the fierce storms of winter and the unrelenting cold.

In the same clearing, but somewhat nearer to the friendly shelter of the woods, were seven other cabins belonging to those Cree of the district who made the lake their headquarters. There was, too, a little log church where, perhaps twice a year, a priest from the Catholic Mission of Isle a la Crosse held services.

There were two glass windows in the trader's cabin, one facing the south, the other the east, so from the inside one could not see out over the broad expanse of the lake, which lay to the north and west. In the centre of the northerly end of the building, a large mud fireplace projected into the room, in which the firewood was placed vertically and the flames roared up the straight column of the chimney. The roof, of a fairly steep pitch, was covered with sods and the walls were whitewashed inside and out. The floor was of whipsawed timber from the adjacent woods.

The post was not occupied in summer, but from the middle of October until the end of May it was the headquarters of the Company's agent who, visiting their lodges in the fastness of their hunting grounds, traded with the few Cree families that hunted and trapped over an area of some four thousand square miles. [10,350 square km].

Early in November or in October, before the freeze-up, the Indian families, with one or two exceptions, "pitched off" to their several trapping grounds where they remained until the great festival of Christmas brought most of them back, via the lake, to the Mission at Isle a la Crosse. It was a long way to go—for some of them nearly a hundred miles [160 km]—to attend the midnight mass and other services, but it made a break in the winter, and then too, some of them only returned as far as Canoe Lake, where they stayed during January, usually a period of very low temperatures and bitter winds, when even the fur-bearing animals stayed near their lairs and the rewards of trapping were therefore few.

By the middle of February, however, all the Indians had again pitched off, and this period, particularly in March, when the snow was sometimes soft and the winds often high, was the best for hunting moose. The Chief, who was a great hunter, had once killed, skinned and cached five moose in one day, a remarkable achievement.

The Indians used every part of the animal and boiled most of the meat, and though this was a season of feasting for themselves, their dogs fared but badly, for at this time they were usually far away—often more than a day's journey—from those caches of fish which they had put up in the fall, and the animals, but little satisfied with the few scraps of meat that were occasionally tossed to them, would come into the lodges, looking for food.

Again at Easter most of the Indians went to the Mission, unless the festival was very late and the spring early, when the trails were often impassable.

The spring came in gradually and winter seemed reluctant to let go her hold. The American crow was one of the first birds to arrive, though early wildfowl, not far behind,

soon found patches of open water where the current ran swiftly. The Indians passed this season hunting bears and muskrats. The former, fresh from their winter dens, were gaunt and hungry and quite ready to take the rotting fish bait in deadfall or steel traps. Their pelts during the month of April, though somewhat dirty, were quite prime.

The muskrats were trapped and shot along the lakes and streams. Many Cree could imitate the squeaky call of a rat so exactly that the little animal would come swimming towards the hunter to be readily shot by an arrow or a very few pellets from a muzzle loader. Many rats would thus be secured after the sun had sunk behind the distant hills and the violet dusk had crept over the wilderness. A V-shaped ripple in the water indicated to the native, sitting motionless in his birchbark canoe amongst the reeds, the presence of a rat which, at the calls given by the Indian, would usually turn and come straight for the sound and its doom.

By the end of May the outpost was again deserted until the naked trees and the bitter winds heralded the approach of another winter. And so the seasons passed, year after year, and the white men, except for the missionaries and the traders, were far, far away to the south beyond the fringe of the forest.

The post journal described two occasions when Lamarque sent in furs from Canoe Lake in May. "May 13—Two chaps brought in furs [worth] $101 from Canoe Lake, Mr. Lamarque's trade, and freighted back supplies." "May 20—Two men from Canoe Lake with some furs from Lamarque, some 400 [musk]rats and other pelts. We fixed them up with the supplies they wanted and they left about 6:30 p.m." On the final day of the month the post journal stated: "Last night about 10 o'clock Mr. Lamarque with Jerome Collinson arrived from Canoe Lake with 2 bundles furs, including 9 bears. After putting together a few supplies he was short of he left after dinner with a good wind behind him." Lamarque returned to Île à la Crosse for the summer on June 10. "Lamarque with François Collineur and Joseph Opikokew bringing in his furs and goods. His fur list included 13 bears, the majority of the Canoe Lake hunt."

Fugl went out that summer to England and Denmark. He had made a good trade at Souris River and obtained much fur. That summer was principally interesting because of the passing of many would-be Klondikers, en route to the Yukon, who had been persuaded by the merchants of Prince Albert that it was a good route to follow. It was, of course, nothing of the sort. These men were mostly from cities or farms, and few indeed ever reached their destination. This route was one that joined the so-called Edmonton–Mackenzie River one at Fort McMurray, where the Clearwater River enters the Athabasca. The first party arrived over the ice at Easter. They were an alert,

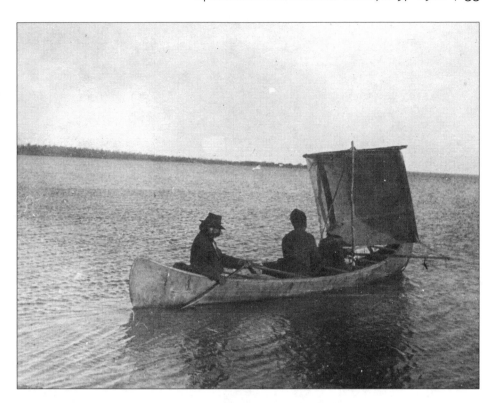

James McCallum and Pierre Maurice on Lac Île à la Crosse. A sail has been rigged to catch a favourable wind. 9-13, Whyte Museum of the Canadian Rockies.

forceful outfit, and arranged with Mr. King for their transportation as far as Fort McMurray. I expect that the Company lost out on this contract. If any of the many parties who passed through Isle a la Crosse reached the Klondike, I feel sure it was they. One remarkable group of four arrived in mid-summer. They had managed to get a boiler and engine to Green Lake, set it up in a boat there and come on down the Beaver River on their own steam: the first steamer—and probably the last—to arrive at Isle a la Crosse. One was a French count,[†] one English and other two German... They wasted two or three weeks at Isle a la Crosse, the Frenchman, on occasion, going over to the mission to play the harmonium in the church... They never reached the Klondike, but I believe that they did get their boat to McMurray where it was bought by the Company.

† The French count was Jean de Jumilhac. He was one of a group of French aristocrats who had settled in southeastern Saskatchewan in the late 1880s.

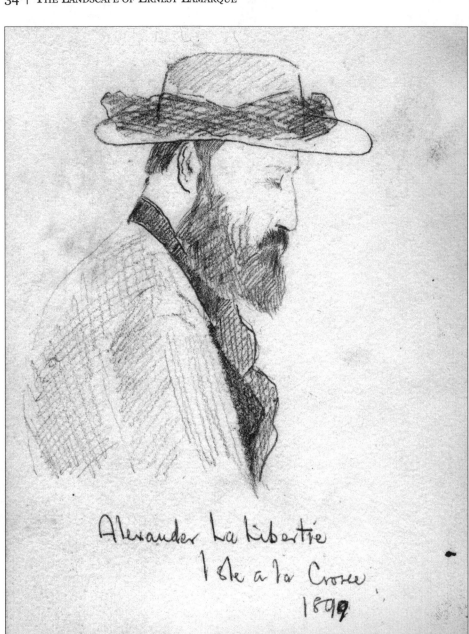

Alexander Laliberte. The brother of Baptiste Laliberte, Alexander worked for the Hudson's Bay Company in the southern part of the English River district for several years. From 1888 to 1890 he managed the small HBC post at Canoe Lake. While living there, he married the daughter of the Cree chief, Raphael Iron. In 1902 he retired from the HBC, and then ran the Revillon Frères store at Beauval until 1931. LaE.09.01-1, Whyte Museum of the Canadian Rockies.

According to the post journal, Lamarque went to Canoe Lake in early August to check on conditions, and he purchased some dried fish for the sled dogs for the winter. On September 13, "Lamarque left for Canoe Lake with the skiff accompanied by R. Gardiner, to pick up what furs he could at Canoe Lake. A few bears coming in daily here." He returned on September 17 "with a few furs, some dry fish, and some moose meat, old François Collineur having killed a moose on the river not far from here." Lamarque took another short trip at the end of September. "Lamarque left this morning with canoe for Canoe Lake along with old François Roy to see the Crees as they now all assembled there, and see what he could pick up on the fur line." On October 1, "Mr. Lamarque and old François Roy returned from their trip to Canoe Lake, having met the Indians on the river, who were coming in to Isle a la Crosse along with the Rev. Jules Teston, one or two bears the outcome of the venture." October 12, "Lamarque with the big skiff along with Proper Vincent and Natomagan left for Canoe Lake to fix things for the winter. They took out a good load, mixed cargo." Unfortunately the weather turned cold and by the time they returned on October 15 the river had frozen so the skiff had to be left at the lake. On November 8, Lamarque came to Île à la Crosse with 200 furs and left with a load of supplies. In mid-December, he brought in furs valued at sixty-three dollars. Once again Lamarque returned to Île à la Crosse for Christmas. "Dec 24—Mr. Lamarque arrived in the afternoon from Canoe Lake with his Indians and some furs." "Dec 26—The first to leave was Lamarque for Canoe Lake along with his Crees."

The 1899 English River District register of employees listed E.C.W. Lamarque as one of the clerks and Alexander Laliberte and Magloire Maurice as servants.

In mid-February, Lamarque and Magloire Maurice brought in furs and took back supplies. The post journal recorded that the furs Lamarque sent at the end of the month included one silver fox. Lamarque's return to Île à la Crosse for Easter was noted in the post journal: "April 1—Lamarque arrived with 192½ lbs. fur [88 kg]." The fur-trading season ended on June 10, when "Lamarque arrived with his furs and goods—also most of the Crees arrived."

> The following winter and spring I was again at Canoe Lake, travelling much of the time by myself or with the native who had been with me before. The next summer, my school friend paid me a visit... That summer, too, Cornwallis King was transferred to York Factory on Hudson Bay and English River district was taken into the Saskatchewan District with Chief Factor James McDougall in charge. It was only on the arrival of McDougall in mid-June that we knew that King had been transferred...

THE ARRIVAL OF THE BRIGADE

ALL DAY LONG the wind howled out of the northeast, whipping the surface of the lake to foam. Squalls of rain passed, hiding at times, the long, low island two miles [3.2 km] out in the lake with its fine sandy bench, on which, nearly a century before, the employees of two great companies, the Hudson's Bay and the North West, met when they were not fighting, to play lacrosse.

"The brigade will be at the mouth of the river," said the Chief Trader, "and if the storm passes at sundown they will be here very early in the morning." And at sundown, sure enough, the wind fell and by midnight, except for a slight swell, the lake was calm and the sky clear. There had been no news from the outside for several weeks, and the thought of the approaching brigade with the mail that they might have, had kept me awake. Towards midnight, however, I dozed off into a somewhat restless sleep from which I was awakened about dawn by my fellow clerk touching my shoulder. "The brigade is coming," said he, "they will be here in about an hour. Listen." At first I could only hear the hum of the mosquitoes, and then, very faintly—*klunk—klunk—klunk*; steady, persistent, the sound of the sweeps in the rowlocks.

In two minutes I was dressed and out. The sound of the sweeps was louder, but still far away. The lake, in the first rays of the morning sun, shone like silver. In places the low shores were clear-cut; at others, particularly in the southeast there was mirage. Smoke was already ascending from many chimneys of the cabins in the village across the bay.

"Do you see them?" said my companion. I stared long and steadily in the direction of the sound.

"I see nothing," I replied.

"Just to the east of the island," said he, "merging with the far shore. Look." Ah, I saw them now; mere specks and partly involved in the mirage.

"They will hardly be here for an hour yet," said my companion. "Here's Che Vincent from the village. We'll get him to hustle our breakfast, for we shall be too busy to eat when they arrive."

Our cook hustled, and we were through our frugal meal ere the boats were half a mile [800 m] distant. Freemen from the village were arriving—swarthy, alert men; French Crees and Scotch Cree; voyageurs who merely did not happen to have gone with this brigade. Men who, either themselves or their parents, had been in the steady employ of the Company but, having taken their discharge, were now called "freemen." Interesting characters, many; hardy, all.

See that tall barrel-chested man of sixty, wearing the plain moccasins and the broad many-coloured l'Assomption belt around his hips. That's old Michelle who in his younger days had made many trips with the Company's boats to York Factory. He, who only a few years ago, when the Company, in the spring of the year, were practically out of tea, went in his little birch canoe to Green Lake and back in three days and three nights—240 miles [400 km] as the river flows (120 miles upstream and 120 downstream with 30 miles of rapids to negotiate), bringing half a chest of tea and so saving part of the spring trade. Why, only the other day, he came in from Patchewanak, where the Churchill River commences its turbulent course to the Bay, arriving shortly after noon—45 miles [70km] for a morning's paddle.

As the brigade approaches, the two leading boats race for the shore, and amid much laughter and shouting, the four bateaux—long, flat scows, each with 120 pieces (about six tons of supplies) are beached.

Baptiste, the guide, another old-timer, comes ashore with a packet and bills of lading, and without more delay the crews commence carrying up the cargoes. They are all barefooted and hatless, these hardy fellows, many of them wearing bright cotton handkerchiefs tied around their heads. They use the long, narrow leather straps that open out into a broad band in the centre, known as portage straps or tump lines and the usual load from the boats to the warehouse is two pieces—200 pounds [90 kg], more or less. Bags of shot, half chests of tea, bales of goods, bags of flour, sacks of bacon and cases of hardware—in two hours the cargoes are safely stored in the warehouses, the tarpaulins drying in the sun and the crews have swarmed into the store for their pay and rations.

Some of them have little to take, for they have already been advanced most of their pay, but all have a ration coming—of flour, bacon, a making of tea and sugar, a plug of tobacco and a paper of matches. Receptacles for putting commodities into, such as flour, tea, rice, etc. are lacking, so the voyageurs buy gaudy cotton handkerchiefs into which they may tie tea, sugar or flour; and it is not unusual to see a purchaser of a pair of overalls fill one leg with one commodity and the other leg with another. By noon the store, except for a few stragglers, is practically deserted and the staff has a chance to read the news from the outside, store equipment and send the boats to the little sheltered bay 300 yards to the northeast.

Then, as the shadows deepen, we sit around the little wharf, look out over the placid lake and talk with old Michelle of those strenuous days of long ago when all the supplies for the north came through York Factory on the Bay. Another pipe, another tale, and the old voyageur, with a dignified inclination of the head and a hearty "bon soir" picks up his light canoe, places it in the water, and with a few powerful strokes of the paddle, disappears into the night.

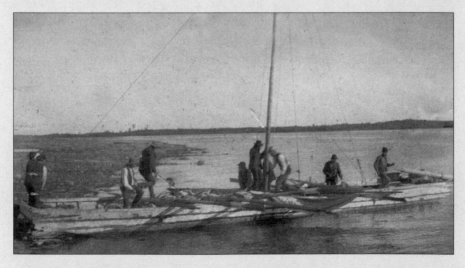

Bateau at Île à la Crosse. 9-8-2, Whyte Museum of the Canadian Rockies.

When I first met McDougall he was 59 years of age, a tall, rather heavy man with greenish eyes and a greying beard... He immediately sent me to take inventory of the Company's stock at Souris River, whither I went with two canoemen. The first 45 miles [70 km] was over the lake, the remainder, about 100 miles [160 km], down the Churchill River, a typical Laurentian stream with many lake expansions between which there was usually a heavy rapid. To avoid the worst of these we had to portage. We were away about 10 days and soon after McDougall went south again to Prince Albert, now to be the head post of the combined districts, taking the accountant with him and leaving me in charge at Isle a la Crosse.

In a letter to Tommy Walker in 1964, Lamarque recounted a fond memory of canoeing on the Churchill River while en route to the Souris River post at Pinehouse Lake. When he and his canoemen stopped for lunch one day, they met Pierre Maurice "who entertained us with many jigs and tunes on his fiddle... I can yet hear the vibrant tunes of the various reels. A fine lunch indeed on the warm sandy shore." The post journal for June 26 recorded that Lamarque left for Souris River "to take inventory and clean up the establishment for the summer." Magloire Maurice was listed as one of the canoemen accompanying Lamarque. Their return on July 4 was also noted.

McDougall... had left his buckboard at the south end of Green Lake. His servant, Louis LaRocque, who usually accompanied him on his travels, was a very capable all round man; good with horses; good in a canoe; a first class bushman and winter traveller. Louis did the cooking, drove the team, and attended to and arranged the camps. Charles Mair, the poet and author, happened to be at the north end of Green Lake when McDougall arrived on his way south. Mair wanted to get back to Prince Albert, so McDougall offered to take him...

The accountant got back from his furlough two or three days before Christmas. Three or four sleds arrived together from Green Lake and on one of these was Fugl, who had come to buy furs for cash for a firm in New York. He went over to stay with a trader named Marcelin, who had arrived in the country the previous summer. I believe he bought Marcelin's furs. Fugl's headquarters were at Prince Albert, whither he returned shortly after Christmas. Marcelin had a phonograph, the first any of us had seen or heard of. We heard, too, of the Boer War, which had then been in progress for nearly three months, for while there was a monthly mail to Green Lake even then, mail

from there north was carried haphazardly, by the Company's boats in the summer or by infrequent freighters in winter. By this means, about the middle of January we had further and disturbing news of the war, and so, a few days later, I started out with my dogs for Green Lake, accompanied by a Freeman from the village. The winter trail was at least 20 miles [32 km] shorter than the water route, and as the trail was good, we made the 100 miles [160 km] or so in 2½ days. I was delayed for 4 days at Green Lake on account of the illness of my companion. Ned Camsell, the eldest son of Chief Factor Julian Camsell, officer in charge of the Mackenzie River district, was in charge at Green Lake. He was then about 30 years of age and had come there from Stuart Lake where he had been in charge of a small district in northern British Columbia. We spent much of our time discussing the war and reverses to Buller, Methuen and Gatacre.

The post journal entry for January 17, 1900, stated: "Early this morning Mr. Lamarque left for Green Lake, along with Pierrish Malboeuf, taking up a case of marten which has to be forwarded to Prince Albert by the end of the month, in time for transhipment to London to catch the March sales." On January 30, the two men returned bringing the mail.

On our return journey to Isle a la Crosse we made a detour to Dore Lake, following a small river thereto from its confluence with the Beaver and thence across the lake to the easterly shore where I hoped to trade with a family of Cree encamped there. However, we were caught by a blizzard on the lake and were glad to seek shelter for the night on an island some five miles [8 km] from our destination. The next day, after leaving early and getting but little fur from the natives, we travelled till long after dark to reach a deserted cabin on the banks of the Beaver River, between 50 and 60 miles [80 to 96 km] from our encampment of the previous night. I broke the tip of one snowshoe in the brulé on the portage between Dore Lake and Lac la Plonge, an accident that retarded my progress and caused many a fall.

Disturbed by vague rumours about the war, I again started out for Green Lake towards the end of March, taking with me the same freeman, Pierrish Malboeuf. There we learned that Ladysmith and Kimberley had been relieved, Bloomfontein captured, and Cronje taken with 4000 prisoners. Thus reassured, we returned to the fort and I spent that spring at Canoe Lake to which early in April, I had portaged my light birch canoe over the cold melting slush of the

winter portage. In this light craft, and usually alone, I traversed the numerous waterways to trade the furs that the natives had collected in their spring hunts.

During the winter, Lamarque made a few trips to Canoe Lake to take supplies and check on the person operating the Hudson's Bay post that season. In late March, "Lamarque and Pierrish Malboeuf for Green Lake to meet Mr. Sinclair coming from Prince Albert with mail, probably the last chance this spring." A week later they returned "bringing quite a bit of mail." On April 10, "Lamarque left this morning with Gardiner and 3 horses for Canoe Lake to look up the spring trade, taking out with him flour and other trading supplies." "May 17— Lamarque arrived from Canoe Lake in the forenoon with 900 [musk]rat, 2 bears, 8 mink, 1 skunk—very good considering the heavy opposition he has to contend with, the no debt system. Getting a few things together for Lamarque's trade." Lamarque completed the spring trade at Canoe Lake at the end of May. The post journal for June 25 recorded Lamarque's departure. "About 8 o'clock Tomma Dejarlais left for Green Lake with bateau... Mr. E.C.W. Lamarque, retiring from the service."

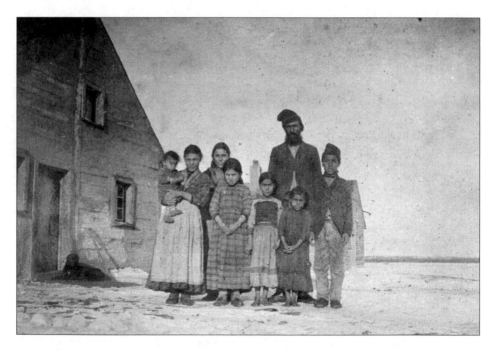

Pierrish Malboeuf and family at Île à la Crosse, 1899. Malboeuf, his wife, and children are listed in the 1901 Canada census. 9-16, Whyte Museum of the Canadian Rockies.

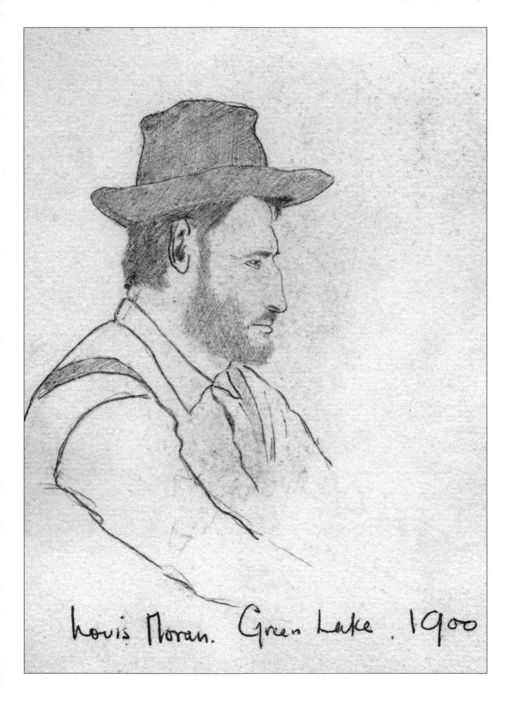

Louis Moran [Morin], Green Lake, 1900. Morin was born at Île à la Crosse but lived most of his life at Green Lake where he worked for the HBC. LaE.09.01-4, Whyte Museum of the Canadian Rockies.

That summer I left the Company's service, and as Ned Camsell was leaving Green Lake, we travelled out together to Prince Albert, and as a tent was part of his travelling equipment I, sharing his, slept in one for the first time, except for tipis, since leaving Prince Albert three years before. It was not then the custom to use a tent in winter time, and, at any other time, an upturned canoe was considered a sufficient shelter when it rained. We crossed to the southerly side of the North Saskatchewan River by the ferry near old Fort Carlton, which had been destroyed by fire, so that only the foundations remained... On our arrival at Prince Albert, a day or two later, my three year period of service with the HBC came to an end.

1902–06 | FOUR YEARS MORE IN THE NORTH

Between 1900 and 1902, Lamarque worked in several positions. Although he spent some time on a ranch near Calgary, most of his employment was in the Winnipeg area. In the summer of 1902, while working for a CPR land inspector, Lamarque learned that the Hudson's Bay Company wanted him to be a clerk again and had offered him a position at Fort Simpson, the headquarters of the Mackenzie River district. He decided to rejoin the company because it provided him with an opportunity to see more of northern Canada and have new adventures.

FORT SIMPSON

After an interview with Commissioner Chipman in Winnipeg I left by train for Edmonton, the northerly terminus of the branch line from Calgary... I was there about a week and most hospitably entertained by many new acquaintances. The old, partly palisaded fort of the Hudson's Bay Company was situated on the top of a high bank overlooking the river. F.B. McMahon, who had been the accountant at Prince Albert when I had passed there on my way north five years before, had been transferred to the Athabasca district, the headquarters of which were at Edmonton, and it was largely due to him that I met with so much hospitality...

I left Edmonton by four horse stage on a road that was not too rough and the creeks bridged. The distance to Athabasca Landing was about 90 miles [144 km] and we stopped at Egge's for the night, half way on our journey. From there to the Landing there was only one settler; a family by the name of Whitley, where we stopped for a meal.

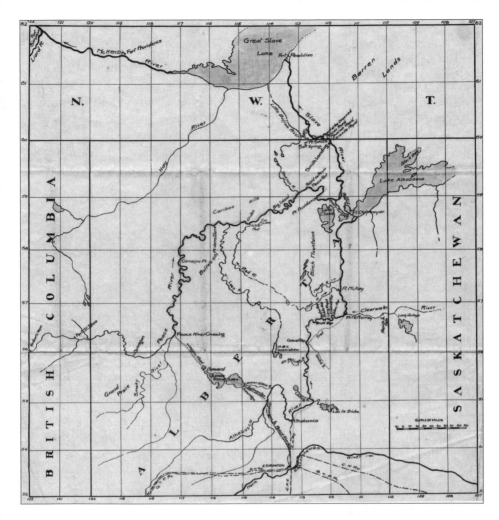

Lamarque's map of northern Alberta, a portion of the BC Peace River district, and part of the Northwest Territories shows the locations where he worked for the HBC from 1902 to 1906, along with his surveying in 1914. M88-81, Whyte Museum of the Canadian Rockies.

Athabasca Landing was then a very small settlement. When I arrived it was full of bustle, for the last brigade of boats for the north was about to leave, and we pulled out the next day, a brigade of perhaps 20 scows. It was about 150 miles [240 km] to the first of a series of heavy rapids, known as the Grand Rapid, where the river falls precipitously over sandstone boulders and is divided by a long low island across which the Company had constructed a light railway for transportation purposes. The boats were run into the head of the island, the supplies unloaded and trundled in light cars across the railway,

loaded again at the foot and the scows then assembled in a bay just below the island known as the Big Eddy. The boats were taken down the narrow easterly channel, as the main channel was not considered navigable at any stage of water, though a steamer was run through it on two occasions when the water was very high, a remarkable feat of courage and skill in navigation, for the best passage through it could only be judged, so to speak, on the run, and once started and the course decided on, there was no possibility of stopping or changing the general direction. Moreover, there were ten heavy rapids below through which steamers had never gone, though they had been navigated many times by the various brigades of boats.

We were several days on the island at Grand Rapids and then, as the water was at a good stage, we ran down the 90 miles [145 km] to Fort McMurray in about a day and a half, without having to make half cargo, even at the Big Cascade. In this section, the banks of the river are high, broken and terraced. It was August, when the berries are ripe, and we saw many bears at which the boatmen, quite stupidly, fired; for had one been hit, it is doubtful if any boat would have stopped to collect the meat; and why, needlessly, perhaps merely wound an animal? The boatmen were mostly French or Scotch Cree, of the type I had known at Isle a la Crosse, not used to or requiring many amenities. Few wore hats, and their long black hair was usually bound round with coloured handkerchiefs, their feet either bare or moccasin clad. James Stuart Spencer was in charge of the brigade. He was of an old Hudson's Bay family. I shared his tent.

On arriving at Fort McMurray, which then consisted only of one large log warehouse near the river at the foot of a steep escarpment, the brigade was beached on the shore of an island on the northerly side of the Clearwater River, which here enters the Athabasca. Having had little exercise since leaving the Landing I started to take a walk along a good trail on the island. Feeling suddenly unwell, I returned to the tent where I remained while we were there. Two or three days later the steamer to which the freight was to be transferred, arrived from the north with the Indian Treaty Payment party aboard, and Dr. Hyslop, who accompanied them, told me I had pneumonia and to lay low, so, when we boarded the steamer, I stayed in bed for the next few days until we arrived at Fort Chipewyan on Lake Athabasca. Tommy O'Kelly, the purser, took good care of me and Miss Potts, en route to the Anglican Mission at Hay River on Great Slave Lake, helped to look after me.

We disembarked at Fort Chipewyan and then the steamer went on down the Slave River for a hundred miles [160 km] or so to the head of the rapids at Smith Landing, now known as Fitzgerald, named after an Inspector of the Mounted Police who lost his life on the patrol between Fort McPherson on Peel River and Dawson City on the Yukon. At Smith Landing the freight was loaded into carts drawn by either oxen or horses and thus transferred to the steamer Wrigley at Fort Smith, at the northerly end of the 16 mile [25 km] portage. This, over the rough trail, was a day's journey.

Fort Chipewyan consisted then of many fine log buildings situated on a rocky point of land on the northerly shore of the lake, over which it commanded a fine view. George Drever, who I had met at Green Lake, was then in charge there, and John Sutherland, the chief engineer of the steamer *Grahame* lived there. His wife and Drever's took good care of me and I was practically over my illness when I caught measles, a disease that was then ravaging the country. This, in my weakened condition, was quite a setback and I could barely walk when we started on again, a few days later, for Mackenzie River. We travelled on a small steamboat to Smith Landing and I went across the portage lying on a mattress in an ox-drawn cart. Fort Chipewyan had then been established for about 100 years and had only recently lost the dignity of being the head post of the Athabasca District, now controlled from Edmonton. There was quite a village strung out along the lake front westerly from the fort. There was a large Roman Catholic mission, a small Anglican one in charge of the Rev. Warwick, and a detachment of Mounted Police in charge of Constable [Frank Hedley] Field... A Free Trader, Colin Fraser, was a son of the piper who used to accompany Governor Sir George Simpson on his travels of inspection.

We did not delay at Fort Smith which, with the exception of Fort Nelson, was the Company's most southerly establishment in the Mackenzie River district. All the goods for the district were there loaded on to the steamer *Wrigley* to be distributed thereby to all the posts bordering on Great Slave Lake and the Mackenzie River. Fort Smith was and is situated on the top of the high westerly bank of the Slave River, near the foot of the rapids, and as the 60th parallel, which forms the northerly boundary of the province of Alberta is about half a mile [800 m] to the south, the fort is just within the Northwest Territories... The S.S. *Wrigley* was screw propelled and

was designed to take the rough water frequently experienced on Great Slave Lake... It was the first steamer to ply in those waters and had then been in operation for about 17 years. From Fort Smith to the delta of the Mackenzie River is a good 1200 miles [2000 km], and as the ice on Great Slave Lake does not break up until sometime in June, the boat was laid up for the winter near Fort Providence, usually, at that time, making an early trip, not far behind the retreating river ice, to Fort Good Hope on the Arctic Circle, by which time the lake would be free and the boat could get up to Fort Smith with the fur returns of some of the lower posts. Then it would make one straight run, and one only, to Fort McPherson, near the upper end of the delta, on Peel River. Its last trip of the season, the one I was taking, only went to Fort Simpson, where we arrived on the 15th of September. SEE IMAGE R1150.4, PAGE 106-107.

Fort Simpson was then the head post of the district. It consisted of several large, clapboard log buildings laid out in the form of a rectangle, surrounded by a strong fence and situated a few feet from the top of a high bank of a long, generally low island. The main channel of the river is here a mile [1.6 km] wide, while that to the west of the island, here about half a mile wide, has only a width of a few hundred feet and known as the Snye, contains none, or only pools of water when the river is low. The Big House, where we lived, had, besides quarters for the officer-in-charge and the accountant, and the mess hall, all on the ground floor, at least twelve rooms on the second floor, two of which were large, one used for billiards and the other as a lounge. The other rooms were all bedrooms except one, which was used as a library. The kitchen projected from the Mess Hall and was on the northerly side of the building. The building faced to the south and commanded a fine view upstream to and beyond the confluence of the Liard, which here enters the main river from the southwest. The engineer of the *Wrigley* and his assistant, who spent the winter there, generated electricity from a steam engine from dusk until 11 p.m., so we were the most northerly people in Canada at that time, with the exception of Dawson City, in the Yukon Territory, to enjoy that form of lighting. SEE IMAGE R792.4, PAGE 110.

On Sunday, the day after my arrival, I was sitting in my room at the southeasterly corner of the Big House. It was a dreary, cold day. Snow, falling in heavy, wet flakes, obscured the view so that the Gros Cap, a high point of land a mile or more distant at the apex of

the angle between the two rivers, was not visible. As I watched this wintry scene three men, each carrying a pack, appeared at the entrance to the fort. The leader had a great, ragged beard and seemed bowed with fatigue or the weight of his pack. The others were younger and more buoyant. I did not recognize the leader, but he was none other than the David T. Hanbury whom I had seen fifteen months before in Winnipeg, hatless and carrying a fan in his hand. Hanbury was now on his way out to civilization... Hanbury stayed a few days at the fort, pending the departure of the S.S. *Wrigley* for her winter quarters near Fort Providence, some 200 miles [320 km] upstream...

My duties were light and uninteresting—helping the accountant with his books. Perhaps it was as well, for I never got quite strong again, that winter, and never went more than two miles [3.2 km] from the place. There were the remains of a really good library, founded and built up by the old timers. There was all that remained of a museum, initiated partly, I believe by the late Robert Kennicott, the American naturalist who had years before, spent some time there. Both the museum and the library were in a state of decay, for the type of people who had founded and cherished them had departed...

We lived well at Fort Simpson. There was usually fresh or dried moose or deer meat, whitefish and plenty of potatoes, for they had harvested over 600 bushels of that vegetable there that fall. We also had dried fruits and plenty of cereals.

About the middle of October the first of the fish laden boats from the fishing grounds near Fort Providence arrived, and the dogs belonging to the fort with them, and a day or so later, W. McLeod, a free trader, arrived with a scow load of goods. He established himself some 30 miles [48 km] above Simpson, on the Liard River and came into the fort several times during the winter. He brought some mail from Edmonton and some whiskey. [Willie McLeod was one of the two headless corpses found in the Nahanni valley in 1908.] See image LaE.05.50, page 99, top.

The Liard ice set fast on the 4th of November, the same day that ice started to drift in the Mackenzie above the confluence, but the big river did not set fast until nearly the end of the month. In general, the temperatures were low in January and February, averaging about 20 below zero F. [-29°C], and somewhat higher during November, December and March.

One Sunday afternoon, in the middle of December, there was a suggestion of a chinook. A soft wind came down the Liard and, for an hour or so, the temperature rose to a thaw. The lowest recorded was 60 below [-51°C], for a morning or so at the end of January, but as that was the limit of the thermometer, it may have been some degrees colder. The winter packet with mail for the south left on the 1st of December, and that from Edmonton arrived on the 25th of March. A few days later the Rev. J.R. Lucas, afterwards Bishop of Mackenzie River, arrived from the mission at Hay River on Great Slave Lake, where he had spent the winter looking after the place for the Rev. Marsh, who was out on furlough. He had left his wife and little boy Cyril at the mission at Simpson, where he had been stationed since Bishop Reeve had moved his headquarters to Athabasca Landing. Lucas was a short strongly-built man in his mid-thirties and he had been married on the island in the Grand Rapids of the Athabasca. He was musical, had a good voice, was a capable carpenter, and a good missionary.

The arrival of the first geese had been recorded at the fort for a great many years. It was a harbinger of spring, even though the country was covered with snow. That year the first geese were reported on the 26th of April and on the 19th of May the Liard ice broke up and battered into the Mackenzie pack, which it smashed and carried downstream. *Wrigley* arrived from her winter quarters with Captain Mills, who had been out on furlough, in command... On the 18th of June the *Wrigley* returned from her trip to Fort Good Hope en route to Fort Smith and on her return she had a detachment of the Mounted Police aboard, en route to establish posts at Peel River [Fort McPherson] and Herschel Island. Superintendent Constantine,[†] who was taking the party in, had his wife with him, and there were several outsiders aboard, on a holiday trip to the Arctic and back. I went down as far as old Fort Wrigley, some 130 miles [210 km] downstream, to close up the accounts of that post and take inventory. This post was rather strangely situated on the easterly shore of the river on a narrow channel opposite a low, wooded, rocky island, at the head

† Charles Constantine was one of the prominent members of the Northwest Mounted Police around the beginning of the 20th century. He was in charge of the NWMP detachment in the Yukon when the Klondike gold rush began. He was in charge of the NWMP detachment in the Yukon when the Klondike gold rush began, and established the first NWMP posts in the Arctic in 1903. In 1905 Constantine commanded a force that began constructing the Police Trail, a pack trail that ran from Fort St. John to the Yukon. Lamarque met him again at that time.

of which was a rapid. The five or six buildings were strung out along the bank at the foot of a wet and sloping terrain. The whole river was there about a mile wide and there was a good view of the Mackenzie Mountains. Chief Trader, Thomas Anderson, who had come in to take charge of the district, replacing T.C. Rae, promptly decided to have the post moved down to a point on the westerly bank, across from the "Rock-by-the-riverside."

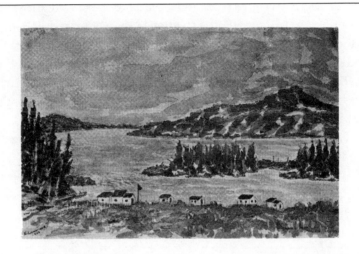

Old Fort Wrigley, latitude 63 north and longitude 123½ west, in the North-West Territories of Canada, established by the Hudsons Bay Company about the middle of the 19th century, was poorly situated on a sloping, somewhat swampy bank of the narrow, easterly channel of the mile wide Mackenzie River, there divided by a narrow, rocky, tree-clad island.

A rapid at the head of this channel made it necessary for the one or two steamers then on the river to approach this trading Post from the lower end of the island.

However, when, in 1903, the late Chief Trader Thomas Anderson took charge of the Mackenzie River District for the Company, he had the Post moved some 25 miles downstream to an excellent position on the high, westerly bank, almost directly across from the steep, isolated hill known as the Rock by the River Side or Roche,-Trempe-l'eau, which rises abruptly from the water's edge to a height of about 1500 feet.

Lamarque's card of Fort Wrigley provides information about the post. 81-9-1, Whyte Museum of the Canadian Rockies.

As I had had somewhat poor health during the winter I decided to go out to Edmonton and therefore took passage on the *Wrigley* for Fort Smith when she returned from the lower river. The boat had a very full complement of passengers. The Constantines were returning; the Rev. Spendlove and his wife, who had been in charge of the Anglican mission at Fort Norman, were leaving the country; Pere Lettier of the Roman Catholic mission at Fort Providence was, after 30 years in the north, going to France on furlough; the two engineers of the *Wrigley* were going out, and there were three or more American tourists. At Fort Providence too we picked up two young biologists of the U.S. Biological Survey—A.E. Preble and Carey. A.E.'s older brother, E.A. Preble, also of the same survey, was at Fort Rae on the north arm of Great Slave Lake when we put in there. He was to stay at Fort Simpson the coming winter, going there via the Camsell River and Great Bear Lake...

Transferring to the steamer *Grahame* at Smith Landing, where we were joined by the Indian Treaty party, Roman Catholic Bishop Breynat and Anglican Bishop Young and his daughter, besides Inspector Dr. West of the Mounted Police, we arrived at Fort McMurray about the 10th of August and with the boat brigade at Athabasca Landing on the 1st of September.

LAC LA BICHE

At Edmonton, Chief Factor [William T.] Livock, who was in charge of the Athabasca district, asked me to go to Lac la Biche to assist James Stewart Spencer who was in charge of that post... I was glad to go to Lac la Biche, for I knew and liked Spencer, whom I had met on the Athabasca River, and so, some days after my arrival in Edmonton old Gilbert Comtois and I left with a wagon and team for the lake. It took us six days to make the 170 mile [285 km] journey, for the trail was but two ruts on the prairie, and in bad places and swampy areas we had, on occasion, to partly unload our freight, making two trips with half cargo. It was a pleasant journey though. We had plenty to eat, good camps and generally fine weather. The terrain was undulating, partly wooded and in general uninhabited. Comtois, a French Cree, was a fine and entertaining man, with many a tale of buffalo hunts on the prairies in days gone by. We reached the lake on the 22nd of September to find the flag at half mast, for the day before Spencer's son, Marvin, had accidentally shot and killed Edward, his elder brother.

The next day we all drove over to the Roman Catholic mission, some miles distant from the post, for the funeral.

Lac la Biche is a large sheet of water with an irregular shore line. From Deep Bay, on the southeast, to where the Lac la Biche River leaves the lake on the northwest the distance is some 25 miles [40 km] with an average width of 7 or 8 [11 to 13 km]. It was then full of fine whitefish. The Hudson's Bay post was situated at the most southerly part of the lake near the easterly end. The forest came right down to the shores. The few scattered settlers were of French Cree or Scotch Cree extraction who made a living by trapping, fishing, freighting supplies from Edmonton and as boatmen on the Athabasca River brigades in the summer. Mrs. Spencer, the mother of four boys and one girl was a fine, kindly woman and an excellent housekeeper...

Towards the end of January I volunteered to take the mail out to Edmonton, starting out with the Company's fine heavy team which I had to abandon for a pair of Indian ponies at the end of the first day, as one of them went lame. I stayed that night at the house of a Metis at Whitefish Lake and the next, in a half-blizzard, was glad to make the homestead of the nearest European settler... It was a rough night and I was glad indeed to find room for the ponies in his stable and for myself in his log house. The settler and his wife slept on a sort of adobe extension of the stove, myself on the floor. The floor was unplanked and the roof sod covered. Outside, the storm raged and I was fortunate to be there. The next day, over drifted trails, I made the old settlement of Victoria on the northerly bank of the North Saskatchewan River and the next evening, late, I reached Edmonton.

My Indian ponies had never seen a lighted street before, and I had considerable difficulty in getting them to traverse Jasper Avenue, the main thoroughfare of the town. They would not be driven, so I had to get out and lead them up the street to the nearest stable.

After two or three days in town I returned to the lake taking a somewhat different route and spending one night under the hospitable roof of the Manns' at the Saddle Lake Indian Reserve. Mann was the agent there. The winter passed and the spring came and, with it, the wildfowl... With the coming of spring and open water I bought a small birch bark canoe just completed by a local Indian. This was a beautiful, light craft weighing 56 pounds [25 kg], and in it I cruised about the lake, going across occasionally to islands far out where black ducks were flying. As the summer wore on, my thoughts turned

to the Peace River, and especially to the upper river, and I applied to the Chief Factor for a transfer to that part of his district. He told me I could have charge of the outpost of Hudson Hope, situated at the foot of Rocky Mountain Canyon, and I left Edmonton therefore on the 30th of August. The route was via Athabasca Landing, up the Athabasca and Lesser Slave rivers to Lesser Slave Lake, across the lake and the portage between it and the Peace River and thence up stream to my destination.

Hudson's Hope

Hudson's Hope (called Hudson Hope at that time) was small but it provided Lamarque with his first opportunity to be in charge of an HBC post. This was Lamarque's first time in British Columbia and the inspiration to go to Hudson's Hope came from a book that he had read in England. In 1873 Francis William Butler wrote *The Wild Northland*, an account of travelling across western Canada that included a visit to Hudson's Hope. See image LaE.09.07, page 102, bottom.

> Just before reaching the halfway house to the [Athabasca] Landing, where the stage stopped for the night, I saw a poor crippled horse, trailing a broken leg and being fairly eaten up by flies. Before leaving town, an acquaintance had given me a small revolver and one shell, and with this I was fortunate enough to kill the poor animal and put an end to its misery. That was the only time that I carried a weapon of that sort. I got no more shells for it and never used it again.
>
> James Spencer arrived at the Landing with the brigade from the north on the 1st of September. This was the appointed day for its arrival and, as it was, fair weather or foul, generally met, it says much for the despatch and management thereof. The York boats for Lesser Slave Lake left on the 4th, reaching the Lesser Slave River early on the 7th. The water was low, and it took the crews three days to ascend the river to the lake and three more to reach the establishment of the HBC at the far westerly end thereof. Near the Narrows, about halfway up the lake, we were delayed by a fierce storm with a deluge of rain. All about us, on the shore, were an abundance of saskatoon berry bushes, full of the largest and most luscious berries, and the rain seemed to improve their flavour. We all ate our fill, and it was a feed to remember. The lake is a fine body of water about 60 miles [96 km] long, lying in an almost due east–west direction, with an average width of ten miles [16 km]. The Company's establishment was about

a mile from the main body of the lake, near the shore of a reedy extension thereof. The traders, Bredin and Cornwall, were at Stony Point, close to the main body. I stayed there for three days and then left with some freighters for Peace River Crossing over one of the worst roads I had ever been on. Some of it was only partly cleared, and between stumps and mud holes, it was surprising that we covered the 90 mile [144 km] portage in four days... The weather, too, was bad; first rain and then two inches [5 cm] of snow. However, the last day was fine and warm, and the view from the top of the hill above the Crossing really magnificent, accentuated, probably, by the contrast to our traverse of the forest-girt road. From the hill top we could trace the deep valleys in which the Peace and Big Smoky rivers flowed for many miles from the west and southwest. The sun lit up the many autumnal colours of the partly wooded terrain and a soft, sweet scented wind from the distant mountains enveloped us. The descent down to the few buildings at the foot of the hill near the river, some 700 feet [215 m] below, was long and steep. Mr. George was in charge there for the Company, and with him I spent the night. He had an excellent vegetable garden and some of the finest cabbages I have ever seen.

I left the Crossing in a small, flat-bottomed skiff with two young French Cree boatmen, one of whom was not more than 15 or 16 years of age. We got away soon after noon on the 21st of September and made camp, some miles upstream, on the northerly shore above the English Mission. A large band of sandhill cranes alighted on a sand bar near us, standing there like a regiment of brown soldiers. A day or two later, while eating our lunch on an island in mid-stream, we watched hundreds, probably thousands of these birds on their southward migration; band after band, each and every one as they came above the valley of the river, circling for elevation when, having ascended probably several hundred feet, they turned once more to the south in V, crescent or long line formation amidst air currents no doubt favourable to their flight. We reached Dunvegan at noon on the 24th, lunching with Bedson who was in charge there for the Company. We were making good time for the river was low and the beaches good for tracking. The shorelines were largely a series of long shallow bays with the eddies carrying us upstream, so that it was only at the points that we had to fight the current. Occasionally we crossed the river to get a more favourable alignment.

THE PASSING OF THE CRANES

NOT FAR BELOW Dunvegan the Peace River, for a short distance, is comparatively narrow, and at the time of which I am writing, a dense stand of pines formed a dark and sombre screen on the southerly shore. It was not long after we had passed these pines that we arrived at Dunvegan where, as it was high noon, we stayed long enough to have lunch with Bedson, then in charge of that post for the Hudson's Bay Company.

Resuming our journey we tracked steadily all the afternoon and made good progress, for the river was low and the footing good. At dusk we halted for the night and made camp in a dense thicket of spruce a few feet above the stream.

I had two Indians from Peace River Crossing with me, and we were bound for that distant outpost at the edge of the mountains, Hudson Hope. We said little, sitting around the fire, but with our blankets round our shoulders and our feet to the blaze, our thoughts were far away, for these, at least, are not subject to the restrictions of time nor space.

From below us came the faint murmur of the Peace. It gave our camp in the spruces a wonderful sense of comfort, and the great wind from the distant hills surged and boomed down the valley. Above us the stars shone and twinkled, for it was a clear night; but there was no moon, so away from the firelight the darkness was intense. And then, as we sat silently before the fire, some very faint sound interposed in the varying tones of the wind and stream. It ceased, but came again.

I looked at Joe, a questioning glance across the fire.

"Cranes," he said.

Ah! I listened more intently as, for a time, the faint cries descended to us from unknown heights.

Then but for the wind, the stream, and the crackling of the fire, all was silent once more. The fire burned low and we sought our blankets, but before doing so my two Indians, true to the teachings of their church, knelt with their backs to the fire in silent prayer. For myself, my thoughts reached out into the great spaces of the night, towards the birds calling, calling in their migration flight.

I remembered our first night out from the Crossing, how, at sundown, a great band of these sandhill cranes had stood like a brown regiment on a sandbar not far from camp, and then, the following day, when we were taking our lunch on a small island in midstream, band after band of these birds, flying swiftly from the north, and evidently meeting with some adverse current of wind over the deep valley of the river, had, one and all, circled and circled for elevation until, apparently above the opposing wind, they had swung again, with elegance and precision, into long string-like or V-shaped formations, and turned due south once more on their vast migration.

Going to the edge of the stream, I looked out across the dim, starlit valley. The wind still boomed down the river with unabated force, and the hurrying waters beat against the shore at my feet in small waves.

The river averaged from 1000 to 2000 feet [305 to 610 m] in width and the current, at that stage of water, about 4 miles [6.4 km] an hour. An interesting feature, at that time, was that the southerly side

of the valley was usually well forested; the northerly side but sparsely. Near the boundary between British Columbia and Alberta... we passed a Dominion Land Surveyor named [H.W.] Selby who, with one companion, was descending the river. Before we reached Dunvegan, the occupants of two small canoes had passed us on their way downstream and before we reached Fort St. John we saw, very early one morning, when a heavy mist was on the river, a raft pass by on the swift current, its crew asleep and a thin spiral of smoke ascending from the fireplace at its centre. Apart from these, we saw no one else on the river and, with the exception of the establishments of the Company at Dunvegan and Fort St. John, no habitations of any kind between The Crossing and Hudson Hope, a distance of about 250 miles [400 km]. I walked most of the way carrying my rifle. Bears, some of them grizzlies, were numerous and their tracks on many a waterless side channel behind islands were very plentiful, and it is quite remarkable that we did not see a single bear during our journey.

As we approached the confluence of the North Pine River [now the Beatton] the going was more difficult and we were much impeded by fallen trees, or sweepers. These trees sprawl out into the current, still partly held to the banks by their roots. To get around these we usually had to take to the oars and as the current was swift and there was usually a gale blowing downstream, our progress at these places was indeed slow.

We reached Fort St. John on the last day of September about an hour before the commencement of a heavy equinoctial gale which lasted for three days, the cold rain turning to snow so that on the 4th of October, when we resumed our journey, there were several inches on the ground.

Frank Beaton was in charge for the Company at St. John... The establishment consisted of a store, a warehouse, a dwelling and a stable, situated well back from the river near the foot of the steep, generally open hillsides leading to the plateau some 700 to 800 feet [240 to 270 m] above. We had come about 200 miles [320 km] in nine days and seen no sign of game with the exception of two lynx, one of which Joe, the older boatman, shot while we and it were crossing the river. Rabbits were very numerous, and the lynx, living mostly on them, were themselves quite good to eat, the flesh white, resembling and tasting much like rabbit.

In his diary, Beaton noted on September 30: "Lamarque arrived from Peace River Landing—he is going to take charge of Hudson Hope." His entry for October 3 stated: "Lamarque preparing to start to Hudson Hope," and the following day Beaton recorded his departure.

> Above Fort St. John the strength of the current increases and mountains soon become visible from the shores of the river, a long line of snowy peaks on the western horizon. We reached Hudson Hope soon after noon on the 7th of October and my boatmen almost immediately started on their return journey, taking with them a young Scotsman named Keith who had come up with some supplies from Fort St. John a few days before. James Heber, of mixed white and Beaver Indian parentage, who had been educated at the English Church mission at Fort Vermilion some 500 miles [800 km] downstream, was to act as my interpreter and cook. He was a small man, and on account of some trouble in a hip, walked only by the aid of a crutch. He could read and write English, though I never saw him read any literature except the Bible, and this he read every day. The outpost of Hudson Hope then consisted of two small log buildings situated on a pine clad bench about 70 feet [22 m] above the river. It was on the northerly side and at the lower end of the 12 miles [20 km] portage trail which led to the upper end of the canyon. It was 60 miles [96 km] by the river from Fort St. John and 150 miles [240 km] from the nearest establishment upstream, Fort Grahame, on the Finlay tributary of the Peace.
>
> The small two-room log dwelling had a cook stove in one room and nothing in the other. It was necessary therefore, to build a fireplace, and Heber said that there was a trapper at Moberly Lake, some 20 miles [32 km] to the south, who was skilful thereat. Thinking that it might be well to make this man's acquaintance, as he was the only white man in that part of the country, I went over to the lake the next day with one of the Indians. We crossed the river in a dugout canoe and, after traversing the rolling upland several hundred feet above the valley, reached the trapper's cabin at the westerly end of the lake by evening. The trapper, Bryan by name, was an American and he had quite a substantial cabin with a fine view therefrom down the lake. I spent the next day with him and then returned to the Hope by myself. There I found five white men, prospectors from across the mountains, on their way out to Edmonton. They had come down to

During his time at Hudson's Hope, Lamarque made some pen and ink sketches, including this set of First Nations people. While at Fort St. John he drew a sketch of Frank Beaton on HBC stationery. LaE.03.03, Whyte Museum of Canadian Rockies.

the head of the canyon in a small snow and they left, a day or so later, on a raft they had built at the Hope. They left me a sack of carrots and potatoes, and as there were no vegetables at Hudson Hope, it was a welcome addition to our rations.

There were about eight or ten families of Beaver Indians [Dunne-za] who traded at Hudson Hope. They were good hunters: mountain Indians and a fine, honest people. We did a good trade in the spring when they brought in most of their furs. By the end of October they had all pitched off to their hunting grounds, anywhere from three or four days to a week's journey away. They were camped amongst the pines about 100 yards from our cabin. Their tipis were of a poor type, the covering material coming only about half way up the poles, thus affording but a poor shelter in stormy weather. Their chants, to the accompaniment of their drums, were both interesting and melodious. As our cabin was in such a mess, for the first couple of weeks I was there I slept in a tent. One night, I remember, when a big chinook wind was booming across the wilderness from the distant mountains, the natives started chanting, to the rhythmic beating of their drum. At times the noise, through some vagaries of the high wind, died almost completely away, to be followed, a few seconds later by a so tremendously increased volume as to seem to come from just outside my tent, and it was long before I fell asleep. Yet, on the whole, it was a remarkable and enjoyable experience.

Heber and I, with the aid of our horse, which hauled rock up the steep trail from the beach, built a good fireplace in the inner room, the smaller of the two, and measuring about 10 by 10 feet [3 m]. It proved to be a good fireplace; the chimney never smoked and we never had any trouble with it. The fire gave a good light, and this was fortunate because our five gallons of coal oil leaked out of its container and I had to send Heber down to St. John for candles. Off he went, astride our horse, with his crutch under his arm, quite a valiant figure and glad of the change and the chance to visit St. John. He was away five days only, returning on the 1st of November...

There was, rather surprisingly, little bird or animal life immediately around us, excepting for snowshoe rabbits, lynx, chickadees and ravens. A saline spring bubbled up from the bench a few yards away from our cabin, right by the side of the portage trail, finding its way to the river down the small ravine that the trail followed. In this little brook, which never really froze over, a pair of water ouzels disported themselves during the winter, and it was always a pleasure to watch these tame little brown birds as they played about in the water. I had a line of traps and snares along the portage trail and Heber, who travelled quite well on snowshoes by placing the padded toe of

his crutch on a shoe, had his elsewhere. We only went out together but once, crossing the river to the high land beyond where, from a vantage point, we had a wonderful view over the vast and lonely wilderness in which we lived. The mountains lay along the western horizon, outliers from which appeared far away to the north across the white, snowclad river in its deep valley, the whole landscape a study in black and white, the silence absolute and impressive. A mile or so away, across the river, two black dots on a bench thereby, the outpost of Hudson Hope were the only signs of habitation in that vast land.

At the Hope we had three books; four, including the Bible: *Ben Hur* by General Lew Wallace; *The Vultures* by Merriman; *Simon Dale* by Anthony Hope Hawkins...

There was no drifting ice in the river until the 22nd of November and the stream was not frozen completely, opposite the post, until Christmas Day. Dokey and Crying Man arrived on Christmas morning with some moose meat which, as I had been unsuccessful in hunting, was a welcome addition to our larder, all our fresh meat to that time having consisted of rabbits, partridge and lynx.

Ever since my arrival, almost to the middle of December, warm chinook winds had been frequent. These mountain winds were often of great strength. Hudson Hope was, indeed, about the only place I have lived in where one might predict the weather from the appearance of the sky at dawn. Quite often at dawn the temperature might be 20 or more below zero Fahrenheit [-30°C] in the valley of the river, the air perfectly still, the sky almost clear except, high up, for fragments of cirrus clouds driving swiftly before a strong, westerly gale—a chinook which we knew, from experience, would soon pervade the valley of the river and bring the temperature up to or above freezing.

A mile or so to the east, where the bench on which we lived dropped down to a small prairie near the mouth of Lynx Creek, we put our horse for the winter. I used to visit him quite frequently, for there were wolves about and, anyway, horses are of a gregarious nature and he was having a lonely time of it. In the spring we used him again for hauling logs for the new house we were building but, before we had enough for our purpose he departed, probably for his real home in the country about Fort St. John and we never saw him again.

We had about six weeks of really cold weather in January and part of February, and then the chinooks came again and by the end

of March the snow, of which we had about two feet [60 cm] on the level, was nearly all gone. At the end of January Bryan came in from Moberly Lake on his way to Fort St. John, where he hoped to hire a train of dogs to take out his furs and few belongings which he had brought as far as the Hope, and I decided to accompany him as far as the Fort, for I thought that there might be mail for me there and I had had no news from the outside since leaving Edmonton. It took us three days to get there for there was no trail broken on the river and we had much rough hummocky ice to contend with—pressure ridges and so forth when the ice set fast in the fall. Bryan dragged a small hand-held sled and I carried a light pack. We had a minimum of bedding and the second night out, near Halfway River, it was so cold that we had to keep a big fire burning all night. The next day we saw seven timber wolves on the far side of the river. They were evidently hunting and I do not think that they saw us, nor did we try to attract their attention.

At Fort St. John we found the advance party of an expedition sent from Ottawa to determine the boundaries of a block of land which the Dominion Government was taking in exchange for certain rights on either side of the Canadian Pacific Railway within the province of British Columbia, known as the Railway Belt. One of the party, an acquaintance of mine, told me that their thermometers had registered 90 degrees of frost [-50°C] during the night we had camped near Halfway River. With one of Beaton's men, Samson, and a train of dogs we returned to Hudson Hope...

Beaton's diary contains several references to Lamarque during early February. On the first day of the month, he and Samson started on a trip to Hudson's Hope to visit Lamarque but they met him and Bryan along the way, so they returned to Fort St. John. Lamarque spent his first day there writing letters. On February 6, Beaton left Lamarque in charge of the post while he went down the river to visit Joseph's camp and collect furs. Beaton returned three days later and the next day Lamarque prepared to return to Hudson's Hope. Beaton wrote that the temperature was -52 °F (-47 °C), the coldest temperature he had recorded that winter. On February 11, his diary entry stated: "Mr. Lamarque & Samson started for Hudson Hope this morning accompanied by Bryan who is going up for his clothes he left at the Hope."

Beaton did visit Lamarque at Hudson's Hope that winter. In his diary entry for March 10, he wrote about preparing for the trip. The next day he recorded:

"Self & Samson started with dog trains to Hudson Hope this morning with supplies for Hudson Hope post." Beaton returned on March 14: "Arrived from Hudson Hope this morning at 11 having had very fine weather for the trip."

> Towards the end of April the ice started to move and by the end of that month the river was open... With the spring the wildfowl and other birds returned. Amongst them were large flocks of wax wings, handsome brown birds with crested heads, somewhat smaller than robins. My spring trade had been a heavy one. John Chunaman especially brought me a large pack of furs.

In late May, Lamarque closed the post for the summer. On May 23, Beaton wrote that "the RC [Roman Catholic Mission] steamer left this morning. The boat arrived from Hudson Hope this evening with the returns, also bringing Mr. Lamarque." The next day Beaton and Lamarque took an inventory of the furs from Hudson's Hope. Lamarque spent the next three days working in the office and on June 3 "all hands working and taking up freight from steamer." See image R1150.1A, page 108-109, top.

> The main party, who were to define the boundaries of the Peace River Block, had arrived at St. John and they were encamped on a wide flat on the southerly side of the river that lay between it and the South Pine, a tributary which enters the Peace some miles below. Early in June an Indian Treaty Payment party arrived and Superintendent Constantine with a detachment of Mounted Police, some of whom were to open out an old trail across the mountains to Fort Grahame. One or more outfits of settlers also arrived, and about the middle of the month the first steamer, under the command of Captain McLeod, that the Company had ever operated on the river above the Vermilion Chutes. So the country seemed at last to be opening up to settlement, and the old order about to change. Roberts, of the trading firm of Bredin and Cornwall, was also at St. John, coming across country with horses from Lesser Slave Lake. Two of his horses, which had been hobbled on the northerly side of the river, were found, still hobbled, on the southerly side. There was much conjecture, therefore, whether the hobbled animals could have swum the flooded, ice-cold, driftwood-covered stream which, there, must be a quarter of a mile [400 m] wide. It was thought that somebody had unhobbled them, driven them across the river and hobbled them again on the other side.

My three year contract with the Company ended that summer and I returned to Edmonton, travelling on the new steamer as far as The Crossing. On my arrival, Chief Factor Livock asked me if I would take charge of Fort McKay on the Athabasca River about 35 miles [60 km] below Fort McMurray.

Agreeing to do this, I left Edmonton early in September, just before the inaugural ceremonies took place in Edmonton whereby that city became the capitol of Alberta. As the driver of the stage to the Landing wanted to get back to Edmonton in time for this occasion, he drove all day and all the next night and we reached the Landing in less than 24 hours. It so happened that there was a fine aurora that night, and as our course was almost due north we were facing this magnificent spectacle.

I left the Landing for my new post in a scow steered by John McDonald, the well-known river guide of Fort McMurray, and though the river was at a low stage, we reached Fort McKay a few days later. SEE IMAGE LaE.09.07, PAGE 103, TOP.

The fort, consisting of a good dwelling house and a combined store and warehouse, was situated on the westerly bank of the Athabasca River, there several hundred feet wide and with a current of perhaps 3 to 4 miles [5 to 6.5 km] an hour. Close to the fort the McKay River came in from the highlands to the west. To the east, across the river, was a densely forested plain, monotonous and uninteresting. Fort McMurray, which had once been of considerable importance, was now an outpost of McKay, and I asked John McDonald, the guide, to look after the trade for me there. He had lived there, I think, all his life, knew all the natives and was liked and respected. That year winter set in early. Ice was drifting in the river on the 17th of October, five weeks earlier than it had on the Peace River at Hudson Hope the previous fall, and set fast by the end of the month. There were some good hunters at Fort McKay, one or more of whom hunted and trapped from the immediate locality. Most of them, however, pitched off to their trapping grounds far to the west or across the river. Before winter set in, I went with pack horses to visit some hunters in the Birch Mountains, some 50 or 60 miles [80 to 96 km] to the northwest. I went there also with my dogs during the winter and made frequent journeys to McMurray. For some reason, which I now forget, a steamer trunk of mine had been left at the Landing. This trunk had been picked up later by a trader named Gordon

who traded at McMurray. He, however, got caught in the ice some 45 miles [70 km] above McMurray and my trunk, amongst other material, had been cached near the Boiler Rapid, so, directly the river ice was strong enough, I went up there with my dogs, an interesting trip in winter and with much rough ice to contend with.

In January John McDonald and I, each with a train of dogs, visited my old friends the Spencers at Lac la Biche which, from Fort McKay, is distant about 250 miles [400 km]. So the winter passed away, and in March Chief Trader Thomas Anderson of Mackenzie River, arrived en route to Edmonton and Winnipeg. I drove him as far as McMurray...

The Hudson's Bay Company post journal for Fort McKay provides more detail about Lamarque's activities during the winter.

"January 2, 1906—Lamarque busy round the place and getting Louis' [Boucher] supplies ready for Island Lake." The next day, "Louis Boucher and Michelford left early for Island Lake. Lamarque over to Old Chute for some lynx and foxes." The journal entries for January 4, 5 and 6 noted Lamarque "busy at accounts" or "busy at odd jobs." On January 9, the post journal recorded that Lamarque left for Fort McMurray and noted his return four days later, along with the fact that he "brought a little deer meat."

A week later Sergeant Frank Hedley Field of the Northwest Mounted Police visited the fort, and "January 17—Sergeant Field and party left for Edmonton. Lamarque for Lac La Biche."

Lamarque returned on February 8. The post journal for February 10 recorded: "Lamarque busy at accounts and attending on wants of Indians who are about to pitch." The entry two days later recorded that it was "too cold for the Indians to pitch."

On February 13, Lamarque was "off to the Boiler with Harris." He finished the month working on the post's accounts and hauling wood. The post journal entry for March 1 stated: "Lamarque winding up month's accounts & getting ready for trip to Island Lake tomorrow." On March 3, "Lamarque reached the Cree's camp at 2 p.m. Traded 2 beaver, 1 marten, 1 red fox, 1 lynx." Two days later, "Lamarque arrived from Island Lake at sunset. Everything alright. Very warm day." The next day was also warm and the snow was "thawing fast. Lamarque & Malcolm counted the furs on hand." During the next week there were three entries in the post journal noting Lamarque hauling firewood.

On March 19, Lamarque and McDonald left for Fort McMurray with some supplies. Along the way they met Sergeant Field and Lamarque then returned

to McKay. Four days later "T. Anderson with Lamarque, George & Alec Loutitt & Alec Linklater for McMurray." Lamarque returned on March 25 after finding everything going well at that post. "March 28—Lamarque & Robertson put up the new fur press to test it, made a couple of lynx packs. It worked very well." Lamarque then spent the next two days hauling supplies from the lower depot by the river to the store.

> One afternoon in March Louis Boucher, one of my best hunters, came in to see me. It was storming and snowing outside; regular equinoctial weather, the temperature not far below freezing and the wind roaring across country. Not only was Louis a good hunter, but he possessed a keen brain and a strong sense of humour. He told me: "I hunt moose today until I know where he is, in thick bush quite near me, standing still and covered by snow so I not see him. I take cover off my gun and ready to shoot, break stick. He jump, I fire and miss." And he laughed, a laugh that had a sardonic ring to it...
>
> Trader Gordon of McMurray had entered the north with his sister during the Klondike rush via Green Lake and Isle a la Crosse but they did not go north of McMurray. Gordon had gone out to Edmonton that winter and, directly the river ran free in the spring, he followed the ice down and picked up the supplies he had cached at the Boiler rapid. I happened to be at McMurray when he arrived with the news that "San Francisco has been wrecked by an earthquake and destroyed by fire."

According to entries in the post journal, Lamarque spent much of April working around the post. When the river began rising he and another employee hauled the HBC's skiffs up the bank. On April 23, "Lamarque & Malcolm left for McMurray," returning two days later.

In May, Lamarque made two trips to Fort McMurray. On May 29, "Lamarque & Malcolm make 2 packs of lynx and one of marten & other furs." The following day the two men completed the fur packing and then spent two days taking an inventory of the supplies at the post. During the first week of June, Lamarque worked on the post's accounts. The post journal for June 5 also noted that "Mr. M. Jose accidentally shot his brother-in-law Cleaque, mistook him for a moose." By June 7, Lamarque "completed accounts as far as possible with data on hand." Then he and Malcolm began "cleaning up round the place" and on June 9, "got the bacon & butter up from the lower depot. Malcolm hung up 400 lbs [180 kg] bacon."

Having completed the trade and wound up that season's accounts at McKay I was asked if I would stay on until the fall and put the books at Fort Chipewyan in order. On the scow by which I went from McKay to Fort Chipewyan, was a pleasant young man by the name of Stefansson.[†] He was en route to the Arctic and this, as far as I know, was his first journey into the north. We played, I remember, a game or two of chess...

After completing my work at Chipewyan I took a trip on the steamer *Grahame* up the Peace River as far as the Chutes. From there the purser, Tommy O'Kelly and I tracked and poled a canoe to Fort Vermilion, some 50 or 60 miles [80 to 96 km] upstream, paying a visit to the Wilsons. Wilson had been in charge there for the Company for many years and was a very able and energetic manager. His wife, too, was a capable and genial hostess. We sat down to an excellent supper, and the table appointments could hardly have been surpassed. The Company had a small flour mill there and excellent crops of grain were grown by the one or two settlers in the neighbourhood.

Returning to Fort Chipewyan, I travelled out to The Landing by the last brigade of the season. Bishop Reeves of the Diocese of Athabasca was also en route to Edmonton and he and I played numerous games of chess during our two week journey from Fort McMurray and also on the stage from the Landing to Edmonton, for the Bishop had a board with a hole in each square into which the pieces could be set. At Edmonton I left the Company's service.

† Vilhjalmur Stefansson, the well-known Canadian Arctic explorer and anthropologist was en route to the Mackenzie River delta to spend the winter with the Inuit.

A survey station and cairn along the 60th parallel on the BC-Yukon Boundary survey. 11-8, Whyte Museum of the Canadian Rockies.

2 | Becoming a Surveyor, 1907–15

It was at Banff that I at last realized that the years were passing and that, while I was seeing much new country, could keep books and trade furs, I had no profession and was, in fact, little better off than I had been when I came to Canada. Prince Rupert, near the mouth of the Skeena River on the Pacific Coast, had come into existence that summer and was to be the terminal city of the Grand Trunk [Pacific] Railway, then in course of construction across the continent. Thinking that there might be opportunities, I took the train for Vancouver and was much impressed by the beauty and formidable nature of the mountainous snowclad landscape through which we passed and the change to the green pastures of the lower Fraser Valley as we neared Vancouver...

On arriving in Vancouver I called on C.C. Van Arsdol, who was the Divisional Engineer for the Grand Trunk Railway. His offices were in the Imperial Block at a corner of Pender and Seymour... As he said that there would be no difficulty in getting survey work at Prince Rupert, very early in January 1907 I went up coast on the S.S. *Tees*, sleeping with many others in the dining saloon, for the boat was crowded. It was the first time for a decade that I had seen the sea, and the forest-clad, heavily indented coastline with its numerous mist-wreathed fiords and many islands, looked sombre indeed.

Prince Rupert, when I arrived, had a dock capable of accommodating a couple of vessels, a warehouse or two and a few tent shacks lining a narrow street or clearing about a quarter of a mile [400 m] long which led up a steep slope to the uncleared wilderness beyond. At the top of this clearing a donkey engine was stationed to haul supplies up the light railway which occupied the centre of the street. The post office was in a tent and the Bank of Commerce had, with the exception of the offices and warehouses at the dock, the only framed building there. Prince Rupert is on Kaien Island and the site consists in general of a long low plateau, from 50 to 200 feet [15 to 60 m] above sea level, with many outcrops of rock and much muskeg...

The day after my arrival I went out with a land surveyor by the name of Barrow [A.R.M. Barrow, PLS #56] who was working in the immediate vicinity of the wharf. Barrow was an Englishman, then in his early forties, who had spent much of his life in India with the Civil Service. Methodical and precise, he was never in a hurry and it seemed to me that we accomplished very little during the few days that I was with him. Anyway, I could have been of little value at his work, for it was all new to me. Soon I was sent to a survey camp some miles away on the other side of the island. Most of the crew there, like myself, had never been on a survey before, but with the aid of a few old hands, we made progress and, no doubt, collected much topographical information, which was what we were there for.

January was a cold month, with ice forming along the shore and a foot [30 cm] or more of snow in the bush. We had a gramophone in camp, and it was a good-natured, rather merry crowd that gathered in the tent shack at night, listening to popular songs and music. There were many timber wolves about, and one day I saw a wolf chase a deer into the sea, making a leap for its back just as it reached the water. A rifle shot scared the wolf off, and the terrified deer came staggering towards the camp, seeking and receiving sanctuary.

In March the snow disappeared, and when it was not raining, it was pleasant working in the forest. With the arrival of spring I decided to return to Vancouver for, despite much flamboyant talk, it seemed to me that it would be a long time ere Rupert became a desirable place in which to settle. On the southbound boat I became acquainted with a young engineer who had been employed on surveys for the railway. He was a pleasant, able and entertaining fellow by the name of Lincoln Ellsworth who later made a name in Arctic exploration.

After a couple of months, Lamarque joined the crew of veteran surveyor J.H. Gray. The BC government anticipated that the construction of the Grand Trunk Railway would bring an influx of settlers seeking agricultural land to the central part of the province. In 1907, Gray surveyed land in the Bulkley valley.

We went by steamer to Port Essington in the estuary of the Skeena River, some miles from Prince Rupert, and thence by river steamer to Hazelton, a small settlement at the confluence of the Bulkley River with the Skeena. The voyage up the coast in mid-June was in great contrast to that of the previous January. The weather was warm and

sunny, and the forest-clad hills looked beautiful and attractive. At Essington we transferred to the SS *Northwest*, in command of Captain Bonser, and reached Hazelton about a week later after a two day delay at the foot of Kitselas Canyon, waiting for the high water to subside. This canyon, half a mile [800 m] or more in length and of a modified S-shaped form, is a serious obstacle to navigation and at high water is practically impossible to ascend. The water was high enough when we went through, warping up from one or more "deadman" iron stanchions [also called ringbolts] set in the solid rock. The canyon is narrow, and a month or so later, the new steamer *Mount Royal*, belonging to the Hudson's Bay Company, got jammed in there on her way downstream and rolled over, a complete loss with six or more of her crew drowned.

In the summer of 1907 Hazelton was a small village, the inhabitants largely of Indian origin. There were two stores, one run by the Hudson's Bay Company, the other by Sergeant, an ex-employee. There was a small hotel and a hospital, run very efficiently by missionary Dr. Wrinch... Over a narrow canyon of the Bulkley River, not far from Hazelton, the natives had constructed a roughly trussed

TOTEM POLE, KITSELAS CANYON, 1907

The Kitselas Canyon, on the Skeena River in British Columbia, was the principal obstruction to navigation on that large and swift stream. In 1872 the Hudson's Bay Company established a post at Hazelton, some 170 miles from the sea, at the confluence of the Bulkley river, as a trading and distribution depot for their posts to the east, which had formerly been supplied from the Fraser river. Freight for the Company and others was brought up by canoes till 1893 and then by steamers till the building of the Grand Trunk railway, some 20 years later. The steamers were wharped up this narrow, S-shaped canyon. In the summer of 1907, the new steamer Mount Royal of the Hudson's Bay Company was wrecked there, with the loss of several lives.

Lamarque made this Christmas card describing Kitselas Canyon. He traveled through the canyon en route to his work in the Bulkley valley. 81-9-1, Whyte Museum of the Canadian Rockies.

Moricetown Canyon on the Bulkley River. This is a famous Wet'suwet'en location for salmon fishing. In the foreground are fishing platforms. 9-1, Whyte Museum of the Canadian Rockies.

bridge of telegraph line wire and small poles, a remarkable and cleverly contrived structure.

Our survey work lay some 20 to 40 miles [32 to 64 km] up the valley of the Bulkley River in which, at that time, there were practically no settlers. There was a good pack trail, one that extended from Yukon Territory to Quesnel, on the Fraser River... to accommodate the building and maintenance of a telegraph line projected, some forty years before, as part of the Overland Telegraph from Europe via Siberia and Bering Straits. This project had collapsed when, in the late 1860s, the first Atlantic cable was laid, but the portion from the Cariboo road at Quesnel to the Yukon was extended and maintained after the Klondike gold rush of '98. The Bulkley River is named after Colonel Bulkley who was associated with the initial project.

Our survey party, of perhaps a dozen men, was maintained by pack trains bringing provisions from Hazelton... For a time we were camped near Glacier House, a very small stopping place in the valley kept by a man called Bannerman, who had formerly lived in the Calgary country. This little log cabin was situated right opposite a small glacier, clearly visible in the Hudson Bay range of mountains on the southerly side of the valley...

With the approach of fall two of us left the survey party, and the late C.G. Frampton—he had been with Locke's Horse in the Boer

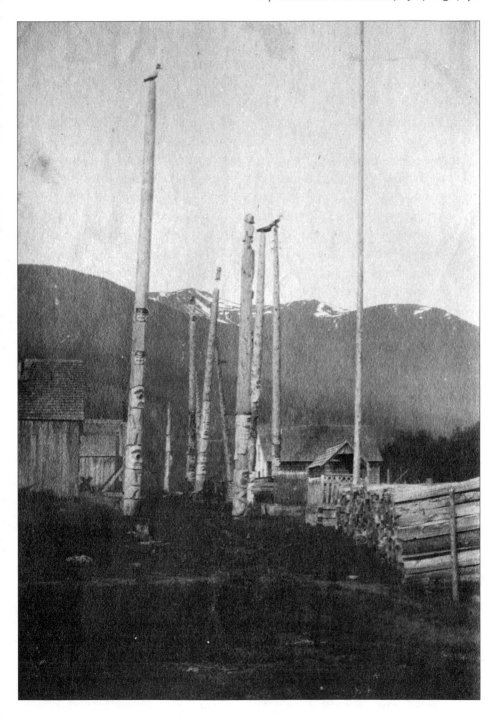

Totem poles at Kitwanga, a well-known First Nations village near the Skeena River. 9-2, Whyte Museum of the Canadian Rockies.

War—and I decided to go through to the Cariboo and the railway at Ashcroft. Accordingly, about the end of August, we bought a saddle pony and pack horse and started out from Hazelton along the Telegraph trail. It was a pleasant journey and we were favoured, in general, by fine weather. We averaged about 15 miles [24 km] or so a day and usually rested for a couple of hours around noon. With a single pack horse it is easy to do this... Our pack animal, a mare, had a colt with her, and I remember that one very rainy night, in the vicinity of Aldermere, a very small settlement some 50 miles [80 km] east of Hazelton, the colt came close to us and lay down by the camp fire, its mother whinnying to it from the darkness beyond...

Near Aldermere, which has long ceased to exist, there was another tiny settlement, Telkwa, down by the river and now on the railway. There was another small settlement, not more than a trading post, at Fraser Lake... Except for those at these settlements we met, I think, only two people on the trail and saw no game. After about three weeks travel we reached Quesnel on the Fraser, some 300 miles [480 km] from Hazelton and then followed the old Cariboo road to Ashcroft, on the main line of the Canadian Pacific Railway, some 200 miles [320 km] to the south where we arrived on the 2nd of October. I remember that I was both surprised and interested in the many old buildings along the road, as old as any to be seen in Manitoba with the exception of the immediate vicinity of Winnipeg, buildings which had been there, some of them, since the early days of the Cariboo gold rush, 40 to 50 years before. The Australian Ranch; Mountain House; the 150 and 100 Mile Houses, all old and well-known names in that district.

Just before entering Ashcroft my partner rode on ahead to enquire about lodgings for the night, and the packhorse, which I was leading, losing sight of the other horse, started to neigh, literally heralding me in to the village... We sold our horses to Judge Cornwall, the riding pony and the horse, for which we had exchanged the mare and foal before we reached Quesnel...

I spent the winter in Vancouver, earning a precarious living by working on surveys, chiefly for James Harrison Brownlee, a Dominion and British Columbia land surveyor whom I met, a day or so after my arrival, walking with a government official I had met on the steamer ascending the Skeena. Brownlee put me up at his club for a few days, a kindly action to a complete stranger and particularly acceptable to myself who knew no one in the city...

1908 | British Columbia—Yukon Boundary Survey

> Early in May I ran across an old acquaintance whom I had met when
> he was one of the detachment of Mounted Police at Fort St. John,
> three years before. He had now left the police and had taken a job as
> assistant packer to a Dominion land surveyor named Wallace who,
> that summer, was going to define part of the boundary between Brit-
> ish Columbia and Yukon territory, along the 60th parallel of latitude.
> He introduced me to Wallace and I became a member of his party.

The survey of British Columbia's boundary with the Yukon Territory was the
province's first delineation with one of its adjoining Canadian jurisdictions (the
province of Alberta to the east and the Yukon and Northwest Territories to the
north). In 1966, the Government of Canada archivist W. Kaye Lamb wrote: "The
60th parallel became the northern boundary of British Columbia in 1863, but it
remained a purely imaginary line until the Klondike gold rush made it necessary

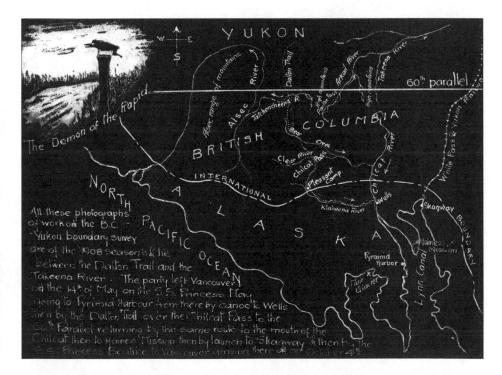

Lamarque drew this map of the area where he worked in 1908 on the first page of the album that
contained his photographs from that year. 11-1, Whyte Museum of the Canadian Rockies.

to locate it with some precision in the region west of Teslin Lake." From 1899 to 1901, the federal government had Dominion Land Surveyor Arthur Saint Cyr delineate the parallel for about 200 km west from Teslin Lake.

In 1903, an American, British and Canadian arbitration panel made its decision regarding the location of the boundary between the United States and Canada where Alaska bordered British Columbia and the Yukon Territory. The result left a small panhandle of land in the northwest corner of British Columbia. Four years later the Canadian government decided to extend the Yukon Boundary survey further west and Dominion Land Surveyor James Nevin Wallace was appointed to lead this project. In 1907, he resurveyed a portion of Saint Cyr's work and then started surveying the 60th parallel between the Takhini and Tatshenshini rivers. He began working at the western end, along the Tatshenshini. Wallace continued this work the following year, hoping to complete the gap between his and Saint Cyr's surveys.

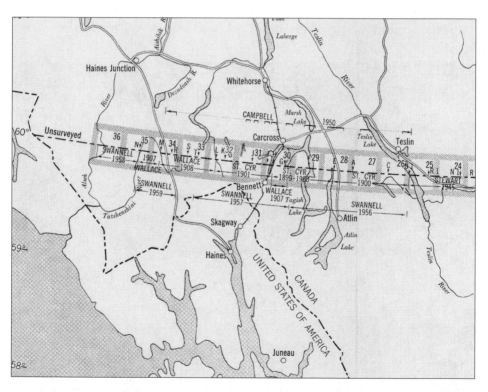

This map shows the surveyors who worked on the western part of the boundary, along with the area they surveyed and the year. The letters along the boundary denote the astrofix stations. *Report of the Commission Appointed to Delimit the Boundary Between the Province of British Columbia and the Yukon and Northwest Territories.*

For Wallace, the easiest access to the Yukon boundary in the area where he was going to survey in 1908 was to travel through a remote section of Alaska that did not have a customs station. Since this was a Canadian government survey party, they needed official permission to travel through American territory.

On March 11, 1908, the Department of the Interior (which was responsible for Dominion Land Surveys) wrote a memorandum:

> The Department of the Interior is having a survey made of that part of the boundary line between British Columbia and the Yukon Territory extending from Dalton trail to the Takhini River. In order to reach this locality, it is necessary to land at Pyramid Harbour, and to proceed for some distance through the U.S. Territory of Alaska before reaching Canadian territory in British Columbia. As there is no customs officer at Pyramid Harbour and no possible way of sending his horses, camp equipage and instruments through that part of the U.S. Territory, Mr. J.N. Wallace, who is in charge of this survey, asks that permission be obtained from the U.S. authorities to land and proceed with his party to the locality in question.

The letter included details provided by Wallace, who suggested that:

> Permission be requested from the United States authorities to allow the Canadian Pacific Railway Company's steamer to land my survey party, horses, outfit and instruments at Pyramid Harbour, Alaska, and that I be then permitted to transport the same up the Chilkat Inlet and River and by the Dalton Trail via Wells and Porcupine to and across the International Boundary at Pleasant Camp, and that during the season my party or members may pass back and forth along the above mentioned route, accompanied by pack horses or other means of transportation, such passage to be always in connection with my survey.

Wallace also wanted the same permission for horses and the pack outfit that he had used in the 1907 survey and left in the Yukon Territory over the winter.

On March 31, Édouard-Gaston Deville, Canada's Surveyor General, sent a letter and the memorandum to the Deputy of the Minister of the Interior. Frank Oliver, the Minister of the Interior sent a letter the next day to "The Governor General in Council" (Privy Council) giving his approval for Wallace's request.

The Privy Council approved the request with an Order-in-Council on April 3. "The Committee on the recommendation of the Minister of the Interior advise that Your Excellency be moved to forward Mr. Wallace's request to His

Majesty's Ambassador at Washington and to ask that he should endeavour to obtain the required permission from the Government of the United States."

The request was then sent to James Bryce, the British Ambassador to the United States at Washington, DC (Great Britain was still responsible for Canadian foreign affairs in 1908), who forwarded it to the American Department of State. Acting Secretary of State, Robert Bacon, sent his approval to Bryce on April 18, who informed Governor General Earl Grey two days later. The information was then relayed to the other people and departments involved in the request.

> We left Vancouver on the 14th of May on the S.S. *Princess May* for Pyramid Harbour, Alaska—a dozen men and as many horses. Two or three of my friends were down to the dock to see us off, including Lincoln Ellsworth... It was a pleasant journey up the coast. In Seymour Narrows the tide was running strongly, but not too much for the *May*, though she shivered in its grip. I suppose that the maximum speed might have been about 14 knots. It was rough on Queen Charlotte Sound which, with the smaller Millbank Sound, is the only really open water to the Pacific on the Inside Passage to Alaska. Prince Rupert was growing, a few good-looking frame buildings had

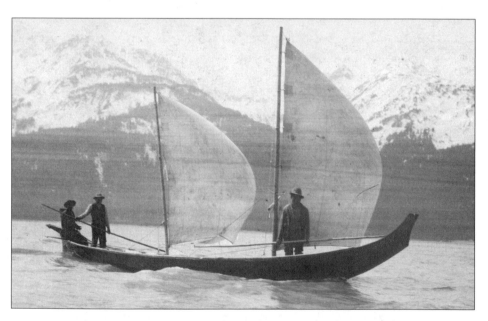

While going up the Chilkat River, Wallace's crew met some First Nations people travelling in a canoe. This photograph was taken by George Blanchard Dodge, the surveyor/astronomer that Lamarque worked with during the 1908 season. J-00809, Royal BC Museum, BC Archives.

been constructed and the dock enlarged. We also put in at Ketchikan, Wrangell and Juneau and reached Pyramid Harbour at 10 o'clock on the 18th. Here the Chilkat River enters the Lynn Canal, a long inlet that terminates near the town of Skagway. The horses were driven up the southerly side of the river and the rest of us proceeded upstream in canoes for about 40 miles [64 km] to the confluence of the Klehini River, where the packers met us with the horses.

The small mining village of Porcupine was about 12 miles [20 km] up the Klehini and to this point our supplies were relayed and then we all moved up the wide valley of the Klehini to the old, deserted Mounted Police station of Pleasant Camp, right on the BC–Alaska boundary on the northerly side of the river, a branch of which could from there be seen issuing from a large glacier. The river was at a low stage, flowing, by many shallow channels, in a wide flood plain so we had no trouble at the numerous fords. The buildings of the old camp were yet in fair shape, though the roofs of one or more had been partly wrecked by the winter snows. We were there for about 10 days and while there improvised a game of cricket; the batsman in Alaska and the bowler in British Columbia. On account of the snow we were not able to get

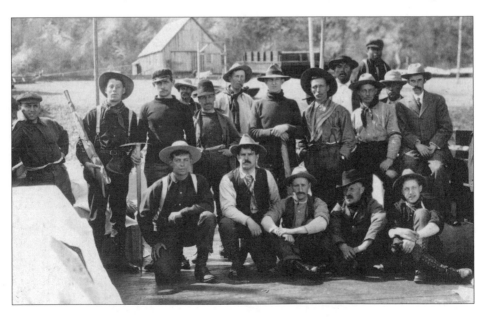

Dodge took this photograph of the survey crew early in the season. Lamarque is in the middle of the front row, sitting. Wallace, in a suit, is on the far right of the second row. J-00810, Royal BC Museum, BC Archives.

Pleasant Camp. The remains of the North-West Mounted Police Post used during the Klondike gold rush can be seen in the foreground. 11-11, Whyte Museum of the Canadian Rockies.

through the Chilkat Pass until the 29th of June and it was the end of the first week in July ere survey operations were commenced.

The British Columbia–Yukon boundary survey was difficult in many aspects. The survey was in a remote area that was hard to access and a large portion of the field season was spent in travel. Wallace left Vancouver on May 14, hoping to spend the maximum amount of time possible. However, due to the depth of snow and cool spring weather he was unable to reach his work location until July 7. Since the timberline was below 1000 m, much of the work occurred in unsheltered country, and on many days rain, snow and fog limited the work that could be done. The surveying was technically challenging for the 60th parallel is a continuously curved line and the measurements had to be as precise as possible. The survey line was supposed to follow the 60th parallel, but the terrain was mountainous and at some locations Wallace and his crew were unable to reach it.

I was assigned to work with the astronomer G.B. Dodge, who was observing pairs of stars for latitude, and to that end, was stationed some miles ahead of the main party. J.N. Wallace knew that I was

Although the Mounted Police closed operations at Dalton Post in 1906, material still remained and Wallace's crew picked up some supplies there. G.B. Dodge photograph. J-00811, Royal BC Museum, BC Archives.

studying in order to take up his profession and it was kind of him to place me where he knew I should find time therefore. See image LaE.05.05, page 98, bottom.

The procedure for establishing the 60th parallel is described in the *Report of the Commission Appointed to Delimit the Boundary Between the Province of British Columbia and the Yukon and Northwest Territories.*

When the boundary between Canada and the United States was established at the 49th parallel, the term parallel of latitude was construed to mean the astronomic parallel, or a line passing through observed positions of equal astronomic latitude. Surveyed lines having the curvature of the theoretic parallel were laid out between these astronomic positions. These precedents were adopted for the 60th parallel of north latitude. The first step, therefore, in the determination of the boundary was the establishment of astronomically fixed control points or astrofixes.

During Wallace's 1908 survey, his assistant, G.B. Dodge, established three astrofixes. Several measurements of the stars were made at each station in order to establish the 60th parallel as accurately as possible. At the first astrofix, Dodge made fifty observations on twenty-two pairs of stars beginning on July 11. After the long delay in reaching the 60th parallel, Wallace was fortunate to have clear weather and Dodge, with the assistance of Lamarque, was able to complete his work at this station by July 16. Wallace then established Monument R on the 60th parallel and began surveying along this line of longitude.

On July 24, Dodge, Lamarque and their outfit moved camp about 13 km east over a mountain pass and into the Kusawa River valley. They set up an astrofix along the bank of a small stream and began observations. By August 11, they had established Monument S.

> At one of the astronomer's camps situated in a sparsely clad timber area overlooking the Kusawa River, Parton, the head packer, arrived one day leading a pack horse with supplies for us. He told us that he had been chased by a grizzly bear to within a mile of our camp.

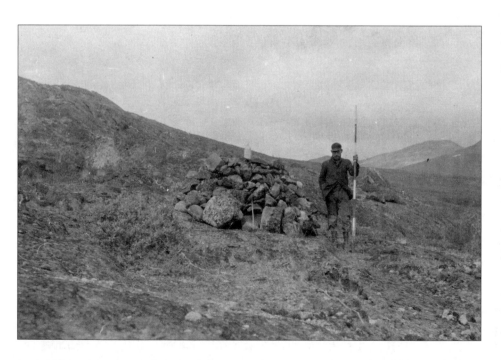

Looking towards the valley of the Alsek River. This station on the 60th parallel is in open, exposed country. Note the number and size of boulders used for the monument. 11-16, Whyte Museum of the Canadian Rockies.

THE GRIZZLY

THE SOMBER HILLS, forlorn, rugged and desolate swept upward from the pass, on either hand towards the lowering, gloomy sky. Rain threatened, or even snow, and a bleak wind, whistling drearily through the crags, was fast breaking to pieces the rotting ice on the little lake near the summit.

The head packer, on his way from the main camp of the British Columbia–Yukon Boundary survey on the Tatshenshini River to the astronomer's or advance camp on the Kusawa, rode slowly through the pass leading a packhorse. His attention absorbed by the roughness of the route, he was quite unaware of the great grey form that, lurking amongst the rock but a stone's throw on his right, watched him with a steady and menacing curiosity.

The astronomer had his camp on a rocky ledge over which a very old and faint trail passed on its way to the valley. It was, really, hardly a trail at all, so vague and ill-defined that it was not always visible. It had probably been made and used at varying and often long intervals by the few Native inhabitants of that remote region, of whom, indeed this trail and the remains of snares outside the burrows of gophers were the only signs.

From the camp, which was quite unsheltered by the scattered trees nearby, there was a magnificent, if gloomy prospect over the Kusawa river and lake. On every side the great, rounded, glaciated hills swept skyward from the valley, their summits wreathed in driving mists which denoted an unseasonable snowstorm.

Lunch was ready, and the fire, generously replenished, blazed cheerily. We were about to eat, when the head packer, bestride a sweaty horse and leading an equally lathered pack animal, came swiftly round a nearby bluff to halt, a moment later, at the camp.

"I have been chased to within a mile of here by a grizzly," said he, as he alighted briskly from his horse. "You better have a rifle handy in case he follows my trail to the camp."

"Your horses look as if they'd travel fast," said the chief. The packer grinned. "When the devil drives," he replied, "but I see that you have lunch ready and—I'm as hungry as my hunter." We laughed, too, and throwing more wood on the fire, enjoyed the warmth and the simple meal.

The packer, who had a strong sense of humour, and perhaps, of the dramatic, smoked for a time in silence when the repast was over. A remarkable character, in many ways, he was an excellent companion in a tight fix, for the worse things grew, the more grim and resolute he became. He was probably amused at our evident curiosity, but at last, at a question from the chief, he said, "I had just passed the summit, in one of the roughest parts of the pass, when my horses both wheeled so quickly that I was almost thrown. For a second I could not make out what had frightened them, and then—well I saw the biggest and greyest grizzly that I have ever seen. He was so much the colour of the rocks that if the horses had not got wind of him I might never have known—until too late—that he was there.

"He didn't keep me waiting as to his intentions for, even as I looked, he dropped on all fours and came towards me. Guess the smell of the bacon on the packhorse was too much for him, for he looked mighty hungry. A morose old fellow, I suppose, who should have been down on the Tatshenshini eating salmon instead of starving on the hills.

Anyway, as I hadn't a gun, I waved my big hat and shouted as loudly as I could, and he stopped. Getting my horses under control, I urged them swiftly down the pass. The bear came on, so I stopped, shouted, and waved again, and again the bear stopped.

"We went on and the bear came on once more, so I stopped and shouted again, but," the packer chuckled, "the dog-gawned bear didn't stop that time, and we went down the pesky hill, hell-for-leather, with that old devil at our heels.

"Well, sir, somehow the horses kept their feet, and as we got down lower, where the ground was better, we gradually gained till he seemed to give up the chase, for I didn't see him after we got below timber line.

"That's all there is to it, but—I don't want to race the old devil again."

Parton had not a rifle, so, when he started out on his return journey I accompanied him to the place where he had last seen the bear, of which there was now no sign. However, we were on our guard for a day or so, in case of a visit... Apart from a couple of trappers and their native wives in the Chilkat Pass, we saw no one and the only signs of natives were the remains of old snares which had been set to catch gophers.

After reaching Monument S, Wallace had to make a crucial decision regarding the survey and he described the situation in his government report.

On August 20 I went easterly from Station S and ascended a high mountain about six miles [9.6 km] away which it was evident, for a long time previously, the boundary line would have to cross. From the summit of this mountain, which is called Kelsall Mountain, and which proved to be at an altitude of 7453 ft. [2240 m], an extensive view was obtained. To the east there was a sudden descent of very nearly 5000 ft. [1500 m] in a little over two miles [3.2 km] to the valley of a stream flowing northwesterly to Arkell River. East of this stream the mountains rose like a wall for about 2500 ft. [760 m] and then formed a confused mass of peaks and glaciers reaching about 7000 ft. [2130 m]. The general position of the valley of Takhini River could be clearly seen about 10 miles [16 km] further east and as this was the westerly end of that part of the boundary which had been already surveyed, it was necessary to consider if the remaining gap could be completed.

There were two courses. One was to get the zenith telescope [the one that Dodge and Lamarque were using] up the valley east of Kelsall Mountain (it certainly could not be got any farther) and

obtain a latitude observation there. This would ensure the survey of the boundary at least as far as this valley, but the delay of taking a new observation would almost certainly leave little chance for completing the line to Takhini River. The other course was to omit this observation altogether and with the time saved endeavor to establish the boundary right through between the monuments on Arkell and Takhini rivers...

It was, in fact, a case of risking a fairly certain part for a very uncertain whole.

Two factors influenced Wallace to choose the first course of action: the rugged terrain and the fact that it was the latter half of August. Wallace ran a trial survey line up Kelsall Mountain, which confirmed that he would be unable to run a line along the 60th parallel straight through the mountains directly to the east. A pack trail was cut out down the valley and Dodge and Lamarque began their observations on the final astrofix, to be used to establish Monument T.

While Dodge and Lamarque were making their observations, Wallace surveyed up to the station. Then he took a small group of men to make a traverse survey that connected with Monument L on the Takhini River. Weather conditions began to deteriorate so Wallace had no opportunity to do any detailed surveying around the monument. Wallace described the situation.

On September 12, with ten inches [25 cm] of snow freshly fallen at our camp, we started back and on reaching the snowfield at the summit found a fresh depth of nearly three feet [90 cm] of soft snow which was steadily increasing. In a driving wind which obscured objects 100 ft [30 m] away we climbed up the snowfield and were not sorry to get back to the main camp.

By the time Wallace and his crew returned, Dodge and Lamarque had completed their work. The final monuments west from Monument T were established to complete the season.

Monuments, consisting usually of four to six inch squared spruce post set in, and projecting above a massive pile of rocks five feet [1.5 m] or more in height, were placed, intervisible [mutually visible, or seen from one to the other], at high points along the boundary.

By the time Wallace's crew started homeward on September 21, there was already snow in the passes.

This is a panorama of the Alsek mountains near the BC-Yukon boundary. 11-15, Whyte Museum of the Canadian Rockies.

> We returned by the way we had come to the Lynn Canal at the mouth of the Chilkat River, thence by launch to Skagway and from there, once again by the S.S. *Princess May* early in October to Vancouver. We had been away 144 days, and almost exactly half that time had been spent travelling to and from our work...

After 1908, the federal government ceased surveying the British Columbia—Yukon boundary until 1945, when they began delineating the 60th parallel east of Teslin Lake. Between 1945 and 1955, the line was surveyed east along both the Yukon and Northwest Territories boundary to the Alberta border. Then, from 1956 to 1959, Art Swannell, son of the famous BC land surveyor, Frank Swannell, resurveyed much of the line west of Teslin Lake and extended the 60th parallel west to the high Coast Mountains where it became impossible to survey further.

I had now quite decided to take up land surveying as a profession, a life which seemed most suited to my temperament and abilities. It was a long time since I had left school and so I devoted much of my spare time to study, and in the meantime, continued to work on various surveys. That fall, on a survey up the coast near the entrance to Jervis Inlet, we lost our cook for three days. We were working from a house on the shore and also from a camp pitched several hundred feet from the end of an old logging road. The cook, setting out from the house by the shore with a load of provisions for the camp, became lost between the logging road and the camp. Hearing the roar of the Eagle River, he made his way thereto and so on down to the sea where the river enters it at Scow Bay. It was raining and storming and a tug boat, taking shelter therefrom, was anchored in the bay, and the cook went aboard. The storm lasted for three days and during that time we searched the woods for the cook. Wet and bedraggled, we returned to the house on the shore—and there was the cook, dry and comfortable.

That was then an area of magnificent virgin timber, the country of the Gordon Pasha lakes. Our camp, indeed, was set amongst Douglas firs that had an average diameter of about six feet [1.8 m] with heavy, ribbed bark up to 8 inches [20 cm] thick; tall and straight with scarce a branch to 60 or 70 feet [20 m] above the ground...

1909 | BRITISH COLUMBIA ELECTRIC RAILWAY

So far my work on surveys had been that of an axeman, rodman or chainman, but in the spring of 1909 I obtained work as an instrumentman on train location lines for a new interurban railway which the British Columbia Electric Railway Co. proposed to build between Vancouver and New Westminster. This was encouraging and my salary of $100 a month and expenses was at least double my monthly earnings of the past two years. On one of these lines which we were

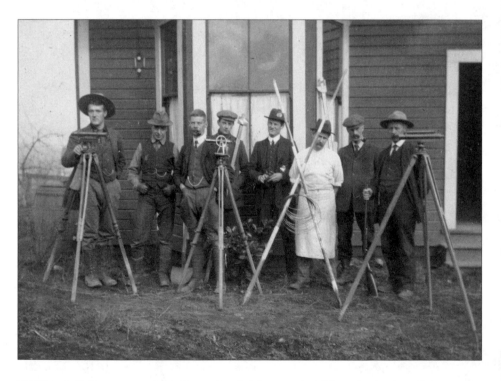

BC Electric Railway survey crew. Survey levels for measuring differences in elevation are on the left and right. A transit is in the middle, while a survey chain and two survey rods are in front of the man with an apron. 10-8-b, Whyte Museum of the Canadian Rockies.

running near the Great Northern Railway on the northerly side of Burnaby Lake, we had an unobstructed view of a head-on collision between a freight and a mixed freight passenger train. We were barely 100 yards distant and could see the trains approaching one another on a single track for perhaps a minute before the actual collision occurred, for, at the last, the trains were moving very slowly, the drivers doing their utmost to stop their engines. At the collision the engines, amidst a vast explosion of steam, reared up like a couple of horses, but the remainder of the vehicles stayed on the rails...

The *Vancouver Daily World* reported this accident in an article on June 15.

Three persons were killed outright and half a score were more or less seriously injured in the head-on collision which occurred this side of Burnaby Lake yesterday afternoon between the inbound Seattle express and the Guichon local.

Through some misinterpretation of the train order, the Guichon local, which left the Great Northern Station on Dupont Street half an hour late and was probably making 25 miles an hour, was allowed on the same stretch of single track as that on which the Seattle Flyer was making the last stretch of her fast run to the city, with the result that while round the curve at Wolf Spur the two came together with a deafening crash.

Lamarque's memoir continued.

Later on, during the winter, we ran a line for the company up the Capilano River, on the northerly side of Burrard Inlet, for a proposed scenic railway, using an old cedar bolt flume to get through a canyon. The line was not built and today the Cleveland Dam, built by the Greater Vancouver Water Board, is at the head of this canyon. SEE IMAGE R1150.2C, PAGE 111.

The BC Electric Railway Co. had streetcar service in North Vancouver beginning in 1906. The same year, a Bellingham logging syndicate bought a large parcel of timbered land above Capilano Canyon and tried to negotiate a deal with BC Electric to construct a rail line into the area. The Capilano River valley was also a popular tourist area with hotels. BC Electric did not construct a railway on the line it located, but the Capilano Timber Company built a rail line up the valley in 1917.

In 1910, Lamarque's work with BC Electric finished and he joined the Engineering Department of the municipality of South Vancouver where he did drafting and survey work. At the end of December, Lamarque married Winifred Cope, a nurse trained at Calgary General Hospital whom he had met when he was in Alberta. There were no children from the marriage.

1911 | MINERAL AND TIMBER SURVEYS

In the fall of 1910, Lamarque passed his preliminary exam for becoming a British Columbia Land Surveyor and in the spring of 1911 began his three years of articling with Walter Birch Bucknill (BCLS #29). Bucknill, who was born and raised in England, became a Dominion Land Surveyor in 1908 and received his British Columbia Land Surveyor certificate the following year. In early 1911, he went into partnership with Robert Guthrie Russel (BCLS #68), who had just become a registered land surveyor.

Lamarque took this photograph of the Lil'wat First Nation village at Pemberton Meadows. 11-24, Whyte Museum of the Canadian Rockies.

Above: Pack train crossing Chekamus River near Summit lake. 11-22, Whyte Museum of the Canadian Rockies.

Below: Camp by Mackenzie's store, Pemberton Meadows. 11-23, Whyte Museum of the Canadian Rockies.

Lamarque wrote that he carried out

> mineral claim surveys for them in the Alta Lake country, about 30
> miles [48 km] inland from Squamish at the head of Howe Sound, and
> timber limit surveys around the southerly end of Chilliwack Lake...
> This lake, set amidst high mountains, is about five miles [8 km] long
> and ¾ mile [1.2 km] wide, its southerly end about a mile [1.6 km]
> north of the international boundary. Its waters are probably very
> deep and they certainly contain fine fish. We caught Dolly Varden
> trout two feet [60 cm] or more in length. Near Depot Creek, which
> flows into the easterly side of the lake about a mile from the southerly
> end, is the grave of an infantryman of the US Army who drowned
> there in 1857; a member no doubt, of a party surveying the interna-
> tional boundary.

Camp on the shore of Chilliwack Lake near Silver Creek. Bucknill and his crew surveyed several timber licence lots around the lake. 11-26, Whyte Museum of the Canadian Rockies.

1912–13 | CPR TWINNING PROJECT

In early 1912, Bucknill suddenly disappeared. He was last seen on January 10, "when he was very melancholy," according to the coroner's report. As spring approached and Bucknill's fate was still unknown, Lamarque decided that he needed to find another surveyor who would take him so he could continue his articling. Russel was younger than Lamarque; had only recently become a land surveyor; and was trying to maintain a surveying practice amidst trying and uncertain circumstances. This was a time when many people were articling to become surveyors in British Columbia and it was difficult to find a surveyor who was able to take on a pupil. Finally, Lamarque was able to article to F.T.P. Cond (BCLS #71), who was in charge of the Canadian Pacific Railway's land surveying program in British Columbia and needed a surveyor for the new project that he was undertaking.

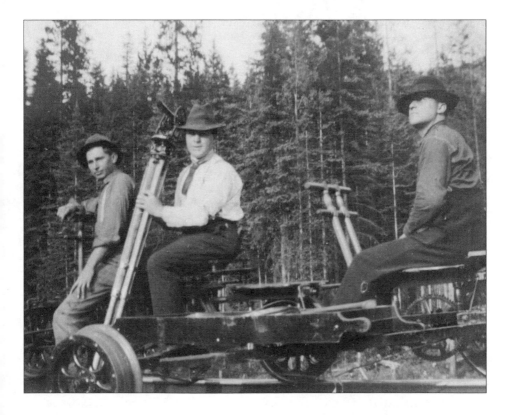

Travelling to work on the CPR survey near Field, 1912. F.T.P. Cond is on the left. 11-26-r, Whyte Museum of the Canadian Rockies.

F.T.P. COND

BORN IN ENGLAND in 1886, Frederick Thomas Piercy Cond came to Canada when he was twenty. He attended the University of Toronto, taking a civil engineering program. In 1911, he received his BCLS and DLS and, in 1912, obtained the position of chief surveyor for the CPR's surveys in British Columbia. In January 1913, Cond married Janet Mowat, an aunt of the famous author, Farley Mowat. During the 1913 field season Cond's wife accompanied him on his surveying, with the couple living in a railway car. Cond enlisted in the navy in 1916, serving overseas in various motor torpedo boats. During his return to Canada in 1919 he contracted the Spanish flu and died in Halifax. Cond Peak in Kokanee Glacier Provincial Park is named for him.

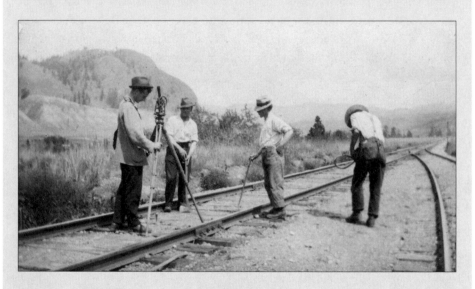

F.T.P. Cond, left, and his survey crew along the Canadian Pacific Railway line near Monte Creek in 1913. 10-8, Whyte Museum of the Canadian Rockies.

In June, Bucknill's badly decomposed body was finally located in a wooded area of Hastings Park. He was dressed in a winter jacket; had a gun in his hand; and had died from a gunshot wound. The coroner ruled that Bucknill had committed suicide. Ironically, two days after Bucknill's disappearance, his mother died in England, and his sister died in the same week, on January 14. In October, the British Columbia Land Surveyors Board received a request from Lamarque.

> The Board considered the subject of a letter from Mr. Lamarque dated 17th August 1912, and a certificate from Mr. F.T.P. Cond, BCLS, from which it appears that in consequence of his being unable to communicate with Mr. W.B. Bucknill, BCLS, to whom he was articled, he was unable to get a release from said articles to enable him to become articled

to Mr. Cond with whom he was working from 20th April 1912 up to 15 August 1912 when it was established that Mr. Bucknill was dead [Cond and Lamarque were surveying and didn't learn about Bucknill's death until then], there he entered into articles with Mr. Cond.

The Board decided that Lamarque's articling would remain continuous from May 1911 when he began working for Bucknill.

> Bucknill died early in 1912 and I transferred articles to F.T.P. Cond, who was then chief land surveyor for the Canadian Pacific Railway in British Columbia. Thus I was engaged in many surveys along the main line of the railway from Vancouver to Field. One of these was at Roger's Pass, by which the railway then crossed the Selkirk Mountains... and which it now avoids by the five mile [8 km] tunnel... During the summer I surveyed the line from Field to Golden in the valley of the Kicking Horse River amidst, no doubt, some of the finest mountain scenery in the world.

In an article in the *Vancouver Daily World* on June 12, 1912, Thomas Shaughnessy, president of the CPR, announced that "surveys will start at once for work which will cost $60 million." The CPR planned to double track much of their rail line through British Columbia. Several years of economic growth in the province had increased the railway's transcontinental traffic. The Panama Canal was nearing completion, and the CPR anticipated additional traffic both for its rail line and steam ships as a result. Although it was not publicly mentioned, the CPR knew that two new rail lines, the Grand Trunk Pacific and the Canadian Northern, were being constructed across British Columbia, and it hoped increased capacity would divert some traffic away from these railways.

The CPR project provided living and working conditions that were different from most surveys.

> We had a combined office and sleeping car and one for the cook and were left at any siding most conveniently located for our work which we reached on small, hand-pumped speeders on which, on more than one occasion, we nearly met disaster. In the 35 miles [60 km] between Field and Golden the railway descends some 1500 feet [460 m] and in those days this general descent was reversed by a short stretch of up grade between Old and New Leanchoil, where the line turned away from the river across the shoulder of a hill, this change of grade

occurring in a sharp curve through a narrow rock cut. At work in this locality, Frank Adams and I, having listened for and not hearing any sound of an approaching train, slowly entered, on our small speeder, the upper end of this cut. As a precaution we were both sitting sideways, pumping, each with one hand ready to jump. I was carrying my transit instrument. Suddenly, with a roar, a freight train came rushing into the cut, speeding to take the commencement of the up grade as fast as possible. Hurling ourselves and our car off the rails, we leaned back against the rocks at the side of the track while, a split second later, the heavy freight swept by with a clatter and a roar, a yard [1 m] or so distant. Similarly, in a section of much curvature below the Field yards, Frank, who had one morning remained behind to bring our lunches, saved himself and the speeder but not the lunches.

In 1912, Cond surveyed at several locations along the rail line between the Alberta–British Columbia boundary and Revelstoke. One survey was at Field, the first community west of the Rocky Mountains along the line. The CPR wanted to expand the rail yard and made their initial request and survey in 1909. The land that they wanted was part of Yoho National Park so the railway proposed an exchange of property. The company was used to having its requests granted by

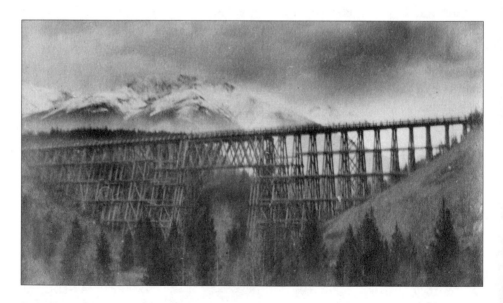

Ottertail trestle. Located west of Field, this was one of the major trestles on the Canadian Pacific Railway line in the Rocky Mountains. Lamarque's photograph is one of the few pictures of this structure. 11-30, Whyte Museum of the Canadian Rockies.

the federal government, so it was surprised when James B. Harkin, appointed as the first commissioner of the Dominion Parks Branch in 1911, rejected the initial application. In 1912, Cond made a survey for a new plan for the Field rail yard. This small piece of property became the source of a bitter dispute between the CPR and the Parks Branch that lasted for about ten years before it was resolved.

During the winter and spring, Cond continued the twinning project with several surveys in the lower Fraser Valley.

> The season remained mild till the last day of the year when a high, westerly gale brought cold weather which lasted till the end of February. I remember using snowshoes on Pitt Meadows where the snow lay nearly three feet deep [90 cm], and in mid-March it still lurked in the woods not far from the railway at Ruskin, at an elevation of not more than 50 feet [15 m] above the sea.

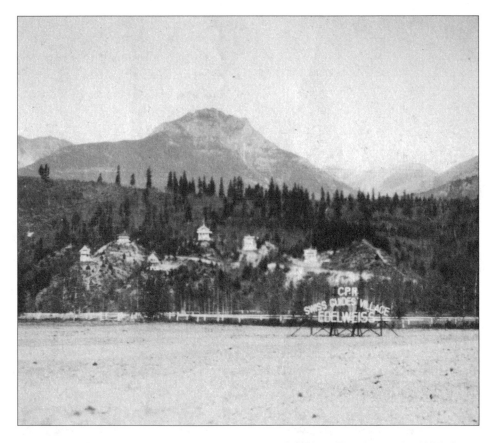

Lamarque took this photograph of Edelweiss, west of Golden. The sign reads: "CPR Swiss Guides' Village Edelweiss". 11-29r, Whyte Museum of the Canadian Rockies.

The CPR built six Swiss-style chalets for their guides so they would remain in Canada year-round. 11-29l, Whyte Museum of the Canadian Rockies.

In April 1913, Shaughnessy announced in the Vancouver newspapers that the CPR twinning project would be continued during that year with millions of dollars to be spent and construction for the tunnel under Rogers Pass to begin. Cond and his crew surveyed farther west at several locations from Shuswap Lake to Kamloops and then down the Thompson River valley.

In January 1914 the railway company drastically curtailed the double tracking operations which it was generally supposed that it intended to extend over the whole or most of its main line in British Columbia, and my survey party, with others, was disbanded.

Edelweiss In 1912. 11-24, Whyte Museum of the Canadian Rockies.

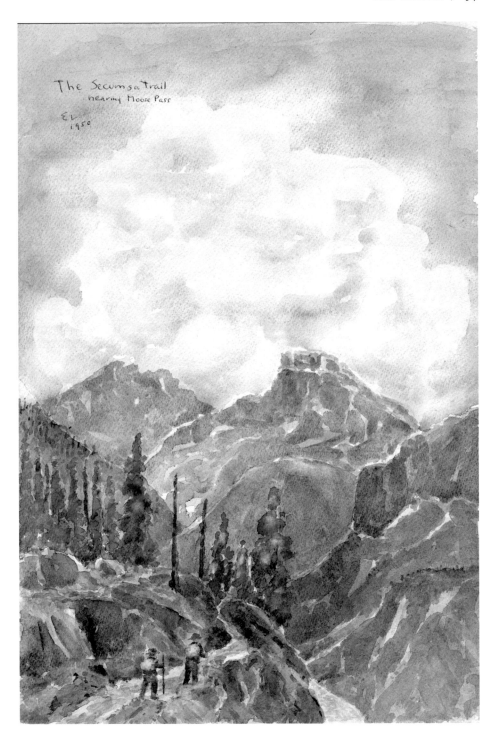

The Secumsa Trail
nearing Moose Pass
EL
1950

LaE.05.20, Whyte Museum of the Canadian Rockies.

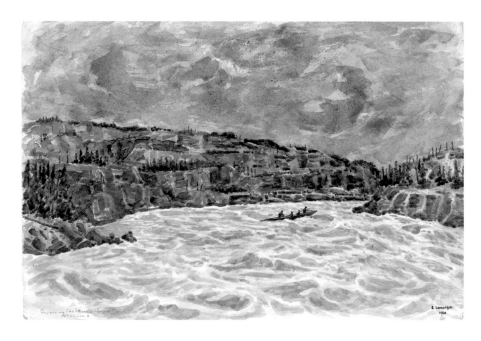

LaE.03.63, Whyte Museum of the Canadian Rockies.

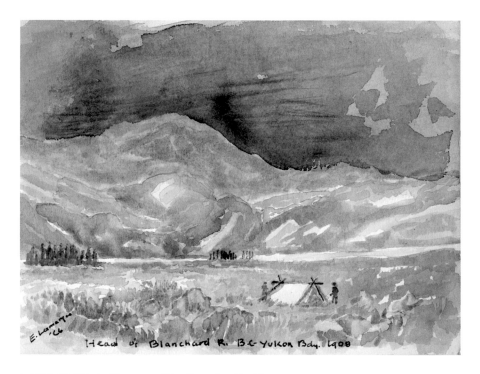

LaE.05.05, Whyte Museum of the Canadian Rockies.

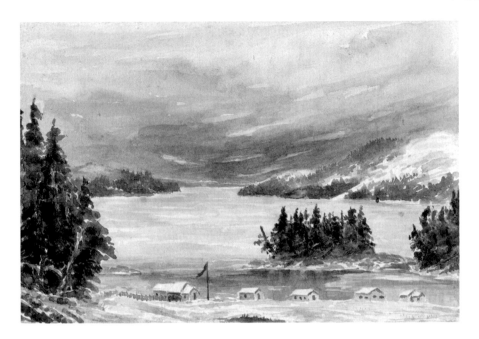

LaE.05.50, Whyte Museum of the Canadian Rockies.

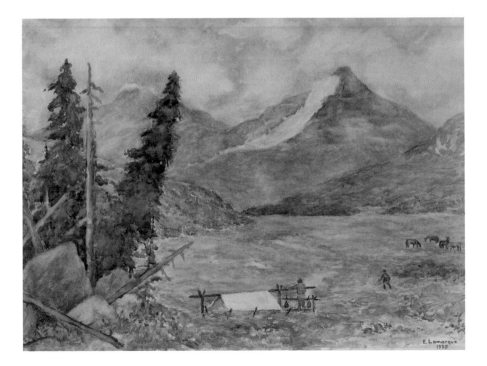

LaE.05.01, Whyte Museum of the Canadian Rockies.

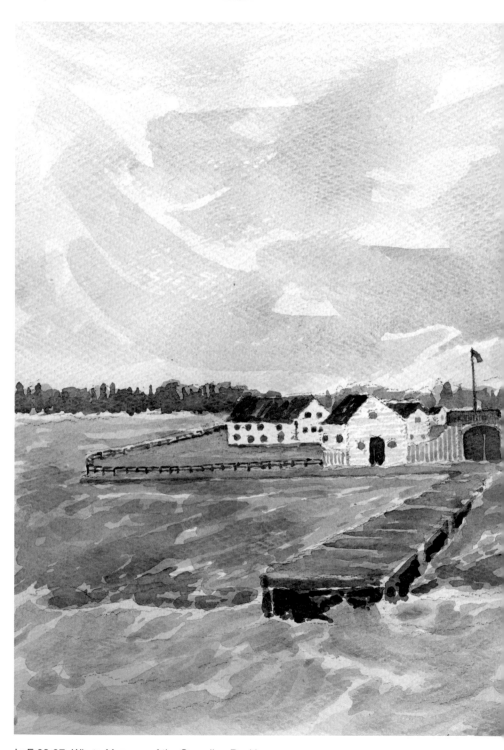

LaE.09.07, Whyte Museum of the Canadian Rockies.

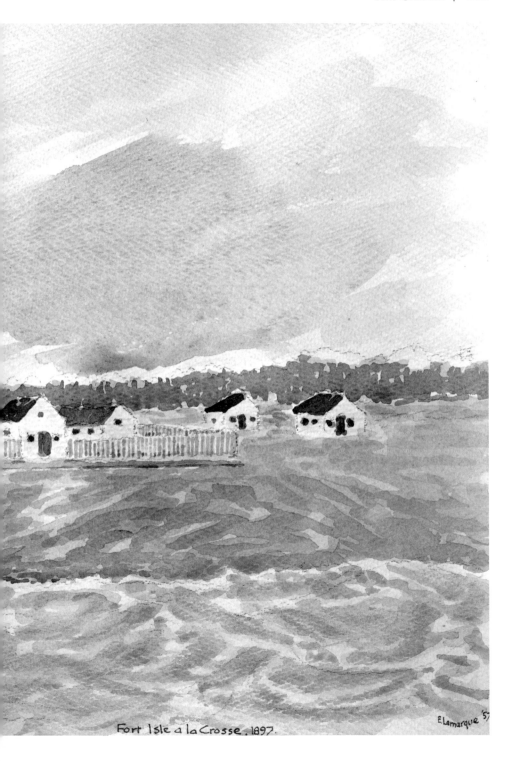

Fort Isle a la Crosse, 1897.

E. Lamarque '5?

LaE.09.03, Whyte Museum of the Canadian Rockies.

LaE.09.07, Whyte Museum of the Canadian Rockies.

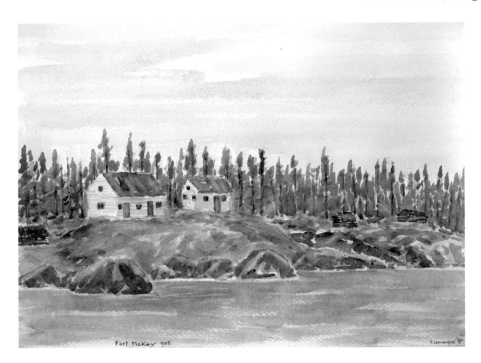

LaE.09.07, Whyte Museum of the Canadian Rockies.

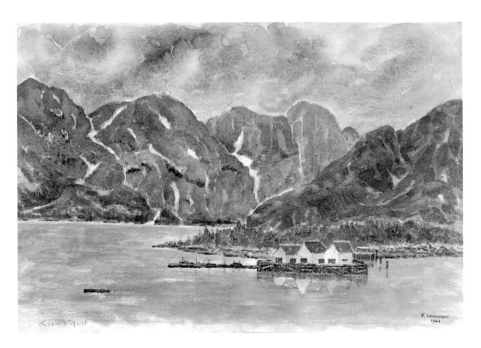

LaE.05.61, Whyte Museum of the Canadian Rockies.

LaE.05.10, Whyte Museum of the Canadian Rockies.

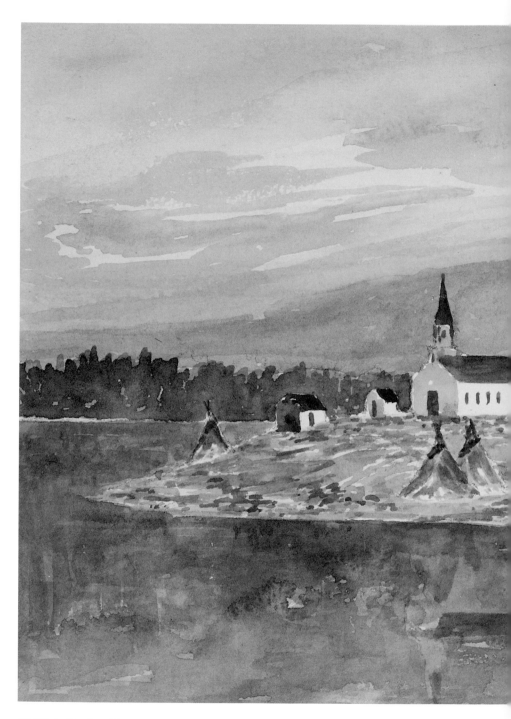

R1150.4, Glenbow Museum.

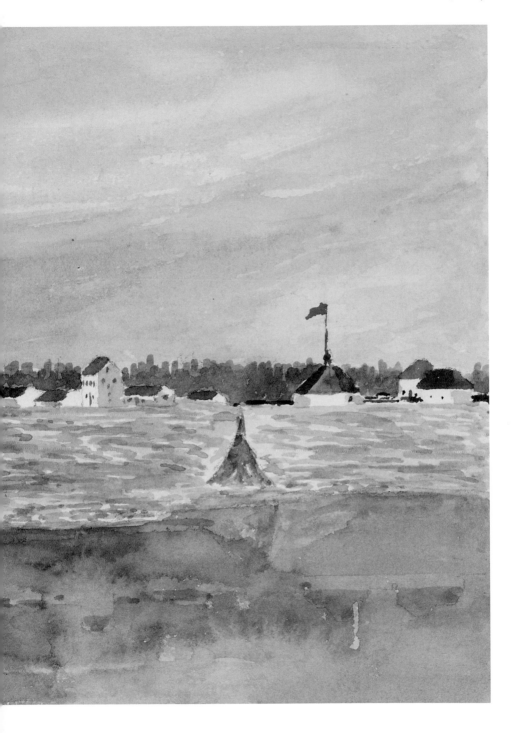

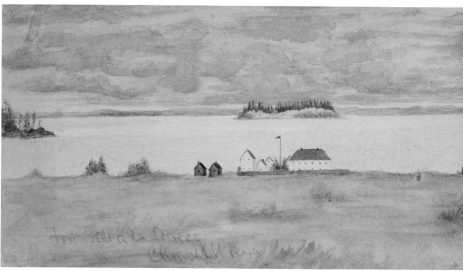

Above: R1150.1A, Glenbow Museum.

Left: R1150.5A, Glenbow Museum.

R792.4, Glenbow Museum.

R1150.2C, Glenbow Museum.

View on the Soldiers' Settlement Area, Creston, B.C. in 1920.

LaE.05.54, Whyte Museum of the Canadian Rockies.

LaE.05.05, Whyte Museum of the Canadian Rockies.

ARTWORK

Page 97: On the Sakumtha trail. LaE.05.20, Whyte Museum of the Canadian Rockies.

Page 98, top: Running the lower Grand Rapids, Athabasca River. Over the years Lamarque made several paintings of the Athabasca River along with a Christmas card. One of his Athabasca River paintings was chosen to be in the First Annual BC Artists' Exhibition at the Vancouver Art Gallery in the fall of 1932. LaE.03.63, Whyte Museum of the Canadian Rockies.

Page 98, bottom: Head of Blanchard River. Lamarque made several watercolour paintings of his work on the 1908 boundary survey. The Blanchard River is a tributary of the Tatshenshini. Lamarque and Dodge worked in this area early in the summer. This watercolour, made in 1966, is one of Lamarque's last paintings. LaE.05.05, Whyte Museum of the Canadian Rockies.

Page 99, top: Beginning of winter, Old Fort Wrigley, Mackenzie River. Lamarque made several paintings of Old Fort Wrigley. This wintry scene was done in 1921 and appears to be a companion to the painting of the confluence of the Liard and Mackenzie. LaE.05.50, Whyte Museum of the Canadian Rockies.

Page 99, bottom: A valley in the Cassiar Mountains. This was one of several paintings that Lamarque made in 1935, depicting his advenures on the Bedaux Expedition. LaE.05.01, Whyte Museum of the Canadian Rockies.

Pages 100-101: During retirement Lamarque produced a set of watercolour paintings of most of the Hudson's Bay Company posts where he worked. This is his painting of Île à la Crosse. LaE.09.07, Whyte Museum of the Canadian Rockies.

Page 102, top: Lamarque made a painting of the Hudson's Bay Company post at Lower Post. It is similar in style but separate from his other HBC paintings. LaE.09.03, Whyte Museum of the Canadian Rockies.

Page 102, bottom: Lamarque's set of paintings of Hudson's Bay posts included one at Hudson's Hope. LaE.09.07, Whyte Museum of the Canadian Rockies.

Page 103, top: Fort McKay. LaE.09.07 Fort McKay, Whyte Museum of the Canadian Rockies.

Page 103, bottom: The cannery at Kimsquit. LaE.05.61, Whyte Museum of the Canadian Rockies.

Pages 104-105: On the way to Chilliwack Lake. This is the second of the two gouache paintings Lamarque made in 1930. The other gouache painting that Lamarque made was of Fort St. John. LaE.05.10, Whyte Museum of the Canadian Rockies.

Pages 106-107: Fort Resolution, Great Slave Lake. The principal HBC post on Great Slave Lake, this was one of the stopping places on Lamarque's trip to Fort Simpson. Today Fort Resolution is a National Historic site. Lamarque painted this watercolour in 1903, one of his early art works. R1150.4, Glenbow Museum.

Pages 108-109, top: In 1905 Lamarque painted the scene of activity at Fort St. John that he describes in his memoirs. The Hudson's Bay post is in the foreground near the Peace River. The tents pitched nearby are from the Indian Treaty Payment party and the Royal Northwest Mounted Police (the force's new name beginning in 1904.) Across the river is the camp of the Dominion land surveyors who were going to begin the delineation of the boundaries of the Peace River Block. This watercolour was selected for the Vancouver Art Gallery's All-Canadian Exhibition in 1932. It is one of four paintings Lamarque made in 1905 that have the Peace River for its setting. All of them include some of the bright green colour that is prominent in this landscape. R1150.1A, Glenbow Museum.

Pages 108-109, bottom: Lamarque's 1903 painting of the HBC post at Île à la Crosse is the oldest of his watercolours. It provides an unusual perspective of the post from the land looking out to the lake and the big island. The Roman Catholic mission is on the point of land to the right. R1150.5A, Glenbow Museum.

Page 110: The confluence of the Liard River with the Mackenzie River. Lamarque painted this scene near Fort Simpson in 1921. R792.4, Glenbow Museum.

Page 111: A view over Capilano valley. In 1910 Lamarque made two watercolour paintings of the Capilano valley where he had surveyed. He did two additional paintings in 1917. R1150.2C, Glenbow Museum.

Page 112, top: View of the Soldiers' Settlement area, Creston. Lamarque surveyed in this area in the late fall of 1920. LaE.05.54, Whyte Museum of the Canadian Rockies.

Page 112, bottom: Camp near Dease Lake. Lamarque made this painting of the conditions that he and Jack Stone encountered on their return trip from Dease Lake during the Bedaux Expedition. LaE.05.05, Whyte Museum of the Canadian Rockies.

1914 | PEACE RIVER TRAMWAY AND NAVIGATING COMPANY

After several years of prosperity, British Columbia experienced an economic recession in 1914 and the CPR discontinued its twinning project. In a letter to his friend, James Spencer, Lamarque described his situation in late April. "I have been laid up since the beginning of the year, had to be operated on for an abdominal rupture but am pretty strong again now... I have been doing a great deal of work for the CPR surveying and making land ties through various sections in the mountains. At the time of writing I do not know what I shall do this summer." He noted that the economy was stagnant and many people were leaving Vancouver. Lamarque completed his articling with F.T.P. Cond and then obtained a surveying position in Alberta.

David Alfred (D.A.) Thomas, Viscount Rhondda, was a British coal baron from Wales. The son of a coal owner, Thomas was president of Cambrian Colliery Trust and a British MP for over twenty years. Through his company he acquired coal fields in the United States and western Canada. In 1914, he received a charter from the Canadian government for the Pacific, Peace River

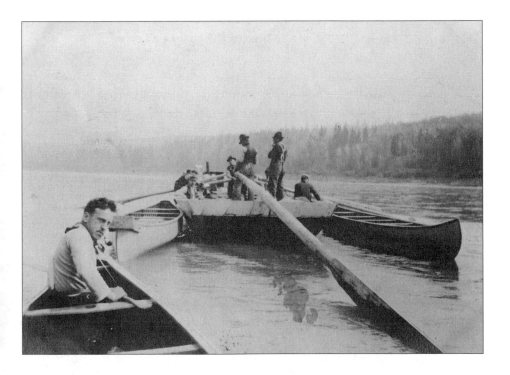

At the beginning of the trip down the Athabasca River. pd7-1, Whyte Museum of the Canadian Rockies.

and Athabasca Railway. The railway's planned route was from the mouth of the Nass River through the Groundhog Coalfields in northwestern BC to the Omineca mining region, and on to the BC Peace River region. It would then follow the Peace River into Alberta as far as Vermilion Chutes where it would head to the mouth of the Athabasca, the oil sands of Fort McMurray, and terminate at Prince Albert, Saskatchewan, where it would join the Canadian Northern Railway.

Thomas also incorporated the Peace River Tramway and Navigating Company to construct two small railways: one at the 25-km portage on the Slave River between Smith Landing and Fort Smith and the other to bypass the Vermilion Chutes on the Peace River. Lamarque was hired to survey this project. In his memoir, he provided a summary.

> In hospital for a time, it was not till the following June that I went north into the lower Athabasca and Peace River country to carry out surveys for the late D.A. Thomas, the Welsh coal magnate, who had then envisaged great projects for the Canadian northland, principally in transportation facilities, including an electric railway across the portage between Fitzgerald [Smith Landing] and Fort Smith on the Slave River and another at the Chutes of the Peace River, with power, in both cases, developed from the adjacent falls and rapids.

Lamarque described this work briefly in his memoir but provided a more detailed description in an article titled "A summer on the lower Peace & Athabasca Rivers, 1914." This article, written in 1915, is used as a source for this chapter.

Lamarque left Vancouver on May 28, proceeding by train to Calgary and Edmonton. Then he took the Canadian Northern Railway to Athabasca on the Athabasca River where he met the representative from Thomas' company and the remainder of the crew. The men travelled on a scow down the Athabasca River, reaching the Grand Rapids on June 3. Lamarque described the situation there.

> When we arrived the water was exceedingly low and still falling, therefore the navigation of this rapid was even more difficult than usual. The Hudson's Bay brigade, including some mission scows, was here and had been here for some days prior to our arrival. There were nearly 40 boats in the brigade and the crews, totalling over 200 men, were very busy getting the cargo unloaded and across the island and running the empty scows down the side channel...
>
> Early next morning, the 4th of June, Mr. L. [the tramway company executive] went down to the island to see what arrangements could be made with the [Hudson's Bay] Company for our transportation over

this rapid and for another steersman to take us down the 90 miles [144 km] of rapids below to Fort McMurray. Now the HBC had a very large brigade of boats, quite the largest that had ever gone down this river, and with the exception of another smaller one later on in the season, probably the last brigade of any size that ever would descend this river again for... the railway was expected to be at the Peace River by 1915... Mr. L. very soon found that the HBC could not spare any steersman for they had not enough good men to control all the boats of their own as it was... However an arrangement was made that we should form part of the HBC brigade from here on and they would see that we had a steersman capable of managing our boat... As soon as this had been decided upon we left for the island and remained in camp there at the lower end until the morning of the 10th...

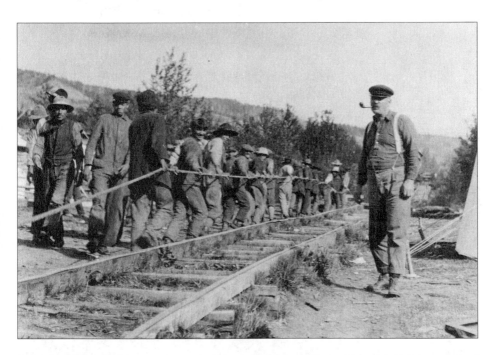

At the Grand Rapids, there was a tramway to haul goods around the rapid. Captain Haight supervised the men who were doing this work. Lamarque made a Christmas card with a picture and description of the Grand Rapids. He wrote: "At the Grand Rapids the river is divided by an island on which the Hudson's Bay Company placed light rails for the transportation of freight. As the main channel, to the west of the island, is unnavigable, the boats were usually emptied, or partly emptied, at the head of the island and then let down the narrow, easterly channel to be reloaded at the foot, where the company had established a warehouse and other buildings." 11-58, Whyte Museum of the Canadian Rockies.

On the night of the 4th rain fell heavily and until noon on the following day which delayed the work of handling the cargo. The river was rising, however, and if it continued to do so it was decided to try and take down the 7 ton boiler which was going to Fort McMurray for the new HBC steamer in course of construction there.

The next day, as the water had risen nearly a foot [30 cm] in the rapid the attempt was made. A strong crew was placed on the specially constructed double bottomed scow in which the boiler was securely fastened and a start made about 10 am to negotiate the side channel. Besides the crew aboard about a hundred other men... helped to control the scow from the shore by means of strong lines. The scow repeatedly struck and stuck on rocks but after four hours exertion and some excitement it was safely taken into the eddy at the foot of the rapid...

Sunday the 7th the crews rested and the Catholic fathers held a service in the warehouse at the foot of the island which was attended

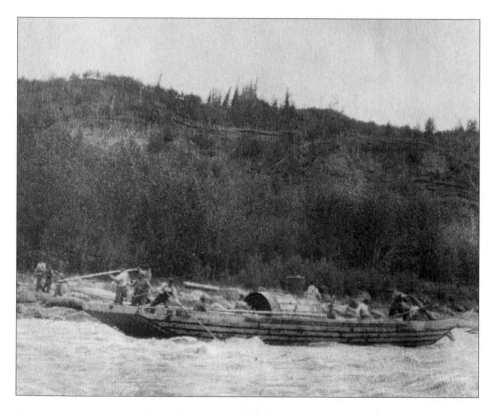

Taking the seven-ton boiler down the right channel of the Grand Rapids. The boiler is in the middle of the scow. 17-4, Whyte Museum of the Canadian Rockies.

by many of the crews and by the sisters going down the river to one or other of the missions below.

The brigade left the Grand Rapids on June 10 with the river in full flood. At Stony Rapids the scow carrying the members of the commission distributing the Treaty 8 annual payment encountered difficulties.

The boat ahead of us, though, with the Indian Treaty Commissions aboard, was not so fortunate. This scow, already weakened by its handling at the Grand Rapids, had its back broken by the force of the water when passing through and quickly filled. It was probably a quarter of a mile [400 m] ahead of ours and we did not notice that it had come to grief until we had passed the rapid ourselves; then we saw the Commissioner, his party and the crew in a canoe which they had along with them making an effort to tow the water-logged scow to the left shore... They were forced to cast her adrift, and all they saved out of the wreck was a few articles of clothing and the tin box containing the money for the treaty payments. See image LaE.03.63, page 98, top.

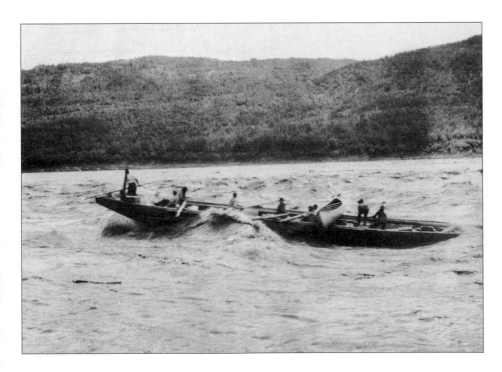

Running the Big Cascade. 11-36, Whyte Museum of the Canadian Rockies.

In his annual report to the federal government, Henry Conroy, Inspector for Treaty No. 8, described the incident.

> We had the misfortune to be swamped by such a volume of water which came in over the bow, that the scow practically broke in two, the stern dropping down into the rapids and the baggage floating out into mid-stream. It was with considerable difficulty that the crew and passengers, eight in number, got ashore by means of a canoe, before the wrecked scow plunged over the Big Cascade, overturned, and deposited the entire contents into the river. The whole of our outfit was a total loss, with the exception of the treaty funds, which were taken into the canoe when the occupants left the scow.

The brigade reached Fort McMurray on June 12. Three days later Lamarque noted:

> The Treaty Commissioner paid treaty to the Indians who had assembled here for that purpose and the three or four stores did a roaring business. A little over 1000 dollars in treaty money was paid out.

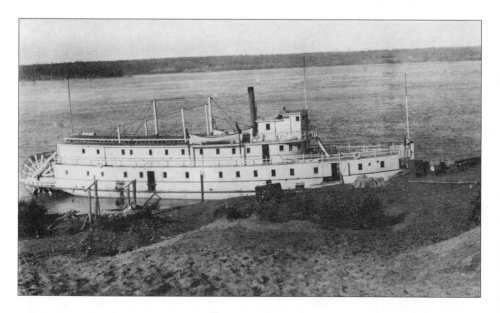

The Hudson's Bay Company steamboat, *Mackenzie*, at Fort Smith. This boat was constructed in 1908, after the last time Lamarque had been in the area. 17-7, Whyte Museum of the Canadian Rockies.

At Fort McMurray the tramway crew boarded the Hudson's Bay Company steamer SS *Grahame* on its first trip downriver for the 1914 season. They reached Fort Chipewyan on Athabasca Lake on June 20. The Treaty Commission party, who were also on the steamer, made payments to a group of Chipewyans and a group of Cree who had assembled there. Lamarque met Dr. Charles Camsell, from the Dominion Geological Survey, who was making a reconnaissance between Athabasca and Great Slave Lake. He also visited Alfred Fugl, his friend from the Hudson's Bay Company. The SS *Grahame* left Fort Chipewyan on June 23 and travelled down the Slave River, arriving at Smith Landing two days later.

Lamarque and the crew spent the first few days making a quick reconnaissance of the 25-km portage between Smith Landing and Fort Smith along with checking their equipment. The survey for the tramway started on June 29.

> This preliminary work fully occupied our time until the 24th of July during which period we moved camp to a small creek two miles [3.2 km] from Fort Smith and during which period, also, the energy of the swarming mosquitos did not appear to abate one jot, day or night. The weather was very warm so that the head nets and gauntlet gloves that we were forced to wear as some protection against the pests were

The community of Smith Landing where a series of rapids on the Slave River started, and Lamarque's survey began. 17-5, Whyte Museum of the Canadian Rockies.

Prepared for mosquitos. 17-6, Whyte Museum of the Canadian Rockies.

not comfortable. The bush, in fact, was an inferno; we worked and slept under netting and ate all our meals in a heavy smoke...

Lamarque noted that the weather was dry for much of the summer. They had a good variety of food and were able to make arrangements with a First Nations man who had nets on the river to obtain several meals of fresh fish.

The actual location of the tramline, including some revisions, took us until nearly the end of August. On Sunday the 30th the *St. Emile* [a Roman Catholic Mission steamer] arrived from Fort Chipewyan to take us up the Peace River where we had a similar piece of work to attend to. Directly we got word of her arrival we moved into the landing... On the last day of August, soon after noon, we embarked on the tug en route for the [Vermilion] Chutes. The little vessel made good time against a three mile [4.8 km] current and the weather was perfect. During the afternoon we tied up to a little rocky island in the middle of the river to collect some driftwood for fuel. This business of cutting fuel was a daily occurrence for we could not store enough on the little vessel to keep us steaming for more than 12 hours at a time.

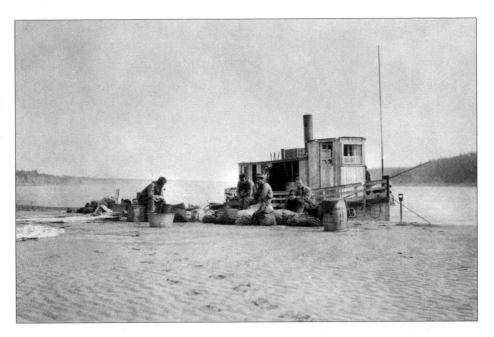

The *St. Emile* at the foot of Rapid au Boyer. 17-8, Whyte Museum of the Canadian Rockies.

By the time they reached Boyer Rapids the water was so low that the *St. Emile* could not go any further upstream. The boat returned to Peace Point where a group of Cree had an encampment. With the pilot acting as interpreter, Lamarque

> bargained with the Indians for an hour or more in two different tipis and finally a powerful looking Cree about 30 years of age and a boy of 17 agreed to come as far as the Chutes with a rowboat each. The captain of the tug agreed to loan his dinghy... Our Indians were to bring back the mission skiff with them and take it on down to Fort Chipewyan later in the fall when they would be going there for supplies.
>
> About 9 o'clock we left again aboard the tug for the foot of the rapid with the three skiffs and two birch canoes in tow for two of the older hunters were coming up the rapid again to hunt. It rained heavily for an hour after we started but cleared up and the sun came out before we reached the sandbar that we had moored to the previous day and where we transhipped our outfit into the skiffs which just about held the stuff and that was all. The tug then cast off and was soon lost sight of down the river.

Tracking a canoe up the Peace River. 17-9, Whyte Museum of the Canadian Rockies.

The two old Indians now proposed for a small remuneration to help us to the top of the rapid in which they said we should have trouble lining up our heavily loaded boats. So for $3 each they came along and we reached the head of the rapid about 6 in the evening after 4 hours of hard tracking and wading. All three skiffs got stuck on rocks and shoals several times but we only had to surmount two short stretches of strong water and the old Indians, who did the steering had what they were looking for.

Above the rapids, Lamarque and his crew rowed and tracked their vessels up the Peace River. On September 11, just before sundown, they reached the HBC post at Little Red River where they learned about an important event.

There was no sign of life at all, not even a dog to be seen and as we had hoped to replenish our stock of supplies here which were running very low this caused us some concern for the nearest post was Fort Vermilion 60 miles [96 km] further upstream above the falls. However, after a while an American trapper made his appearance, said that he had been expecting us, and that Mr. L [the Tramway executive] had left a letter here for us. He had the keys of the HBC and Revillon Frères buildings so we made ourselves at home in a large single room log cabin belonging to the HBC which had a fine open fireplace in it.

On our expressing surprise that neither the Company's agent or Revillon's man was here he said, "It is on account of the war. There will be no market for furs now and though I believe the HBC man will stay

here this winter Revillon have shut up their post indefinitely." This was news indeed. "And what war are you referring to?" we asked, to which he replied—"Why, say, haven't you heard? Hell, the whole of Europe is fighting" and then he told us what little he knew of the bloody business that had started six weeks earlier…

The following day Lamarque and his crew got supplies from the HBC store and, with the assistance of the two Cree, reached the Chutes where they set up camp on the north side of the Peace River.

During the next two weeks Lamarque and his crew surveyed a route for the tramway above the north shore. The country was fairly flat and there was not much elevation difference from the bottom to the top of the tramway. Lamarque wrote that by September 26 "all necessary work, including soundings at their end on this side of the river, was completed." The men then portaged their outfit across the river and above the falls to the HBC steamboat landing. On October 2, the SS *Peace River* arrived and transported the crew to Peace River Crossing, which they reached on October 6. From there, Lamarque and his crew travelled by wagon to Lesser Slave Lake and by boat to Sawridge, where they boarded the train to Edmonton. Lamarque concluded his account by commenting that at the time he was writing his account of the 1914 survey many of the men were "either somewhere in Flanders or preparing for the fray."

World War I halted Viscount Rhondda's plans for economic development across northern BC and Alberta. Viscount Rhondda and his daughter visited the United States in 1915 to inspect his coal operations there. Their return trip was on the *Lusitania* which was sunk by a German U-boat; however, both Thomas and his daughter survived. During the war, the Peace River Tramway and Navigation Company constructed two boats to operate on the upper Peace River. The *D.A. Thomas,* built in 1916, was the largest and most famous boat on this waterway. The second vessel, the *Lady Mackworth*, was named for his daughter who was actively involved with Thomas' company. Thomas died in 1918 and after the war there was no revival of his railway and coal-mining plans. Rhondda Peak at the north end of Yoho Park, along the Alberta–British Columbia boundary, commemorates D.A. Thomas.

3 | Interlude, 1915–29

Lamarque passed his final exam in early 1915 and became BCLS #185. In May 1916, he enlisted in World War I with the 6th Field Company, Canadian Engineers, whose primary function was to operate an engineer training centre. The following year he was transferred to the 196th Battalion (Western Universities), D Company. When the soldiers in this battalion were shipped overseas, Lamarque received an honourable discharge. He then passed the exam to obtain his Dominion Land Surveyor commission. In the fall of 1917, he conducted timber licence surveys for Pacific Mills, which operated the pulp mill at Ocean Falls.

In his memoir, Lamarque devotes only a few pages to this portion of his career. He wrote: "With the end of the war there was more or less of a boom in the west which continued for a full decade, and innumerable surveys, generally local, kept me busy." Lamarque had his own small surveying practice and occasionally worked out of town. There are no existing photographs or written articles from this time period, but there are some paintings.

In the fall of 1920, he surveyed some lots for the Soldier Settlement Board at Camp Lister, south of Creston. The Canadian government established this organization in 1917 and worked with provincial governments to assist returning servicemen in setting up farms. Most of the soldier settlement areas in British Columbia were in the Central Interior region. Camp Lister, founded by Colonel Fred Lister in 1919, had small farms for about seventy soldiers. Its purpose was to grow fruit like other orchards in the valley. Unfortunately the farms at Camp Lister were not very successful because most of the land was above the valley and lacked good sources of water. SEE IMAGE LaE.05.54, PAGE 112, TOP.

The next summer, Lamarque made a mineral claim survey at the northeast end of Canim Lake in the Cariboo.

One winter, Lamarque surveyed at Chilliwack Lake where he had been in 1911. In his memoir he wrote: "Then I had gone in from Chilliwack with a pack train to the lake. This time we had to carry our supplies ourselves and as the weather was atrocious we had a rough time of it. The distance from the end of motor transportation to the lake was then, however, only about 35 miles [60 km]." SEE IMAGE LaE.05.10 ON PAGES 104-105.

Jericho Beach, on the west side of Vancouver, had one of the first air stations in Canada, beginning in 1920 as a site for water-based aircraft. The Royal Canadian Air Force took over the Jericho Beach station in 1924 and

Lamarque surveyed a lot that the Department of National Defense used for a wireless station.

Lamarque surveyed for the University of British Columbia's forestry department on a few occasions. In 1926, he surveyed several parcels within the forest belt, a tract on the university's lands. A 1925 UBC booklet described this land. "The [Forestry] Department possesses in the forest belt, which has been preserved on the campus, a natural park, a very valuable outdoor laboratory for forestry students." In 1931, Lamarque surveyed the university's farm woodlot, and when UBC started its demonstration forest, they hired Lamarque to survey it for them in early 1939.

Lamarque made some mineral claim surveys in 1927 in the Portland Canal area near the Alaska border. He was scheduled to return to this area the following year, but A.B. Root did the actual surveys there.

In 1927, Lamarque surveyed a set of mining claims for the Wigwam Mining Company southeast of Revelstoke. The claims were within the Railway Belt, land given to the federal government as part of British Columbia's agreement to join Confederation in 1871, coupled with the federal government's promise to construct a transcontinental railway through the province. Most British Columbia land surveyors also had their Dominion land certificate so they could work in the federal lands of the Railway Belt in southern British Columbia or the Peace River Block in the northeastern part of the province. There were some differences between the provincial and federal survey regulations and in Lamarque's survey this led to a controversy between F.H. Peters, the Surveyor General for Canada, and J.E. Umbach, British Columbia's Surveyor General. Umbach and Peters did not have an amicable relationship. Earlier in the 1920s, the two men got embroiled in a dispute over British Columbia's policy for naming geographical features for the province's surveyors who had died in service during World War I. It would take about twenty-five years for the two organizations to resolve this issue.

Lamarque's survey included several claims surrounding a small parcel of unclaimed land called a "fraction" that the Wigwam Mining Company did not want. The land for the mineral claim was to be transferred to British Columbia, but the federal and provincial governments had different policies on how to handle the fractional parcel of land and this sparked another disagreement between Peters and Umbach.

In December 1927, Lamarque sent his survey and map of the mining claims to the provincial Surveyor General's office. When the federal Surveyor General questioned the fractional piece of land being left to the federal government, Umbach wrote on April 16, 1928: "Concerning the fraction which lies between Lots 12280, 12284 and 12285, I may say that it is impossible to include this area

as a 'fraction created' in any of the claims in accordance with the interpretation of the Mineral Act."

At the end of the same letter, Umbach mentioned another matter that was intended to irritate Peters. The legal tie that Lamarque needed to use for the survey was beyond the three-mile [4.8 km] limit specified by the Surveyor General of Canada. Umbach refused to pay for a survey to this post and instead had Lamarque connect his work to a nearby timber limit survey. He quoted from Lamarque: "The timber limit post tied to was referenced by a bearing tree, about a 40 inch [1 m] cedar marked B.T. 12. No tie was made to the quarter section corner on the east boundary of Section 1, Tp. 22-1-6, across the river." Umbach concluded by telling Peters, "Please let me know if this is sufficient to identify the witness post."

The simplest solution would have been for the Wigwam Mining Company to claim the small parcel of land. Lamarque wrote to the Surveyor General: "The triangular area to which you bring my attention was at first desired as a fractional mineral claim by those interested in the group. Latterly, however, they changed their minds and decided not to bother with it and as they have not, apparently, applied for a Crown Grant for this property the matter would appear to be in abeyance."

On April 19, 1928, Umbach sent another letter to Peters containing the information Lamarque had sent: "I shall be glad to be advised, therefore, whether it is your desire to have this area posted with standard iron posts before the lands are transferred to the Province."

Peters replied to Umbach on April 26: "When the Regulations for the disposal of Quartz Mining claims in the prairie province etc. were revised in 1917, a clause was inserted giving authority to the surveyor to include a 'fraction created' in the survey of a claim." This would enable a federal survey to include any remaining fraction of land as part of the survey.

Since the British Columbia government appeared to have different regulations, Peters sought clarification: "From your remark it is apparent that there are definite restrictions to the inclusion of a vacant triangular parcel and I would be very glad to receive a copy of any discussions, rulings or court decision you may have dealing with the general subject in order that we may take such steps to avoid difficulties as may be found desirable in the matter."

The next day, Peters wrote another letter to Umbach based on the letters of April 16 and 19. He began by informing Umbach that the survey of two timber berths in the area only showed one witness post and, though it didn't match Lamarque's description, "there is no doubt but this is the monument to which Mr. Lamarque tied his survey." Then Peters noted that it would be necessary to

have the fraction "properly posted with Dominion Government standard survey posts before the transfer is effected." Peters concluded his letter by stating: "When Mr. Lamarque is completing this posting he should be instructed to continue his tie line from its present termination at the witness monument to the quarter section corner on the east by section 1, township 22-1-6 and add this information to his field notes of a survey."

On May 2, Umbach replied to Peters' April 26 letter by noting the provincial legislation regarding the inclusion of a fraction and including a copy of the "Manual respecting the survey of mineral claims." Umbach also answered Peters' April 27 letter by telling him that he was forwarding the letter to Lamarque.

On May 12, Lamarque responded:

> I am not yet aware that the Wigwam Mining Company intend to Crown Grant their claims and, if they do so, it is possible that they may take the triangular area under discussion as a Fractional Claim. With regards to the tie to the quarter section corner, I hold instructions from Ottawa that a tie to a Timber Limit was sufficient and I assume it is the intention of the Department at Ottawa to refund me for any further ties that may be necessary in this matter if the Company eventually decides to Crown Grant.

In the meantime, Peters read the manual provided by Umbach: "It is noted that by your Act the surveyor *shall* [underlined in original letter] include the fraction created whereas by the Dominion regulations our surveyor *may* include it, making it a matter of discretion." Peters wanted to know more detail about the rationale regarding why Umbach was not including the fractional parcel in the survey: "I should like to have your views on this point or any decision that may have been given." The two surveyor generals exchanged further letters regarding the interpretation before this issue and Lamarque's survey finally came to a conclusion.

Linocut of Frenchman's Cap, a distinctive mountain in the Monashee Mountains on the west side of the Columbia River valley about 50 km north of Revelstoke. Lamarque created several linocuts of the locations where he surveyed in 1930. 7-2, Whyte Museum of the Canadian Rockies.

4 | The 1930s

The 1930s was the most productive decade of Lamarque's surveying career, and during that time he worked on several significant projects in the central and northern part of the province. Much of his surveying was for the provincial government's Department of Public Works, which had responsibility for BC's highways and other public transportation routes. And in 1934, Lamarque was a key member of the Bedaux Expedition, the adventure for which he is best known.

1930–32 | Big Bend Highway and the North Thompson

After World War I, as the number of automobiles in British Columbia increased dramatically, the province's highway network began to expand into the Interior. The Cariboo Highway, from Hope to Prince George, was constructed in the mid-1920s. This road largely followed the route of the original gold rush trail from the Fraser Canyon to Quesnel.

In the late 1920s, when Simon Fraser Tolmie became premier, the BC government began to envisage a network of major highways in the Interior. British Columbia and the federal government came to a joint agreement in 1929 to construct a trans-provincial highway that would connect BC with Alberta. The Big Bend Highway, about 265 km long, would go north from Revelstoke, follow the Columbia River around the Big Bend and then head south to Golden. From there it would use the same route as the Canadian Pacific Railway to Kicking Horse Pass on the Alberta border and into Banff National Park. In the 1870s and early 1880s, the CPR had examined the Big Bend as one of its potential routes but decided to construct its line through the Selkirk Mountains because the distance was about 150 km shorter. However, because of avalanches and other difficulties in the Rogers Pass area during the winter, the railroad later had to construct a tunnel under the pass. The Big Bend Highway was designed to stay in the Columbia River valley instead of going through these mountains.

At the northern end of the Big Bend, where the Columbia River left the Rocky Mountain Trench and began flowing south, both the BC and federal governments considered constructing a highway that would continue north through the Rocky Mountain Trench. The road would follow up to the headwaters of the Canoe River near Valemount, proceed to Tête Jaune Cache on the Fraser River, then go east up this river to Yellowhead Pass and on to Jasper.

The provincial government had already started constructing a highway north of Kamloops up the North Thompson River valley and it wanted to continue this

Lamarque described this viewpoint: "Looking into the fastness of the Gold Range from a point on their eastern flanks near the confluence of Birch Creek with the Columbia." 6-12, Whyte Museum of the Canadian Rockies.

route to Valemount. In addition, the government planned to extend the Cariboo Highway east from Prince George to Tête Jaune Cache. On June 5, 1930, the *Prince George Citizen* declared: "The tying in of those three highway segments will mean a great deal to the interior of British Columbia as it will open it up effectually and at the same time afford two of the greatest loops in the province, but it appears to be a development which will require four years to bring about." The newspaper noted that, "The largest of these is the highway around the Big Bend of the Columbia, which incidentally is to connect Revelstoke and Golden on the Canadian Pacific Railway, and when connection has been finished with the north end of the elbow will provide direct automobile communication between the Banff and Jasper national parks."

In June of the following year, the same newspaper carried a front page article with the headline "Tolmie Submits Relief Work for Consideration: has four major highway projects on which he seeks federal co-operation." These included the three projects mentioned in the previous year, along with the

Camp on the Columbia River. 7-1, Whyte Museum of the Canadian Rockies.

Hope–Princeton Highway. The *Prince George Citizen* noted that the Big Bend Highway was a central transprovincial highway involving both the federal and provincial governments.

In 1929, construction of the Big Bend Highway was started northward from Golden by the federal government, and northward from Revelstoke by the provincial government. Lamarque was hired in 1930 by the provincial Department of Public Works to continue locating the route of the highway towards the Big Bend.

> In 1930 I went to locate a section of a new road which it was proposed to build around the Big Bend of the Columbia River from Revelstoke to Golden, a distance of about 165 miles [265 km]. In the 1870s the CPR had surveyed this route from Beavermouth, about 30 miles [48 km] below Golden, before they decided on the shorter and steeper one through the mountains, up the valley of the Beaver River, over Roger's Pass and so down the valley of the Illecillewaet River to the Columbia at Revelstoke... I remember coming across traces of their surveys in the region of the Big Bend.

Looking across the Columbia river near Birch Creek, from the Gold Range towards the Selkirk mountains. 1930.

A page from Lamarque's photo album with two images looking from the Gold Range towards the Selkirk Mountains. 6-14, Whyte Museum of the Canadian Rockies.

In 1930 there was a road, passable for motor vehicles, as far as Cairns Creek, some 30 miles above Revelstoke. From there I boarded a small, motor-driven boat for Downie Creek, some 15 miles [24 km] further upstream and thence by pack train to my destination...

The location party, of which I was to take charge, relieving an engineer who had been recalled to Victoria, had already been in the field for a couple of months. I found them in camp near Eight Mile Creek, a short distance above Goldstream. Goldstream, which comes in from the east, was in the mid-1860s the scene of considerable placer mining activity, particularly on its French and McCulloch tributaries. Then the only old-timer left was Raymond Allen, who had a small cabin and garden in which he raised some strawberries. He spent his winters in Revelstoke. Except for old Raymond, our survey party and another under John Elliott on triangulation work, I do not think that there was a soul in the valley between Downie Creek and the Big Bend.

The valley in which the Columbia flows southerly from the Bend is known as the Selkirk Trench. It is narrow, heavily forested and flanked by high mountains. In winter the snow is deep and in summer the humidity is so high that the vegetation is similar to that of

Lamarque drew these sketches to accompany his two photographs of Gordon Rapid (the official name in 1930). The rapids were submerged in Lake Revelstoke after construction of the Revelstoke Dam. 6-1, Whyte Museum of the Canadian Rockies.

the coast, with large cedars, firs and spruce and a heavy, rank under-brush including ferns and devil clubs to eight feet [2.4 m] in height.

I was busy there from the 11th of July to the 20th of October, carrying the location to Mica Creek, some 12 miles [20 km] below the Big Bend, to which area, with one companion, I made a swift reconnaissance. It is about 12 miles from Mica Creek to the Big Bend where the Canoe and Wood rivers join the Columbia at the historic Boat Encampment of the fur traders... There used to be a ferry across the Columbia at the Bend which, with a telephone line thereto from Revelstoke, was maintained by the Provincial Forestry Department. When I was there, both the ferry and telephone line were no longer in operation.

Towards the end of the field season, Lamarque still had 20 km to the Canoe River at the Big Bend that he had not located. He decided to make a rapid reconnaissance of this portion of the route to check whether there were any significant geographical features like waterways and steep hillsides that needed to be considered in the remaining section. He would use this information in his government report. Lamarque wrote an article about this trip.

At the Big Bend of the Columbia

TAKING NOTHING BUT a good lunch, we left our camp at Mica Creek on the Columbia, following the faint overgrown trail up the side of the mountain. It was slow work forcing our way through underbrush that had invaded and, in many places practically obliterated the trail, so that it must have taken a good hour to reach a low saddle over which it passed. There another trail joined that which we had followed, and though this too had hardly been used for a score of years the going was now easier and generally downward to the north. So, on we went, at times very slowly and at others making good progress. Once, in a swamp, we lost the trail altogether, and it was not until we had circled around for a quarter of an hour that we were able to find it again.

Towards noon, coming close to the river again, where the traveling was good, our progress improved. If we had not happened to glance towards the stream, we might not have noticed the old cabin on the bench below us. I called my companion's attention to the structure and we descended the hill to more closely observe it. There was a faint path leading from the one we were on to the building, but we had not seen it and consequently had to make our way over logs and the debris of the forest to reach our objective.

Close by, we saw that it was by no means a tumbledown affair, but rather a very compact and well-made cabin of logs with an out-porch as large as the cabin itself—not big, perhaps ten feet [3 m] square, but withal well-made and staunch with excellently squared logs and a well-made window frame into which the sash fitted as snugly as might be. There was no lock to the door, merely a latch which we lessened and entered the building. There was little there in, but an air of neatness pervaded the little place within and without. The little table, right under the window, was remarkably well-made. The few cooking utensils were hanging in orderly array on the walls. The well-arranged pile of wood in one corner was covered with mildew, and so was the larger pile on the porch outside. It was obvious, then, as there was no stove to heat the cabin, a poor place in which to spend the night, and yet, had we known it, we were to spend the night there. Just below, at the foot of the steep rocky bank, the Columbia swept mightily to the southwest, and the view, both up and down the river but particularly up, was very fine.

It was nearly noon and we decided to push on, for we hoped to be back at our camp by nightfall, and we had yet some miles to go ere we reached the site of the old ferry across the Columbia. Abandoning the trail, we held along the broad, stony beach of the river, with the magnificent and partly snowy clad range of the Rockies before us, until we reached a point where the river set in from after its junction with the Canoe and Wood rivers. Here we lit a fire and ate part of our lunch, conserving some of it against the possibility that we might not get back to our camp by nightfall. It was, there could be little doubt, a wonderful place to have lunch, for it was at the junction of the Rocky Mountain and Selkirk trenches, at the spot where the Columbia left the former for the latter. From our fireside we looked directly up the great valley through which the Canoe makes it way to the Columbia and which the Columbia follows from its source to this point. To the northeast we could see the wide gulch in the hills through which the Wood River enters the Trench while beyond were the great ramparts of the Rockies, many of the more magnificent peaks wreathed in mists.

Reluctantly leaving our splendid lunch place we plunged again into the forest, coming happily on to the trail but a few feet distant from the river. This we followed along the lower flank of a hill for over an hour, and then turning off the main path, followed a still fainter one to the old ferry crossing. We could not delay for the afternoon was passing and we were many miles from our camp. The weather was grey and threatening and both the Rockies and Selkirk ranges were partly obscured by mists which suggested snow flurries. The air was cold and the few leaves that were left shook forlornly in the light northerly breeze.

As we turned to retrace our steps along the overgrown trail it soon became obvious that we could not reach our camp by nightfall, and as it would be quite out of the question to try and follow the trail in the dark, we should have to camp in the best place we could find when night fell. There used to be a telephone line to the ferry, and this, hung on trees, had long been in disuse, and we paused where a moose had been caught and strangled in this old line which now lay for long distances on the ground. The moose had evidently made a great fight to free himself, for the bush was now all scarred and bruised nearby but the old wire was round both horns and his windpipe, and it was only the skeleton head of the animal, partly suspended and partly on the ground, that was visible to tell the tale.

Leaving this cheerless spectacle, we trudged along in silence. No sound whatever broke the stillness of the woods, except, maybe, the crack of a twig on which we trod. The breeze which we had felt near the river was not apparent in the deep woods, and the serried ranks of the conifers were motionless in the gathering gloom of the night. Then, suddenly, the telephone wire tightened and jerked beside us. There was evidently something, some big animal caught in the wire. Proceeding cautiously, with the wire still taut and jerking alongside, we peered ahead to see what was entangled. As suddenly the wire lay limp and still once more, and we soon came to where a moose had been caught, the torn ground and the kinked wire being sufficient evidence of the frantic struggles to escape. We were glad that he had done so, ere we came up. We could at best have helped him to do so by cutting the wire with our axes, and it was better for him to have freed himself than dragging some of it with him, or free, he might have attacked and treed us.

We were now not far from the old cabin we had observed in the morning, so we pushed on, built a fireplace of rocks in the porch, cut piles of spruce, hemlock and balsam boughs for our beds and passed a comfortable, though blanketless night, with half of our meagre rations conserved for the morning's meal. It was a wonderful night. The river murmured below us and the wind, carrying with it the tang of the forest and wilderness, added its light tones to the deeper ones of the stream, while the hunter's moon sailed serenely in the misty sky.

Lamarque described his return to Revelstoke at the end of the field season.

> Our party had been supplied by pack train from Downie Creek to the Beaver Dam, which is above the 12 Mile rapids, and thence by boat. There were two boatmen, the owner of the boat being Bob Blackmore, who had worked on the river for 40 years. He was then 63 years of age, strong and skilful, whose capabilities were indicated by the fact that he had survived 40 seasons' work on this dangerous river...
>
> As his boat was not large enough to transport the whole outfit at the end of the season, we built a strong raft to take us as far as the Beaver Dam. From there I accompanied the boatmen to Downie Creek, making a portage at Death Rapids but negotiating without trouble the 12 Mile and Priest rapids. We cut the raft loose above the 12 Mile and, unguided, it successfully made its way down the two upper rapids, but got hung up on a rock between the Death and the Priest, off which we managed to pry it, and it was finally taken down to and broken up at Revelstoke.

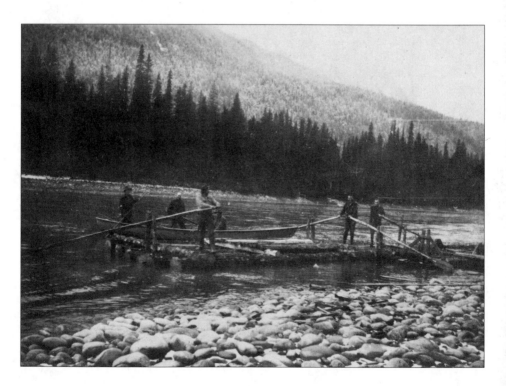

The raft constructed at Maloney Creek that was used for travelling down the Columbia River at the end of the field season. 6-5, Whyte Museum of the Canadan Rockies.

After the 1930 field season, Lamarque wrote a newspaper article about the Big Bend area for the *Vancouver Province*. He described the history and geography of the region and commented on the rationale for the Big Bend Highway. "It was felt that it should be possible to cross British Columbia into Alberta without having to make a detour into the United States... At Revelstoke the motorist came to a full stop, and so, about two years ago, active and enthusiastic construction of a road around the Bend commenced, the federal government undertaking the easterly portion from Golden to Canoe River and the provincial government the section from Revelstoke north. Already the location is largely determined, the road is practically constructed from Golden to Bush River on the east, and from Revelstoke to Downie Creek on the west." This was about 40 per cent of the road.

In 1931, the Public Works Department hired Lamarque to locate the North Thompson Highway southward from Valemount, the last major section of this highway to be completed. One of the men that Lamarque hired that summer was Bill Blackman from Valemount. Blackman worked with Lamarque again in 1932 and 1934.

The following year, 1931, I went to the small settlement of Valemount on the main transcontinental line of the Canadian National Railway, to locate a highway southerly therefrom towards Blue River. Valemount is situated in the Rocky Mountain Trench near the head of the Canoe River and is close to a divide or pass in the Trench between waters flowing to the Columbia via the Canoe and those to the Fraser via the McLennan River. This is quite a different type of country to that of the Selkirk Trench where I had been the previous summer. The valley is a couple of miles or so in width and in general, forested with jack or lodgepole pines...

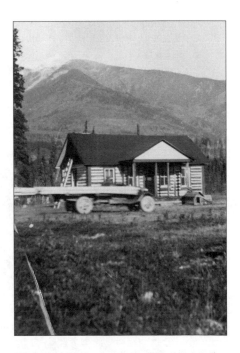

Settler's cabin by the north side of Cranberry Lake swamp 3 km south of Valemount. 6-24, Whyte Museum of the Canadian Rockies.

Near Canoe River. Structures for the CN Railway can be seen in the background. 5-18, Whyte Museum of the Canadian Rockies.

There was but one store and a handful of settlers at Valemount, many of them old-timers who had been there since construction days on the railway, some 20 years before... From Valemount southward to the Albreda summit, some 17 miles [27 km] away, from which the waters of Camp Creek flow to the Canoe River and those of the Albreda Creek southward to the North Thompson, there were then but half a dozen settlers, men who eked out a living by trapping and hunting...

Lamarque took this photograph of the Canadian National train station at Albreda in November, 1931. 5-12, Whyte Museum of the Canadian Rockies.

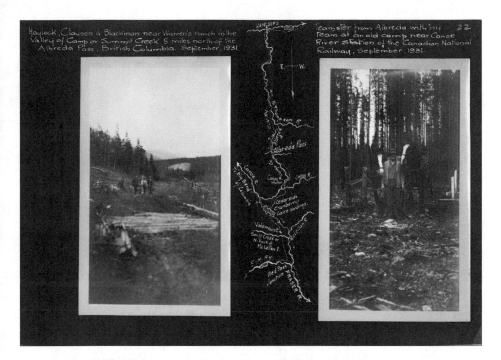

Scenes from Lamarque's highway location near Valemount. On the left are members of La-marque's crew about 8 km north of Albreda Pass. On the right is a teamster from Albreda near the Canoe River station of the Canadian National Railway. In Lamarque's map north is at the bottom of the page. 6-22, Whyte Museum of the Canadian Rockies.

The following spring I went again into the Valemount area, on a prospecting trip down the Canoe River with three of the boys of the Blackman family of Valemount, one of whom had been on my party of the previous summer. It was in March and on snowshoes, we packed our supplies for some distance down the valley of the Canoe to a tributary which was said to contain placer gold. We had no luck.

During the 1930s, the Depression limited the amount that the federal and provincial governments spent on these highway projects. But they did proceed, for highway construction provided relief work for many unemployed people. The Big Bend Highway was officially opened in 1940. It was never paved, nor maintained in the winter, and the northern connection to Valemount and Jasper was not constructed. In 1962, the Trans-Canada (Highway 1) was completed across the Selkirk Mountains, largely following the original CPR route through the mountain range. Today a large portion of the Columbia River in the Big Bend region has been flooded by the Revelstoke and Mica dams.

Lamarque's survey crew in the Canoe River valley in the Rocky Mountain Trench in 1931. Bill Blackman is second from the left. 6-28, Whyte Museum of the Canadian Rockies.

The North Thompson Highway was completed to Valemount and Tête Jaune Cache and is part of Highway 5. The route from Prince George to Tête Jaune Cache was also constructed and has become part of Highway 16, the Yellowhead Highway, which runs from the Alberta border to Prince Rupert.

1933 | CUNNINGHAM CREEK

In the 1860s, there was a large gold rush to Barkerville, an important event in British Columbia's history. Gold was also discovered in other nearby areas. About 25 km southeast of Barkerville, William Cunningham, an American miner, found a significant amount of placer gold on the creek that is today named for him. Gold mining from quartz veins started on a tributary of Cunningham Creek in 1922. In the early 1930s, there was a second large gold rush in the Barkerville area. Several mineral claims were staked along Cunningham Creek and in 1933 Lamarque surveyed them.

In two letters to the Surveyor General's office in 1961, he outlined his work. "I made a stadia traverse of Cunningham Creek from a point about a mile and a half [2.4 km] from the confluence thereof with the Swamp River [today called the Cariboo River] for some four miles [6.4 km] upstream to just above the falls."

Lamarque noted: "It was not possible to make any land ties for at that time they did not exist in that area, as far as I am aware. The survey was undertaken merely to determine the approximate location of a number of wildcat

mineral claims which had been staked in winter during a mining boom in that area, and, as far as I know they were—probably wisely—allowed to lapse... These falls, therefore are the main topographic 'tie' on this plan and the position of several small tributaries is helpful. I may say that the survey seems to have been made with considerable care; all angles were doubled and stadia measurements checked on the long traverse."

In his memoir, Lamarque outlines the work that he did. He also kept a diary which he later transcribed, adding several small sketches. The diary provides more detail about his surveying at Cunningham Creek. The memoir is presented first, followed by more specific information utilizing Lamarque's diary.

> In 1933 I went into the Cariboo country to locate the position of some mining claims which had been staked on the lower reaches of Cunningham Creek, the waters of which finally find their way to the Fraser by way of Swamp River, Cariboo Lake and the Quesnel River. The headwaters of this creek interlock with those of Antler Creek, some 15 miles [24 km] to the

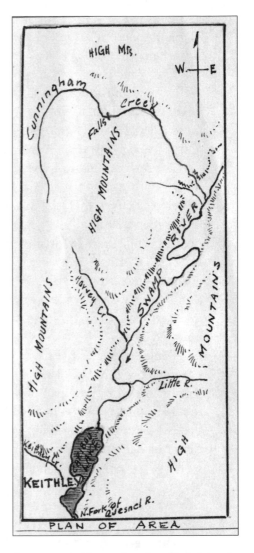

Lamarque made a series of small sketches to accompany the transcription of his 1933 diary. This is the sketch map that he made of the area where he surveyed. 22-2, Whyte Museum of the Canadian Rockies.

southeast of the old mining town of Barkerville, the region of the Cariboo gold rush of the 1860s and the rich gold placers on Lightning, Williams, Antler and other creeks... Some 45 million dollars of gold is said to have been recovered from these placers, but from the quartz veins and ledges in the nearby hills... little of economic value was

found until, in the early 1930s, good values having been discovered by the Cariboo Gold Quartz mine, there was a rush to stake claims almost anywhere and everywhere in that general area...

I left Vancouver early in June and did not return until the middle of August. The route was by steamer to Squamish at the head of Howe Sound, thence by train to Williams Lake, then a very small place indeed; thence by motor car to Keithley Creek on Cariboo Lake, and so by boat or trail to Cunningham Creek.

The road to Keithley passes through the hamlet of Likely where the south branch of the Quesnel River leaves Quesnel Lake. I located some claims in that locality and, while doing so, pitched my tent where the road forks, one going to Keithley and the other to Cedar Creek... While there I visited the Bullion Mine, at the site of Dancing Bill's Gulch, from which a great deal of gold had, and was being taken. The Gulch had been so enlarged with the aid of powerful hydraulic monitors that then there was an excavation at least a quarter of a mile [400 m] in length, some 200 feet [60 m] in depth and several hundred feet wide...

While waiting at Keithley for supplies and further information, I made a rapid overland trip to Cunningham Creek and, returning by raft, which my companion and I made where the creek enters the Swamp River, we were beset by so high a wind on Cariboo Lake that, with one broken paddle, we should have had difficulty in making shore had not a settler come out to us in his boat. Early in July, with two assistants, I went again to Cunningham Creek in a motor boat to define the location of 60 claims staked along the creek. The man who took us there left a small skiff for our return journey. We were there nearly a month and at first were hampered by high water. The creek, from 30 to 50 feet [9 to 15 m] in width, is turbulent and swift, flowing between steep, heavily wooded banks. We had, in the course of our survey, to cross it many times, whether on trees which we felled therefor, or by fording. Once, by the latter method, I stepped into a hole, and had not one of my men sprung onto a nearby rock and handed me a pole I should have had difficulty in escaping a complete ducking [Lamarque's word]... We frequently came on to old working where the placer miners of 70 to 80 years before had moved boulders, dug trenches, and in general searched for the gold they had come for. On the whole we were favoured by the weather. This was fortunate, because during the latter part of the work we bivouacked

On Cariboo Lake. 22-1, Whyte Museum of the Canadian Rockies.

where we were when the day's work was finished, carrying our rations and blankets with us...

By the middle of August, having completed our surveys, we headed down the Swamp River in the boat which had been left for us, seeing several moose and many wildfowl before we reached Cariboo Lake.

Lamarque's diary began on July 18.

Thunder showers and hail, that seemed to threaten a prolongation of the unsettled weather of the past month, ceased as the summer's afternoon wore on, the sky cleared and a wind, blowing softly out of the southwest, rustled the leaves of the many magnificent cottonwood trees in the vicinity of our camp by the motor road near the lower end of Cariboo Lake. As darkness fell, our belated supplies arrived on a truck, and at the same time the younger of my two assistants, Jimmy, came in a Peterborough canoe from the head of the lake, reporting that he had seen a cow moose crossing the lake near the Narrows to our side of the water. With all supplies on hand, our boatman's motor in good order and the weather fair, there should be nothing to delay our early start tomorrow.

The next morning Lamarque and his crew awoke at four and "by six, with our small rowboat lying across our craft, we started from the Landing. A's well-shaped boat with its 3 horse power outboard motor took us across the lake towards the Narrows at about seven miles [11 km] an hour." By 2:30 in the afternoon "we tied our craft up to the bank at the Cunningham Creek Landing where the old, forest-gird and abandoned road that a mining company had constructed comes down to the river." After a meal the boatman left, the crew stored its rowboat on the bank, and "we then commenced packing our supplies to the head of the road on Cunningham Creek a mile and a half [2.4 km] distant, where we pitched our camp. We had all the stuff over in three trips each... Before dusk we had a really comfortable camp made on an attractive site on a raised, open bar a few feet above the rushing torrent of the creek."

On July 20, Lamarque began the survey with one of the assistants while the other set up camp and started cooking.

> The traverse of the creek, up which the location lines of sixty claims had been staked, presented, it was quite obvious, no light task, for the stream pursued a torrential course through a deep heavily wooded V-shaped valley with, in places, rocky precipitous bluffs descending to its edge against which the water roared and foamed in indescribable confusion... The creek, at the stage of water at which we found it was, on an average, about four or five feet deep [1.2 to 1.5 m], and as it is a continuous rapid, wading, should we want to cross it, was out of the question. Rather remarkably, too, there are very few places where, despite the heavily wooded nature of the valley and country generally, it is possible to find trees suitably located for bridging purposes below the falls, some ten miles [16 km] from its mouth.

There were some claims that were not along the creek, so Lamarque decided to survey these first while waiting for the water level on Cunningham Creek to drop and make it easier to work up the stream. This occupied Lamarque and his assistant for the next three days. There was a large amount of underbrush, including devil's club and stinging nettle, which made the work difficult.

Lamarque began surveying up Cunningham Creek on July 25 and the next day moved camp to a location upstream from their work. On July 27, Lamarque and his assistant "brought the survey right up to the camp and then explored and cut line ahead for about a mile [1.6 km]." At the upper end of their line they reached an area that had been burned and had "comparatively little timber near it and we were able to make considerably faster progress. We crossed two very small creeks and saw two places where placer mining operations had once been

carried on." It rained that night and at times during the day but Lamarque continued surveying to the end of the line that they had cleared. There was rain most of the following day so the men stayed in camp and Lamarque worked on his survey calculations. In the late afternoon the men took some supplies upstream and cached them in preparation for moving camp the next day. At the site was a large cottonwood tree that Lamarque hoped they could use for a bridge across Cunningham Creek.

Second Siwash camp on Cunningham Creek. 22-3, Whyte Museum of the Canadian Rockies.

On July 30, "we left camp at eight o'clock with everything on our backs— quite heavy enough—and with good walking sticks to help us over the rough and slippery way, started out for our cottonwood tree and proposed bridge for it was evident that the other side of the stream would afford much better going than the side we were on above the point to which we had taken our survey." Lamarque continued surveying up the creek for about 800 m to a location where he wanted to take the survey to the opposite bank. "Returning to our cottonwood, we completed the felling of the tree, had lunch, crossed the stream on our excellent bridge and got everything up to the point to which we had carried the survey. There, by the remains of an old log cabin, the logs of which have long since fallen in and are fast decaying, we put up my canvas bed cover again for a shelter under the thick branches of a bushy spruce and made ourselves comfortable for the night."

There was frost on the ground when the men awoke on the last day of the month. "J. and I explored and established survey points ahead all day with B. looking for the posts or stakes set by the locators of the mining claims and cutting out an old trail which leads up the valley from the tumble-down cabin. The old trail is very dim and quite hard to follow, but even so, it was a remarkable help to us, and we reached a point fully a mile further upstream." Lamarque noted that the water level in the creek was falling and "each day conditions were becoming more favourable for our work." About 800 m further up the creek, Lamarque

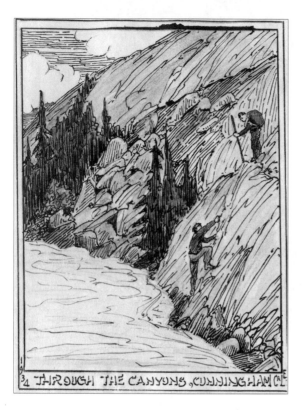

Through the canyons, Cunningham Creek. 22-4, Whyte Museum of the Canadian Rockies.

found "a little windowless log cabin belonging to a French Canadian who uses it for a shelter when prospecting or trapping in the locality."

On the first day of August, "J. and I carried our instrument survey to above the French Canadian's cabin. B looked for posts, and bridging the creek with a large spruce found, after a search of two hours, the posts or stakes he was looking for lying at the base of a hemlock tree across the stream." The following day Lamarque and one assistant continued the survey up the creek while the other went back to the main camp to bring up some supplies the men had left there. On the morning of August 3, the crew moved camp 2.4 km up the creek valley "to a point where the French Canadian and others had whipsawed some timber a year or so ago. This place was a very suitable one for a camp. There was a rough table at hand, plenty of firewood, and very fortunately, a rough oven built into the side of the hill for baking bread or roasting meat."

About 800 m above this camp the old trail left the Cunningham at the confluence of a large creek. "Above this point we had to carry on as we had done below the old cabin site, hacking our way through a country which, had we known it, became rougher as we ascended." Lamarque wrote that "we should have to move forward our supplies with us day by day." The next evening, after talking with his crew, Lamarque decided that since "long trailless walks were out of the question, to siwash it, e.g. take a minimum of food and bedding along and bivouac at night where we stop work."

On August 5, "we carried the survey to near the foot of the canyon. B. looked for posts and returned ahead of us to camp. J. and I studied the lower end of the

canyon on the southerly side, to which we had crossed by another spruce tree that B. had felled. There the length of the precipitous fall sheer to the stream was considerably less than on the northerly side and it was evident that it was only on the southerly side that we could hope to pass through the canyon at the foot of the bluffs."

The men spent the next morning "cooking and getting supplies and equipment ready for four or five days siwashing ahead. B. made bannocks in the very useful oven we found here."

Lamarque described its construction.

> To make the oven they excavated in the bank and put a large piece of flat slate from the nearby rocks across the excavation about two feet [60 cm] from the bottom thereof. This slate, and another piece about a foot [30 cm] above it, extended to within a foot of the back of the excavation. The fire is lit on the ground below the lower piece of slate and the smoke goes up the aperture left at the back. The oven is formed between the two pieces of slate, a piece of flat slate being used for a door in front, resting on the lower piece and leaning against the outside edge of the upper piece which does not come out quite as far as the lower...

The crew left at noon.

> It took us about two hours to get to the canyon and nearly two more to explore and find the way through. One large piece of driftwood, with which we attempted to bridge the stream, was swept away like a chip in the furious water, but we managed to tow another large piece up and anchor it alongside a bluff which fell sheer into the creek, and thus pass up to a log, a driftstick which bridged the canyon at its head, on which we crossed back to the north side of the stream which was still the easier side to negotiate. Leaving B to look out for a good place to camp and do some clearing ahead, J. and I returned below the canyon and brought the survey up to a point above it just as the light was beginning to fail.

After rain for much of the night, the men got up at four o'clock, started a fire, and had breakfast. The weather cleared during the day and the crew continued surveying upstream, having to cross the creek twice. Fortunately they found a good campsite and the evening was fine so the men could dry their clothes and get warm.

Lamarque had a lengthy diary entry for August 8.

> A beautiful day. We had to wade the creek twice soon after starting and had, generally a difficult country to negotiate until noon, when we enjoyed a meal in a beautiful spot by the side of a sparkling brook with a fine waterfall just above. Then all afternoon we worked our way up the side of a canyon where, fortunately, there was a narrow footing at the base of the cliffs alongside the stream. Towards dusk, however, we were confronted with the necessity of either wading the creek in an obviously dangerous locality or of descending a steep bluff to the water and wading at the foot thereof. [The men found the latter choice to be better.]
>
> By the side of a great, leaning spruce we made an excellent camp, quite cheered by the appearance of the country immediately ahead which seemed to be opening out and to be less rugged. We soon dried out in front of our cheerful fire, and reclining at our ease on a thick bed of spruce boughs, the vicissitudes of the day were speedily forgotten. The weather was really beautiful, providentially beautiful, one might say, and the serenity of that night is not to be easily forgotten. Soon after the darkness had fallen a great horned owl appeared suddenly above the tree tops across the creek... He lit on the top of a spruce on the skyline above the opposite hill and sat there for many minutes, looking very large in the soft light of the moon... It was a cold night and none of us slept comfortably with our minimum of bedding, so we put on a fire early and were away.

That day they had difficulty locating some of the posts for the mineral claims. The men were able to find the trees used for cutting them as well as a recent slide nearby, so they assumed the posts had slid into the creek. Near this spot a large rock dislodged from the hillside above, rolled down and struck the leg of Lamarque's tripod. Fortunately, he was able to hang onto the instrument and keep it from being knocked into the creek below. From camp that evening Lamarque "cut a trail ahead through the willow thickets lining the stream, finding that the thirty foot [9 m] falls of the Cunningham were just around the next bend."

On August 10, "we carried our line to its completion and reached the upper end of our survey about an hour after noon." The men then started their return trip, getting back to the camp with the slate oven that evening. After some survey work around the camp the next morning the men reached their camp at the head of the road near the Cariboo River. "It was good to be back and to know

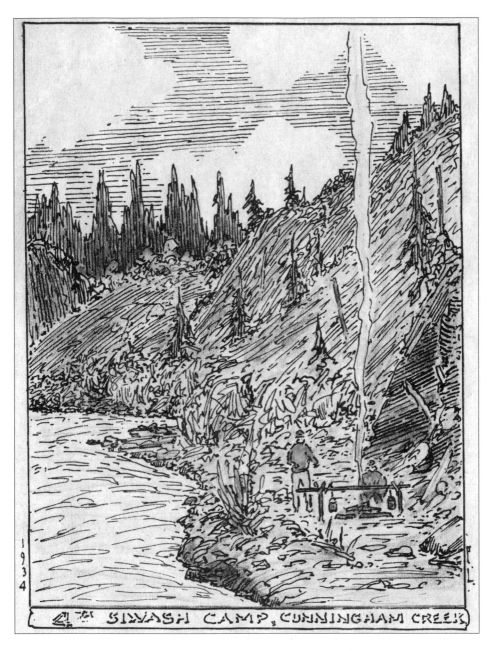

Fourth siwash camp, Cunningham Creek. 22-5, Whyte Museum of the Canadian Rockies.

that, except for a day's work in the locality, the task which we had set out to do was accomplished." On August 13, the men packed back to the Cariboo River, where they used their rowboat to go downstream to the lake. "We had a head wind on the lake and a hard row of it for over two hours ere we put ashore near the Keithley Post Office above the Narrows. There we got our mail—the accumulated mail of a month."

The following day Lamarque and his crew got a truck ride to Williams Lake and from there returned to Vancouver via the PGE railway to Squamish and a boat trip along Howe Sound. The claims that Lamarque surveyed did not develop further at that time but mining activity still exists in the Cunningham Creek drainage. With forestry road access from Barkerville, the area is not nearly as remote as when Lamarque surveyed there more than eighty years ago.

1934 | BEDAUX EXPEDITION

The Bedaux Expedition was one of the most unusual events in the history of northern British Columbia. In 1934, Charles Bedaux, a wealthy French entrepreneur whose head office was in New York City, attempted to drive five half-track Citroen vehicles across northern British Columbia. Bedaux spent over $250,000 on this expedition in the middle of the Depression and his extravagance led the event to be nicknamed "The Champagne Safari." Bedaux's personal entourage included his wife, Fern; their maid, Josephine Daly; a companion, Madame Chiesa; and a gamekeeper, John Chisholm.

Four years previously, Bedaux made the first automobile trip across Africa, and in 1931 he led an automobile expedition across part of central Asia. When reporters asked Bedaux why he wanted to undertake this expedition, he replied: "It's fun to do things others call impossible. Everyone says to take a fleet of automobiles through the unmapped Rockies can't be done. I say it can. The Government hasn't much faith in me. But I've done the impossible before."

Bedaux had been to northern BC before. In 1926, he came for a guided hunting trip with his wife, son and a group of friends to the Cassiar Ranch north of Fort St. James. The party spent six weeks hunting, travelling north to the Thutade Lake area near the headwaters of the Finlay River.

Bedaux, his wife Fern and a group of friends went on another hunting trip in 1932, this time to the Peace River area northwest of Hudson's Hope. The party initially went to Edmonton where they met and hired Jack Bocock to organize their trip. Bocock, who had a university degree in geology, was one of the geologists on the BC government's 1929 and 1930 PGE Resources Survey in the Peace River region. Earlier that summer, he had worked on a mining venture on

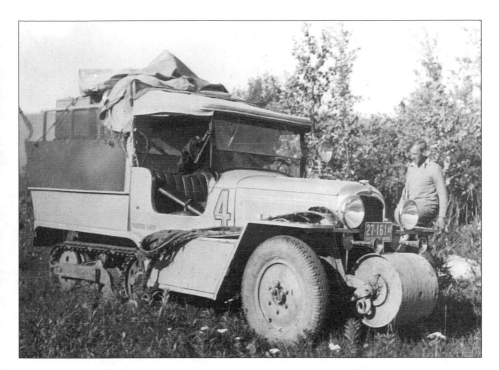

Al Phipps, the assistant to Frank Swannell, the geographer for the expedition, stands beside one of the five Citroens that Bedaux attempted to drive across northern British Columbia. Courtesy Bob White family collection.

the upper Peace River. The party travelled to Hudson's Hope where they hired Bob Beattie, a local packer and guide, who took them on a six-week trip to the Rocky Mountains. Bocock accompanied the group.

In 1933, Bedaux, who had a great interest in mining ventures, invested some money in a small mining company near Hudson's Hope in which Jack Bocock was a partner. He also began preparations for a motorized trip across northern British Columbia and in September purchased five half-track vehicles from French manufacturer Andre Citroen. These vehicles had wheels on the front and a caterpillar track on the back and were similar to the machines Bedaux had used for his trips across Africa and Asia.

In the fall of 1933, Bedaux hired Bocock to organize his 1934 expedition to northern BC. Bedaux came to Edmonton intending to take a duck-hunting trip to central Alberta in November. However, he became ill and remained in Edmonton for the rest of his stay. He used the time to begin planning the 1934 trip with Bocock, who had a large amount of food and equipment to gather and men to hire during the next six months.

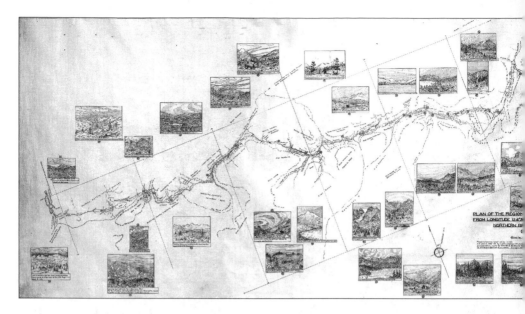

Lamarque produced this large map of the terrain and route that he followed through the Rocky Mountains to Dease Lake. It is about 3 m long and contains over 50 small sketches that illustrate the landscape that Lamarque traversed. A copy of this map hangs at the Whyte Museum. M8-Bedaux map, Whyte Museum of the Canadian Rockies.

To make his expedition more credible and gain the support of the provincial and federal governments, Bedaux decided to employ some scientists. Jack Bocock was the geologist, and his brother, Bruce, was the mineralogist as well as supplies handler. Art Paul was from the Soils Department of the University of Alberta, while Earl Cushing, who worked for Jack Bocock in 1933, had a mining engineering background. Bocock also had to hire two surveyors. One was to accompany the main part of the expedition and be the geographer and map maker for the route that Bedaux's vehicles followed. The second surveyor would have the crucial role of locating a suitable route for the Citroens to navigate across northern British Columbia.

F.C. Green, the Surveyor General of British Columbia, wanted Frank Swannell to be selected as the geographer. Swannell was one of the province's foremost surveyors and cartographers and he had spent three summers surveying in the Peace River region. Jack Bocock thought that Bedaux should accede to Green's request to help gain the provincial government's support for the expedition. Green had no preference for the surveyor hired to locate the route.

In late January 1934, Bocock went to Vancouver and Victoria to interview some surveyors, including Swannell, for the two positions. In Vancouver,

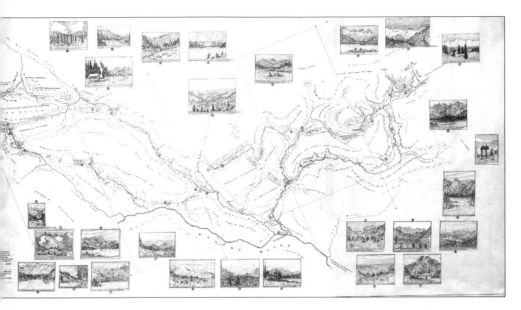

Bocock met Major C.R. Crysdale who had been in charge of the surveying part of the PGE Resources Survey. At that time Lamarque was sharing office space with Crysdale, so Bocock had an opportunity to interview a surveyor who was not among the people he originally considered. The two men quickly established a rapport, and Bocock thought that Lamarque would be the right person for locating the route for the expedition. On January 28, after a long meeting with Lamarque, Bocock wrote to Bedaux:

> I spent most of the afternoon in Mr. Crysdale's office with Mr. Lamarque. Lamarque is an Englishman, a gentleman, about 55 years of age, about 5'9" tall, spare in build. He is not an aggressive type, but gives the impression of being able to take care of himself. Although a BCLS, DLS, nearly all of his experience has been on private work. He is something of a lone wolf. Consequently he is almost unknown to the Department of Lands. He has worked as an engineer and a surveyor in Alberta, Northwest Territories and central and southern BC since 1898. He has a very pleasant manner, wears very shabby clothes, sketches beautifully, writes the best of English and is a good draughtsman. How good a surveyor he is I do not know at first hand, but Mr. Crysdale says he is thoroughly competent.

After visiting Swannell in Victoria, Bocock met Lamarque again when he returned to Vancouver. On February 3, Bocock wrote to Bedaux: "I again saw Mr. Lamarque who lent me some of his sketches and the diary of a trip into the

Cariboo country so that I might send them to you as a sample of the sort of work he is used to. Would you mind sending these back as I have promised that he shall have them returned?"

Following his trip to British Columbia, Bocock decided that he wanted to hire Swannell to be the expedition's geographer and Lamarque to locate the route. Bedaux offered the positions to these two men. In a letter to Bedaux on February 10, Bocock wrote: "I hope very sincerely that Mr. Lamarque will accept your offer. I am sure that if he can afford to do so, he will. If he does join the expedition I am sure that you will be delighted by his quiet and unobtrusive manner and, what is so seldom found in real bushmen, his air of good education and general good breeding." Bedaux told Bocock: "If we have a man of the type of Lamarque to make the trail from the Prophet River to Sifton Pass by way of the Muskwa and Kwadacha Rivers, we can trust him to do the best he can without your having to go and check him on the spot." Both Swannell and Lamarque accepted Bedaux's offer of employment. Surveying work was hard to find in the middle of the Depression and the opportunity for a new adventure appealed to both men. Initially Bedaux hired Lamarque to begin on May 15, but Bocock persuaded him to make the starting date earlier. "I suggest that Lamarque leave [Fort] St. John May 1 instead of 15. This would allow him to take advantage of the good May weather and get up to the Muskwa before the June rains bring down the summer floods. Also it will give him more time for this, by no means light, task. I still think that the crossing of the Rockies will be the critical point for the expedition."

In late February, Lamarque and Bocock began discussing the specifics of locating the route through the Rocky Mountains. Bedaux wanted to follow a new pathway instead of the well-known trail over Laurier Pass. Bocock wrote that the Muskwa Pass appeared to be the only possibility farther north. On March 7, Lamarque wrote to Bocock. "From the scant information available it seems probable that the crossing of the main Rockies will be, as you suggest, the main problem. From the very sketchy map of this particular area it would seem that this route may afford the only pass of this locality."

Lamarque wanted to select some of the men for his crew, particularly his packer and guide. He had employed Bill Blackman in 1931 and gone prospecting with him in 1932. In the same letter Lamarque made his request.

> I have an excellent man in view who lives at Valemount. He has been out frequently with hunting parties in the mountains around Tête Jaune and he is able, energetic and thoroughly resourceful. He can turn his hand to anything, is about 30 years of age and a big, powerful fellow... One of my crew, at least, should be a capable camp cook...

Bill, my Valemount man, is of course good, but he would, very likely, take charge of the horses and the progress of the party will be facilitated or retarded by the abundance or otherwise of pasture.

Bocock approved this request and, on March 21, Lamarque replied: "W. Blackman is quite willing to come and will be a distinct asset. He is full of resource and thoroughly capable. One or more of his brothers might come. They are quite reliable." Bill's brother, Henry, was hired to be the cook for Lamarque's party. Earl Cushing and Art Paul were placed on his crew, while Edgar Dopp and Bill Pickell were selected to be Lamarque's guides for the trip from Fort St. John to the Prophet River where his location work would begin. (Later a third Blackman brother, Charlie, was hired as one of the cowboys for the main part of the expedition.)

Bedaux hoped that Lamarque would make a set of sketches of the expedition that could later be published in a book. To assist him he purchased and sent a complete set of artist's materials to Lamarque.

In early April, Bedaux issued a public release to the newspapers announcing the expedition. He stated that its purpose was to "penetrate the vast area between the Canadian Rockies and the Cassiar and Stikine Mountains, just south of the Yukon, which has never been explored and to record valuable geographical, geological and meteorological data concerning this area."

The expedition was divided into four groups. The trail cutting crew, initially under the supervision of a local cowboy, Tommy Wilde, started in late April. There was an existing wagon road into the Halfway River valley and a trail to the Prophet River, but it would need some improvements for the Citroens to drive on this portion of the route. Lamarque's route location crew would start on May 1. They would proceed to the Prophet River and from there Lamarque was to find the best route across the Rocky Mountains. Then he would head to Sifton Pass in the northern Rocky Mountain Trench, find a route through the Cassiar Mountains to Dease Lake and follow a road to Telegraph Creek where the Bedaux Expedition planned to finish by October. The third group was an advance party of cowboys and packhorses that would carry additional provisions for the main group of people and fuel for the vehicles. The fourth and main group would include Bedaux and his party in the five Citroens along with cowboys and packhorses to carry items that would not fit into the vehicles.

The Bedaux Expedition has received a large amount of coverage. Several participants, mostly those in the main party, kept diaries that are housed in many different public archives. Some expedition members later wrote reminiscences

about the adventure. *The Price of Power* by Jim Christy and *Bannock and Beans* by Bob White are books devoted entirely to this event, while *Return to Northern British Columbia* has a lengthy chapter about Frank Swannell's involvement. *Champagne Safari* is a film about the expedition. Articles include "People and Places of the Bedaux Expedition of 1934" by Ross Peck, published in the Fall 2011 edition of the *British Columbia History* magazine. There were many newspaper articles published in 1934 and early 1935.

Lamarque kept a diary. In addition, he wrote a detailed, unpublished account of his involvement in the expedition. Although undated, it appears to have been written not long after the event. He also summarized his adventures on the expedition in his memoir. Of the four groups on the Bedaux Expedition, the work of Lamarque and his crew is the least known. His writings are the best record of this important aspect of the expedition. In this chapter, Lamarque's diary entries are used as much as possible and are supplemented by his account, which sometimes provides further details and explanation.

Lamarque and his crew assembled in Edmonton and departed by train to Dawson Creek on April 22, accompanied by Jack Bocock. Bocock wrote to Bedaux about Lamarque's crew: "They are very fine looking men, giants physically and cheerful quiet mountain men. I am very happy about the personnel of Lamarque's party." From Dawson Creek the men went by car to Taylor, where they had to wait for two days to cross the Peace River because of ice. They reached Fort St. John on the twenty-seventh and spent the last three days of the month making final preparations. Lamarque had the opportunity to visit Frank Beaton, the Hudson's Bay Company post manager who had been there in 1904 and 1905 when Lamarque was factor at Hudson's Hope.

On the last day of April, Lamarque and his crew, along with seventeen pack animals, departed from Fort St. John at 3 p.m. A large number of the people in the village turned out to watch them leave.

The initial part of their route was through an area of scattered settlements with dirt roads. During the first day they travelled north to Charlie Lake, a location on the present day Alaska Highway near the junction with Highway 29 that goes west to Hudson's Hope.

As with most expeditions there were some unexpected adventures at the beginning. In his diary for May 1, Lamarque noted: "[Art] Paul chases a pack pony for 3 miles [4.8 km] to high bank above Peace valley. Cushing drops .22 rifle in mud hole of trail and finds it after 2 hours search." From Charlie Lake the expedition headed west towards the north side of the Peace River valley, largely following present day Highway 29. After six hours they reached the Freer ranch at Cache Creek near its junction with the Peace. Lamarque commented on the

"beautiful view over and up valley of Peace from hill up above Freer's place. Leaves fast developing and country beginning to look green."

The next morning started with transporting their supplies across Cache Creek in a canoe: "the water just too deep for packing the horses." About three hours of travelling brought the expedition to a plateau above the confluence of the Halfway River with the Peace. The Halfway, which starts in the Rocky Mountains, is one of the major tributaries of the upper Peace River valley. The expedition camped here while some of the men took the horses to feed at the Tompkins ranch on the flats below.

On May 3, the expedition headed towards the Halfway River valley. Following a good trail for about 25 km, the men stopped for the night at Billy Hill's ranch on the plateau between Cache Creek and the Halfway. The next morning, about an hour after leaving the Hill ranch, the expedition crossed the Cameron River about 400 m above its confluence with the Halfway. Later they travelled through the Halfway Reserve and by mid-afternoon stopped to camp at a flat along the river.

On the morning of May 7, it was -5 °C and the day started with fording the Halfway River. In his account, Lamarque wrote: "After examining the ford with Edgar Dopp we successfully passed the whole outfit across the river. It was a long diagonal crossing, advantage being taken of a gravel bar, only partly submerged, in mid-stream. The animals were tied together, head to tail ('tailed up' as they say), each horseman leading two or three upstream so that there was no difficulty in keeping them in the shallow water." Lamarque noted that the river was fast but the bottom was good and at the deepest the water came up to the horses' bellies. That day they travelled for about 20 km and, about forty-five minutes past the Simpson Ranch, camped at a flat near Horseshoe Creek.

On May 8, they forded the Halfway River once more, just below the mouth of a large stream coming in from the west. Shortly before the ford they met a man riding to Fort St. John. He was part of a group of American prospectors who had been on their way to Alaska in late summer 1933 when their plane made a crash landing at Mosquito Flats and was damaged. The men built a cabin and a hangar for their plane and spent the winter there. In the spring they obtained the necessary parts and repaired the plane, and the other crew members had flown out that morning. Lamarque had seen their plane flying south. The *Prince George Citizen* wrote on April 19: "The plane carrying a company of prospectors which was forced down last summer on the upper Halfway River in northern BC and so badly damaged that it had to be abandoned for the winter has been put in repair."

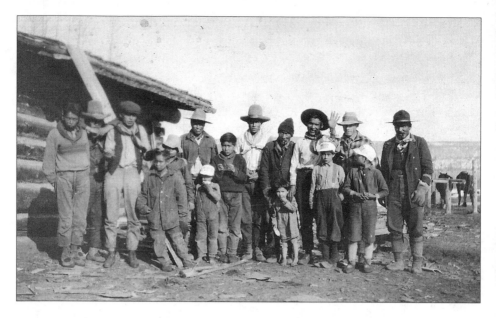

Lamarque took this photograph of a group of First Nations people that he met in the Halfway River valley. Courtesy Cecil Pickell family collection.

Across the ford the expedition met a group of Dunneza First Nations people. Lamarque estimated that there were ten lodges. He visited them and bought two pairs of moccasins. That evening the men camped at MacFarland's Flat.

There was another ford of the Halfway River on May 9. By noon they arrived at the Brady Ranch at Cypress Creek where Lamarque was able to "buy moose meat from Brady's wife, about 25 lbs [11 kg]." The expedition continued its journey up the Halfway until they reached the south end of Mosquito Flats where they camped. Lamarque wrote in his account: "It was one of the best of the numerous fine camps we had enjoyed. We were, almost imperceptibly, getting into the mountains, outliers of which, like Pink Mountain, were visible but a few miles to the northwest. The scenery was becoming wilder and more rugged. We had passed at Brady's, the last settler."

The next morning it was -9 °C when Lamarque awoke. In describing this portion of the expedition, Lamarque wrote that usually they left camp about 9 a.m. and that "six or seven hours is long enough for horses to be under packs, and twelve to fifteen miles [20 to 25 km] on good trails is an average day's journey—about our average from [Fort] St. John to the Prophet River, some 200 miles [320 km]." Lamarque described visiting the airplane camp: "At the northerly end of Mosquito Flats, about two miles [3.2 km] from where we camped, is the hangar and the log dwelling of those prospectors whose plane we had seen

two days before. The hangar… is a large, log building and above the open end, in big letters, are the words 'Mountaineers Hangar No. 1.' Living quarters are several hundred feet away in the woods by a creek."

About an hour later Lamarque and his crew forded the Halfway for the final time at the Big Elbow, where the river changed its direction of flow from the east to the south. They camped that night on Quarter Creek. "We had barely made camp at 2500' [760 m] when we were enveloped by a storm of sleet and on the following morning, the 11th of May, fresh snow covered the hills to below the 3000 foot [900 m] level." At midday they met Tommy Wilde and his crew, who were widening and clearing the trail for Bedaux's Citroens. Since his camp was nearby they decided to stop there for the evening so the horses could have good pasture and some rest while Lamarque visited with Wilde.

On May 12, Lamarque and his men moved ahead of Wilde's crew and crossed from the Peace River drainage to the Liard. The trail passed by Marion Lake and reached the upper Sikanni Chief River where the expedition camped for the night. Lamarque described the scene:

> Our camp on the Sikanni was in a beautiful location on a wide, grassy flat bounded by the river to the north and east and a high hill on the south. To the west, a quarter of a mile [400 m] from our camp, the ground rises sharply from the stream to a high, wooded ridge the elevation of which declines towards the south to merge with a grassy valley paralleling the river at the base of the high hill. At dusk a cow moose and her calf came on to this ridge and paused for a few minutes, silhouetted against the red glow in the western sky. The daylight faded; coyotes called in the valley; a wolf howled mournfully across the river and then, save for the murmur of the stream, silence lay over the surrounding wilderness.

The next day was Sunday, so they remained at camp. Monday, May 14, was a difficult day, for after travelling up the Sikanni Chief for a few hours Lamarque's crew had to ford the river. To add to their travails, the water was about 30 cm higher than when they had arrived.

> Our guide, Dopp, rode into the stream and tested the ford. The river was about 120 feet [37 m] wide, swift and with a rough bed. Dopp was the only man in the party who knew the ford, and even so he nearly got into swimming water ere he found the best crossing. In half an hour we had the whole outfit across, each man leading a pack animal; some of us making two, and others three trips… After leaving the ford

we traveled near the river, soon coming to a stream called Deadman's Creek. It is 30 feet [9 m] where we crossed, a regular torrent, and we strung a rope across just below so that if any of our animals were swept off their feet they would not be carried into the Sikanni.

The men camped that night in a meadow just after crossing the creek so they could check the packs and dry out the blankets. Bill Blackman and Dopp went hunting and got a deer.

The trail headed north along the east side of the Rocky Mountains. On the fifteenth they passed Deadman (also called Trimble) Lake and camped near the Besa River, and the next day followed down the Besa before heading up Keily Creek. On May 17, it was -2 °C and clear in the morning. This was their day to cross the Caribou Range, the highest point on the trip. Lamarque wrote about his concern for one of the horses: "Snowball, the little grey mare, had not seemed well for the past two days so had merely carried a saddle without any pack. We observed her with some concern for it was now obvious—and this had only been recognized since we left the Sikanni—that she would soon become a mother and we could only hope that she would not foal on her way over the range—in some bleak, unsheltered place in the snow, above the timber line. We could not leave her behind, for she would not stay alone."

The weather deteriorated during the morning. "As we proceeded on our way it was evident that the weather was not going to remain fair and that the clouds which were massed threateningly around the great peaks of the west would send battalions to harass our march. We were not mistaken for we had barely reached the last struggling balsams, skirted one patch of snow and crossed another when the vanguard of the storm, passing a heavy squall of sleet and snow, effectually hid from view all but nearby objects."

The men continued on and after four hours reached the summit at about 1980 m.

There, from the northerly edge of the range the view, between the passing squalls, was extraordinarily gloomy. The landscape, because of the storm, was not everywhere visible... The view to the north and west, could we have but observed it distinctly for more than a few fleeting moments, was to us of extraordinary interest from this high point of vantage, for it was through this practically unknown region that we were to find a way and hew a trail for the tractors. It was cold up there on the rim of the plateau, and as we could gain nothing by delay, we pushed on to Richards Creek.

Lamarque's crew on the Caribou Range. 2-7, Whyte Museum of the Canadian Rockies.

There they camped. "The tents were barely up, however, when the armies of the storm, this time out in force, came roaring out of the west to deluge us for many hours with a cold rain, and it was during such a night as this that poor little Snowball, in the shelter of the woods at the easterly end of the meadow, had her foal." Unfortunately, the foal died after a few days and when the guides returned they took Snowball back with them to Fort St. John.

Snowball and foal. 5-2, Whyte Museum of the Canadian Rockies.

On May 18, they reached the Prophet River in the early afternoon where they found the river too high to ford.

> We swam the horses across and rafted the outfit, having everything over before seven that evening. It is a very favourable place for rafting. The stream is only a hundred feet [30 m] wide and we had to go but a quarter of a mile [400 m] to find suitable dead spruce trees standing near the stream, which we cut down and into logs, tied together with rope in raft form and floated down to the crossing place where we hauled the craft backwards and forward across the stream with a rope in the slow current.

It took the men five hours to complete the crossing. There was good feed for the horses nearby, so they stopped for the night.

Lamarque had completed the first and easiest part of the expedition. Now he was heading into steep, rugged terrain and needed to find a route through the Rocky Mountains that would be suitable for Bedaux's vehicles.

That evening Lamarque had an unexpected and fortuitous meeting.

> We camped by the Prophet River on a spruce-covered flat but a few feet above high water, at a bend in the stream which is quite slow

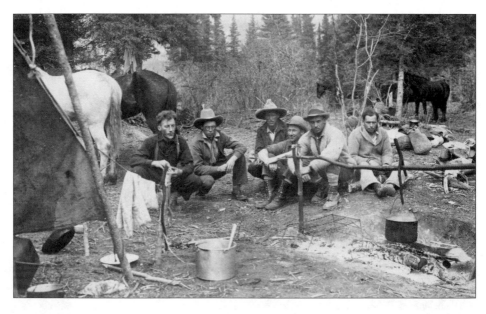

Lamarque's crew in camp at the Prophet River. Left to right: Bill Blackman, Bill Pickell, Edgar Dopp, Henry Blackman, Earl Cushing, Art Paul. 2-52, Whyte Museum of the Canadian Rockies.

and very crooked in that locality. We had seen fresh foot marks of men on the shore when working with the raft and had hardly finished supper when two trappers, [Bert] Sheffield and Elmer Grey, came into camp. These men had been trapping on the upper Muskwa and White (Kwadacha) rivers, and were on their way out with their season's catch of furs.

In a few minutes Willie Artemenko, a teenage boy and nephew of Sheffield, joined the group.

Lamarque wrote: "It was a fortunate meeting, for these men were able to tell us a good deal of the region, and Sheffield, the next day, made quite an excellent plan of the upper Muskwa and White rivers, even as far as Whitewater [the Hudson's Bay Company post], where he had once been in winter, 50 miles [80 km] from his most westerly cabin on the North Fork of the White." Lamarque noted that Sheffield divided the map that he drew into 10-mile [16 km] squares so he had a more accurate scale.

Lamarque remained at the camp the next day working on mail and reports to send out. Dopp and Pickell prepared to return to Fort St. John where they would continue working for the Bedaux Expedition. The trappers came to Lamarque's camp for supper and spent the evening. In mid-afternoon on May 20, the guides and trappers started south together.

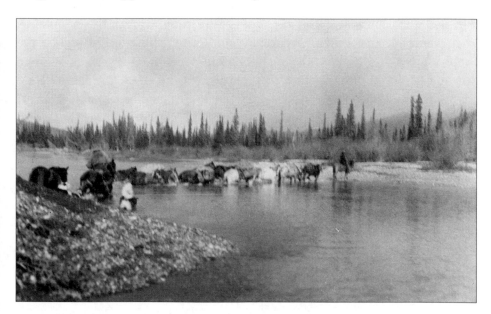

The trappers that Lamarque met crossing the Prophet River. 17-14, Whyte Museum of the Canadian Rockies.

Based on his conversations with Sheffield, Lamarque decided to change his exploration route.

> From the information given me by Sheffield, it seemed doubtful if we should be able to ascend the valley of the Muskwa with tractors, for the stream passes through a canyon about 20 miles [32 km] above the point where the trail from Fort St. John touches it. He was not able to tell me whether the canyon could be avoided and he knew nothing about the head of the Prophet River except that, about fifteen miles [24 km] above our camp, a stream came in from the north by which the south fork of the Muskwa, which entered that stream above the canyon, could be reached and followed. He had been through and so had Billy Hill. Sheffield said that the route along the south fork of the Muskwa was very rough and I could see that he thought that there was little chance for tractors there. Could we, however, get through by the head of the Prophet to the west, we should be, I knew, adopting a route which, from the fact that it was entirely unknown, would be acceptable to Mr. Bedaux and, at the same time, probably reduce the length of our journey.

The next afternoon Lamarque met two more trappers, named Petersen and Miller, who had been farther north. They informed him that the drainage where they had spent the winter was impassable for getting through the mountains. That evening Lamarque, Bill Blackman, and Earl Cushing left to explore the Prophet River. They camped that night opposite some sulphur springs and rode over to examine it. "Besides their sulphur content they probably carry a good deal of lime, for a ridge, 15 or 20 feet high [4.5 to 6 m] and nearly 50 feet [15 m] long has been built up of that material at the base of the cliffs so that the stream at this point is narrower than above or below. The springs are much frequented by sheep, and their dung has been so preserved by the water that masses of it… lie among the rocks over which it flows. There are several springs, their temperature being about 80° F [27° C]."

The three men continued up the Prophet River the next two days. They reached the stream that came from the north off the divide leading to the Muskwa drainage. Near its junction with the Prophet River, they found an old trapping cabin and close by they encountered some wolves. Lamarque described this experience in "The Old Packhorse."

THE OLD PACKHORSE

Bill Blackman with Prince. Blackman was born in 1904 near Pittsburgh, Pennsylvania. His parents had emigrated from Germany in 1901, and his father was a coal miner. The family came to the Valemount area in 1911 during construction of the Canadian Northern railway. Bill's father died in 1918, leaving a widow and ten children. As the oldest son, Bill had a large responsibility for helping the family. He worked in a variety of outdoor jobs and learned to be a packer and guide. Bill worked for many years for the famous Hargreaves Brothers guiding outfit based out of Mount Robson. He was Lamarque's packer for his 1931 survey. In an interview with Lizzie Rummel for the Whyte Museum, Lamarque commented that Blackman was an excellent packer and woodsman. After the expedition Lamarque made a painting of Blackman on the Prophet River. The two men had a long friendship. 2-58, Whyte Museum of the Canadian Rockies.

"THAT IS A fine animal." I looked at my companion and observed that he was watching Prince, our grey pack horse, grazing near the fire. As we watched him, the old rascal looked up, as though aware of our kindly consideration. Then he resumed his feeding, gradually moving away from our vicinity, the other pack animals drifting by in his wake.

"I'd hate to lose that horse," said my companion. "He's a born leader, as wise as they make them." He was wise; sagacious, if you prefer the word, always on the lookout for, and avoiding trouble.

I remembered a bridge I had made; hardly finished, indeed, when the pack train came up with, of course, old Prince in the lead. Just a small bridge over a very narrow little gut of a creek, a mere brook eight feet [2.5 m] wide but with perpendicular banks, the water deep. The logs started to spread as Prince crossed and like a cat he scrambled over without harm.

We stopped the rest of the train, of course, and fixed the bridge, but had it been any other horse there might have been a nasty accident, perhaps a broken leg and an animal lost.

"Do you remember Prince on the upper Prophet, where we came out to the stream between the two falls?"

"Remember? I shall never forget it; of the three horses he alone was aware, or anyway, he alone gave evidence thereof."

"What did he do then?" said the other member of our party, "and what was he aware of?"

"Well, I'll tell you," said Bill, who with Earl, had been with me on a reconnaissance of the upper Prophet River to its very head, in fact where, in many small streams it comes cascading eastward from the precipitous crags of the main range of the Rockies. "It was like this. We'd started early that morning, we usually did, and had followed a rough Indian trail on the southerly side of the river until, an hour or so after we had started, we came down to the bank of the stream, no longer on a trail but following through the scrub as best we could and doing as little cutting as possible. Where we struck it the river was a torrent, about seventy feet [22 m] wide, bounded by low spruce-clad shores. A good sized stream entered it from the north, right across from where we had stopped and there was an old tumbledown cabin at the confluence.

"We were looking at this old cabin and the country in general, when Prince gave a snort and whisked round to face upstream. Neither of our other two animals took any notice of Prince or gave any sign of interest. Of what he sensed they apparently knew nothing. We had noted evidence of a bear near the old cabin, and could see where he had torn open an old rotting log, and we looked sharply for Mr. Bruin. We saw nothing, however, and as we could see but a short distance up the roaring stream, up which Prince persisted in looking, his sensitive ears moving, his nostrils distended, we went down to the very edge of the water from where we could see a hundred yards or more up the turbulent river.

"We learned nothing, however. The banks were of the same low, rocky tree-clad nature, with here and there, little stretches of pebbly beach. There was nothing to be seen; no sound save the rush of the torrent.

"We started off again, then, keeping away from the river along available game trails, for perhaps 15 or 20 minutes, cutting out a tree or log here and there but making fair progress, so that we must have gone nearly half a mile [800 m] when we stopped to cut a way through some windfalls. We were about to start again, when Prince snorted and faced riverward once more.

"Well, there was some pasture, and leaving the horses browsing, we made our way to the river about a hundred yards distant. The stream, where we now came to it, was in a deep gravelly gulch, quite a hundred feet [30 m] below the top of the bank where we were. Just above, it tumbled over a ridge of rocks in a sixty foot [18 m] fall. We had a magnificent view westward, upstream towards the mountains but saw absolutely nothing to account for the actions of Prince. Not satisfied, however, we went along the top of the high bank downstream, until we had a view of the river for several hundred yards below us.

"The cause was there. Out in midstream, with the icy racing waters lapping her flanks, stood a cow moose; bedraggled, forlorn, lacerated. On the far shore—there a low gravelly beach—were three wolves in varying attitudes, their eyes on their quarry. One was lying down; another sitting up; the third standing easily, all tremendously alert.

"It is a singular thing—for after all, had we needed meat we should have tried our best to kill game—that we were annoyed at the wolves and sorry for the moose. Our anger, indeed, was kindled against the former so that, when we had got as close to them as possible, we opened fire.

"At the first shot they were gone, as though a giant spring had galvanized them into action and hurled them with flying leaps into the dark, bordering forest. A second shot, as the last one disappeared, was of no avail, only the stretch of beach was deserted, the moose still in the stream, her only sanctuary from her grim pursuers. High above, an eagle floated on broad outstretched pinions in the cloudless sky.

"It might have been kind to have shot the moose, but there was just a chance that the wolves would not return and that, making off on the southerly side of the stream, she would escape. The warm days of summer were coming, the conditions improving, so perhaps... who knows? She was still standing motionless in the river when last we saw her, as we turned inland from the stream."

"You would have known nothing of all this, then," said our companion, "this glimpse of wildlife, had it not been for Prince?"

"Not a thing. The other horses gave no sign. But Prince knew. And here's the old fellow again. He wants something. Ah, I know, we have forgotten to put out the salt."

The men saw "many old Indian signs where they had camped and dried meat, and it was at such a spot, near the top of a ridge which crossed the valley from the mountains on the north that we decided to camp." While Cushing set up camp, Lamarque and Blackman went out to explore the area. They climbed a high snow-covered ridge but could find no obvious route through the mountains at the head of the Prophet. The next morning they explored to see if they could locate a suitable pass into the Muskwa drainage. They found a trail heading to the north. "In two or three places we found old Indian signs; sticks or pickets propped up by rocks to mark where traps had been set for whistlers [marmots]." When they reached the top, "we could look over the country beyond and the gulch of a creek that flowed northeast—possibly the very head of the south fork of the Muskwa—flanked to the west by a formidable line of crags. There was a break in these precipices a few miles below, but from our position it looked too rough to be of any use and as there was too much snow to judge the ground in the pass it appeared that the route was not feasible." He also commented: "There seemed little doubt that the Indians had, years ago, hunted on the Prophet River to its head, and crossing by the pass we had investigated, gone over to Muskwa waters and back to the lower country to the east down the latter stream or vice versa."

On May 25, the men awoke at four in the morning, left camp at six, and returned to their main camp by supper. Lamarque was disappointed that he was

not able to find a passage through the Rockies on the Prophet drainage, so now it was imperative that he successfully locate a route on the Muskwa.

The next day, from their main camp, Cushing, Henry Blackman and Lamarque rode along a high plateau to the northwest to see if they could find a better and shorter route into the Muskwa drainage. Bill went hunting and returned with a Stone's sheep. May 27 was Sunday so they remained in camp. The next day, Henry and Earl worked on the trail; Bill built a cache, and Lamarque and Art Paul took an inventory of their supplies and arranged some provisions for three members of Wilde's crew who were to come up and assist them.

Two days later the men moved camp about 15 km north towards the Muskwa. In the afternoon they found that the terrain would be difficult for the tractors, so the next morning Lamarque and Cushing explored farther north where they found some extensive meadows. On the last day of May it snowed all morning. In the afternoon Lamarque and Bill Blackman located a route from the meadows to the plateau they had previously visited. The next day, Henry Blackman and Cushing went back towards the Prophet River to mark the new tractor route over the plateau. Lamarque and Bill Blackman continued north on the trail, reached the Muskwa, and travelled for a few kilometres up the river.

Lamarque realized the enormity of the situation. The Muskwa was a big river and in the valley there were many large spruce and cottonwood trees that would need to be chopped down.

> Moreover, from what we could see, it appeared that there might be many miles of this sort of country, and then—there was the canyon which Sheffield had shown on his map and spoken to us about.
>
> It was the first day of June—the glorious first of June. In six weeks the tractors were scheduled to leave Fort St. John and given fair weather, right design and loading, they would perhaps be on our heels before we got anywhere near Sifton Pass, at least 130 miles [210 km] to the west, perhaps much more if we were forced to a tortuous route—and Sifton Pass was supposed to be the general rendezvous for the whole expedition at the middle of August.
>
> However, as the French would say "Que voulez vous" [What do you want?]. I had four good men with me and an excellent outfit. The weather was fine; we were all in good health and spirits and though the country immediately ahead was heavy, it might—who knew?—improve.

On June 2, the men moved camp to the Muskwa valley. During the next days the crew members examined the trail both along the river valley and up

on higher terrain. Lamarque and Bill Blackman went up the Muskwa valley, camping by one of Sheffield's cabins. The following day they reached the canyon. In his diary Lamarque noted: "The canon [canyon], while it means 2 fords, is quite practical for tractors. River rising fast." With the help of Sheffield's map, Lamarque could see the terrain above the canyon, including the valley of the south fork of the Muskwa and the area of the Big Burn.

On June 6, the men were all together again at their camp along the Muskwa. The next day, Lamarque rode over the route that Cushing and Henry Blackman had located on a plateau. "By means of a rough plan, a careful comparison was made of the two routes... It was a question of labour, for there was little to choose as far as the operation of tractors was

Lamarque and Chummy at Muskwa River. 2-53, Whyte Museum of the Canadian Rockies.

concerned. The decision rested on the value of time and as it appeared that, despite heavy chopping, we should have two days less work by holding to the valley, I decided to do so."

During the next week everyone on the crew cleared trail and, on June 16, they moved camp to Sheffield's cabin. Three days later Lamarque and Bill Blackman crossed the Muskwa to examine the country along the north side of the river below the canyon. On the morning of June 20, Lamarque and Bill Blackman marked the fords over three side channels of the Muskwa, and in the afternoon the main channel. Lamarque commented:

> Though the water was swift it was not too deep for pack animals. There was a stick standing on the bar on the southerly side from which we crossed, probably put there by the trappers as a guide, for we ran right on to the old pack trail immediately after crossing. This we followed to the foot of the canyon and so along the base of the cliffs to where it was obviously necessary to cross to the flat above which Blackman and I had been before. The river, where we crossed in the canyon, is about 200 feet wide [60 m], flowing swiftly over a

rough bed. There is no real rapid there, however, and we forded without difficulty to ride for nearly a quarter of a mile [400 m] along this wooded flat by the stream and then, by the help of the island we had observed before, crossed again to the north side.

In his diary that night, Lamarque wrote a cautious note of optimism: "Find we can make all fords at this stage of water." While Lamarque and Blackman followed the traditional route through the canyon, Henry Blackman and Cushing tried to find an alternative route north after the first crossing, but were unsuccessful. On the June 21, Lamarque's crew moved camp to the head of the canyon where they saw some old tipi poles. The crossing of the Muskwa was difficult but it was possible to get through as long as the water level in the river wasn't high. Lamarque knew that the river would be higher during spring run-off, but he hoped that it would drop sufficiently by the time the main expedition was scheduled to arrive in the middle of the summer.

The next challenge for Lamarque and his crew was getting through the Big Burn. While Cushing and Henry Blackman cleared the trail so the pack animals could proceed, Lamarque and Bill Blackman went up to the burn, which was about 6 km up the trail. About 3 km above the canyon, the men found another of Sheffield's trapping cabins opposite the mouth of the south fork of the Muskwa. At the Big Burn, Lamarque noted the rough terrain with a lot of loose rock and the debris of two snowslides. It began raining that night and continued all of the next day, so the men remained in camp. Unfortunately the horses had crossed the river looking for better feed, so Lamarque and the two Blackman brothers had to build a raft and spend time getting them back. Much of the next day was spent cutting a line for the tractors while Bill Blackman shoed the horses.

On June 25, Lamarque's crew heard a plane flying overhead. Lamarque believed that it was from the Bedaux Expedition so he lit a fire and made a smudge, hoping the smoke would attract the attention of the people in the airplane. Art Paul, who was in camp, had also made a fire. The plane passed overhead and then came back. Jack Bocock was looking over the first section of the Bedaux Expedition's proposed route, but he and the pilot did not see the men because the air currents above the canyon created difficult flying. When the crew returned, Lamarque found that all but two of the horses had again crossed the river. "The fact that we could not hold our horses on our side of the river—which was rising rapidly and becoming formidable—and the visit of the plane, decided me to move the outfit ahead without delay... We moved accordingly, the next day, Cushing and I going ahead to clear the pack trail through the Big Burn to a camp site William and I had chosen at the easterly

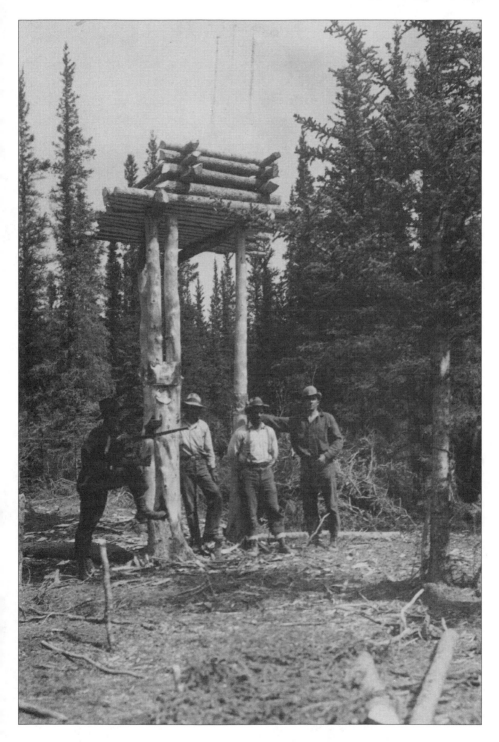

Constructing a cache at Prophet River. E11074400, Library and Archives Canada.

edge of the first snow slide." Lamarque noted the destruction caused by the fire and the slide that was all around them.

On June 27 Earl and Henry cut trail while Lamarque and Bill Blackman examined the country up the Muskwa River. They followed the old blazes through the burn and a second slide to the river where the trail crossed. The water was too high to ford so the two men climbed the mountain until they had a good view up the valley.

> The prospect was of great interest. Always, when approaching a point of vantage from which the country ahead could be examined, arose the question—will it be favourable or otherwise? That afternoon, then, as we sat under the boughs of a pine, partly sheltered from a passing storm sweeping across the country, we were absorbed, even enthralled by what lay before us. The mountains about the head of Nobed Creek and those that loom majestically above the Muskwa, were partly hidden by clouds. The valley of the latter seemed to be hopefully wide, probably in the neighbourhood of the Big Bar, where Sheffield showed that the trail passed along the bed of the stream.

Lamarque recorded in his journal that there were showers or rain for every day during the last week of the month. In his account, he mentioned that they saw numerous signs of grizzly bears including one occasion where the claw marks were high on the tree. "The next morning, as we passed by, Henry Blackman, who is over six feet in height, reached up as far as he possibly could and managed to make a cut on the bark with his axe just above the highest mark made by the bear, saying with a chuckle, 'Well, let's see if he can beat that.'"

During the last two days of June, Lamarque and the two Blackman brothers explored the valley up to the Big Bar before returning to their camp on July 1. The next day the entire crew moved up to this location.

> On the 3rd of July William Blackman and I started off for Whitewater which was, I supposed—I tried to believe—only 70 miles [110 km] away, according to Sheffield's plan... We started in the afternoon with two saddle horses, two pack horses and enough food for fifteen days, though I hoped that we should be there by the 10th of the month... Henry and Paul accompanied us for a day—a reconnaissance that they might choose a camp site above to move to for pasture was scarce near the Big Bar.

Lamarque hoped that he would be able to get a message to Jack Bocock before the expedition left, telling him of their progress in locating a trail and informing him that he had found a route up the Muskwa River. The trip would also give him an opportunity to see what conditions were like along the Kwadacha River.

The next morning the men reached another Sheffield trapping cabin and just above it came to a branch of the Muskwa that flowed from the northeast. "We spent an hour trying to find a way across the northeast branch which, for a mile or so above the confluence of the two streams, flows in a canyon. At noon we lunched by the easterly bank at the head of this canyon where there is plenty of pasture and a fine view to the north through a wide basin surrounded by high, snow-capped mountains. After lunch we parted from Paul and Henry, forded the stream and... turned to the south along game trails leading to the main stream."

By late afternoon, Lamarque and Blackman reached a lake at the head of the Muskwa that Sheffield had drawn on the map. Today it is called Fern Lake, named for Bedaux's wife. At the western end of the lake Lamarque wrote a note, and tied it to a pole that he placed in the ground in a large meadow area. The pole was placed in the centre of a cross about four metres each way made of red, white and blue bunting. Lamarque hoped that the note would be spotted by a plane flying over the area since the lake was large enough for a plane to land

Fern Lake, looking west towards the Lloyd George Range. 2-14, Whyte Museum of the Canadian Rockies.

Crossing the northwest branch of the Muskwa. 2-56, Whyte Museum of the Canadian Rockies.

there. "After leaving the signal for the plane, we turned away from the lake, passing up a green lane between thickets of balsam where the bunch grass grew almost knee high. We camped where the ground fell away to the west, allowing us a fine view of the mountains and snowfields of the Lloyd George Range." Lamarque and Blackman were in the area now named Bedaux Pass.

On July 5, the men crossed the divide and started down into the north fork of the Kwadacha River. When they reached the river they forded it. Lamarque found that the terrain was rough and the trail was not as well defined. To compound the difficulty it started to rain, and there would be rain or showers during most of the trip to Whitewater. In late afternoon they passed another of Sheffield's cabins, but it was on the opposite side of the creek and the river was too high to cross there. Lamarque and Blackman continued down the Kwadacha. "It was hard going. Frequently we struck old blazes and cuttings, which, though of little assistance, at least encouraged us by indicating as good a route as we could have hoped for in that desolate, rugged locality... Our progress was so slow that it took us four hours to cover about three miles [4.8 km]."

"It rained all night and most of the next day, the 6th of July. Any delay for bad weather, however, was out of the question, for though we still hoped to reach Whitewater by the 10th, it was increasingly doubtful if we should do so." Late the next morning the men found a location where they could cross the north fork to the west side. "The rain descended in torrents. We rigged up a rough shelter and dried out the best we could in front of a big fire while the horses fed on goose grass nearby."

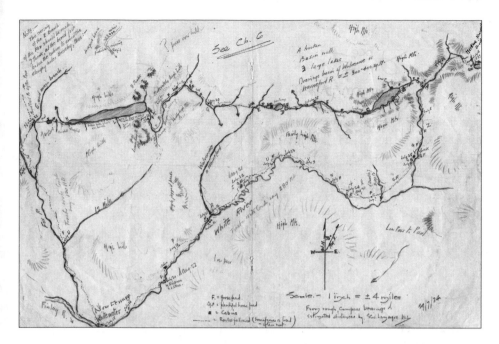

Lamarque made this sketch map of the route that he took down the White (Kwadacha) River, and the shorter route that he followed almost directly between the upper Fox River area and the upper White River. Map 81-14-7-1934, Whyte Museum of the Canadian Rockies.

In the late afternoon, Lamarque and Blackman arrived at Sheffield's farthest west cabin. "As this was an excellent place both for ourselves and the horses, we lost no time in making camp and turning them out to pasture. The cabin was small and not suitable for our use, but the porch was for our saddles and supplies. The altitude of our camp was 3500 feet [1065 m]. We could see that we were near the confluence of the north and east forks of the White [Kwadacha]."

Beyond Sheffield's cabin the trail became almost non-existent, with only occasional blazes and evidence of cut trees, all of them many years old. Lamarque and Blackman slowly made their way down the Kwadacha drainage. On July 8, they were beside the Kwadacha below the forks. "It was evident that it was a larger stream than the upper Muskwa and we could only hope that we would not have to cross it." That afternoon, while clearing some brush, Blackman accidentally cut Jack, the horse he was leading, in the chest. The men sewed up the wound and decided to stop for the night. In his diary, Lamarque wrote: "No feed, tie horses up. Made perhaps 6 miles [9.6 km]. Rather serious position. Brush very wet and no trail. Rough country and river high forming sloughs."

The next morning they came to a pasture where the horses fed for a few hours. "It poured with rain, on and off. The bush was always wet, the saddle

blankets more or less sodden." It was July 9, and Lamarque knew that he was still some distance from Whitewater. "The horses were getting impatient at the roughness and difficulties of the trail and the poor feed, though they were still in good condition. The wound in Jack's chest, which we did our best to keep covered and clean, did not seem to trouble him."

That night the men camped near the river. In the evening, Blackman went to check on the horses. "He returned wet to the skin. He had found Chummy on our side of the river and Shorty and Pet on the island. He had ridden Chummy across to get the other two. When close to the island, right by the bank, Chummy got into a hole, and excited, threw his rider into the stream. Blackman managed to grab an overhanging willow and haul himself out on to the island where Chummy had scrambled. They got back alright at a good ford." Lamarque noted that Blackman could not swim so they were fortunate that this incident didn't have more serious consequences.

The next day, Lamarque and Blackman found a trail that had been cut in the last year or two and followed it for a few kilometres. Then it appeared to cross the river, so they had to resume travelling on their side of the Kwadacha following along an old trail. This trail came to a small creek.

> The old trail there dips into the bed of this little creek right where it enters the White, and immediately after crossing the creek, twists up and away from the stream so that Blackman, who was riding ahead, was out of sight directly he was across. I was behind the two pack animals, and Shorty, leading, instead of following up the trail after Blackman, took to the river. Chummy followed him.
>
> I managed to grab the lash rope at the back of Chummy's pack but was unable to hold him, and as I could not turn them, had to watch the rascals ford and swim the river. Blackman, who heard me shout, came swiftly back and threw, unavailingly, a lariat towards Chummy. We rode down the old trail as fast as possible until we got opposite where Shorty and Chummy were standing on the far shore and tried, for a few minutes, to encourage them to come back. It was no use, so, loosening the girth of my saddle, I rode into the stream to get them.
>
> There is a steep gravel bank above the river where I entered it, and for a hundred feet or so [35 m], the stream flows swiftly over a good bottom, barely reaching halfway up the mare's flanks. Then, suddenly, we entered deep water and had to swim 40 or 50 feet [12 to 15 m] ere making the shallows beyond. However, it was not as bad as I expected... Shorty and Chummy made no attempt to avoid me,

and tying Chummy to Shorty's tail, I led both animals over the stream once more, crossing higher up to avoid being carried down into a jam of logs below the gravel bank from which I had started.

Blackman had lighted a fire and we unpacked the animals, drying out the few things that had got wet. Fortunately our excellent canvas panniers had prevented our supplies from being spoilt.

After getting dried out and warmed up the men continued, not stopping to camp until ten o'clock that evening.

It rained for most of the next two days but the trail improved and, by the late afternoon of July 12, Lamarque and Blackman reached the Warneford, the last major river crossing on the north side of the Kwadacha. They camped there and planned how they would cross the river. It was too high to ford so they found a place where they could swim across. Lamarque didn't want to take the time to build a raft so they decided to swim the horses with their packs on since it wasn't a long distance across the river.

Accordingly, next morning, we cut a trail to where we had decided to enter the water, and each man leading a pack animal started across. Blackman took the lead on Jack whose wound in the chest was now remarkably better and who is a fine swimmer. We did not anticipate trouble for there was a good bar to land on across near the confluence of the two streams.

The Warneford or Wolverine River is about 150 feet [45 m] wide where it enters the White. We had made over half this distance when Jack started to swim. By keeping upstream a trifle I held the shallows longer, but we both had to swim 30 to 40 feet [9 to 12 m] ere reaching the far side.

About 1.5 km below the Warneford they found some cabins. By mid-afternoon the trail became good, "evidently used recently by the natives whose houses we had seen near the Warneford that morning." When they camped on July 14, Lamarque thought that they were close to Whitewater. In his diary for July 15, Lamarque wrote: "Shave & wash up, leave camp at 9:15 and reach HB Company's post at Whitewater at 11… J. [Jim] Ware, manager of the Post, makes us at home where we eat and sleep."

Although it took Lamarque longer to reach Whitewater than planned, he arrived at a propitious time. Lamarque recorded in his diary: "[Del] Miller, who has an Indian wife and large family, 25 miles [40 km] below here, had just arrived with his 45 foot [14 m] 8 HP outboard engine boat. He freights for the

HBC and therefore, as the Company are bringing in Bedaux's stuff, freighting our stuff also. I sent a specific wire to [Hudson's] Hope for Bocock at [Fort] St. John. He left at 6pm and may get there tomorrow afternoon. His charge is $150.00."

Lamarque provided more detail in his account. "It was the 15th of the month, the day that the main body of the expedition was supposed to leave Fort St. John. Through the radio at Whitewater it was known that the party, travelling overland with their tractors from Edmonton, had not yet reached [Fort] St. John, and so, as it was possible for Miller to get through to the Hope in two or three days... it was practically certain that my message would be received." Miller reached Hudson's Hope in two days and Bocock received the message, so the high fee that Miller charged for his express delivery was worthwhile for Lamarque.

While Lamarque and Blackman were traversing the Kwadacha, Bedaux and his five Citroens left Edmonton on July 6. The summer was wetter than normal in northern Alberta and British Columbia, and the dirt roads turned into a very sticky mud called gumbo. The Citroens had difficulty getting through the gumbo, which clogged the tracks, and Clovis Balourdet, the Citroen mechanic, spent a considerable amount of time repairing the vehicles. It took eleven days for the expedition to reach Fort St. John, where they met the cowboys who were to accompany the main party. Bedaux spent five days at Fort St. John getting organized, so by the time the expedition left on the afternoon of July 22, they were already a week behind schedule.

After the rigorous trip up the Muskwa and down the Kwadacha, Lamarque and Blackman rested. Lamarque noted that there was "good feed here for the horses and a comfortable place to have a wash up, rest up, and feed for a few days." He took a warm bath and did laundry. There was a considerable amount of mail to read and answer. Lamarque also hoped that Bocock would have the chance to fly to Whitewater so they could inspect the planned route.

In his account, Lamarque described the Hudson's Bay post and the Kwadacha First Nations people.

> The post of the Hudson's Bay Company at Whitewater has been established for about eight years. It is situated on the bank of the Finlay River and consists of a small, single room log dwelling, a store and three warehouses, all of logs, two of which are built on posts, their floor eight to ten feet above the ground [2.5 to 3 m]; of cache-like construction, so that the supplies may escape the depredations of animals.

Lamarque took this photograph while he was at the Hudson's Bay post at Whitewater. Left to right: Jim Ware, Arnold Myers, Bill Blackman, Ludwig Smaaslet, Fred Forsberg. E011074405, Library and Archives Canada.

Below the post, to the confluence of the White... the benches are sparsely clothed by small poplars and pines. There the natives have their buildings and encampments... There are probably a dozen families of the Sikanni tribe at Whitewater. Their chief [Davie], an octogenarian, is a handsome, medium-sized man of mixed white and Indian parentage... It takes much game to keep a dozen Indian families alive

when meat is their principal and almost only diet. The country within a day's journey of Whitewater has been practically deserted by the larger animals, so the natives, as a rule, do not stay for long periods in the locality.

While Lamarque was at Whitewater, he explored the possibility of a different route to Sifton Pass. He had initially mentioned this idea to Bocock in a letter in early April. "I still hope to miss the Kwadacha and carry a diagonal line through to the [Sifton] pass." After making a plan of the route that he had followed from the pass between the Muskwa and Kwadacha drainage to Whitewater, Lamarque estimated that he could reduce the distance by possibly 80 km by going directly between the north fork of the Kwadacha and the Sifton Pass area. The route would have very little elevation change and avoid the rugged Kwadacha River valley.

At Whitewater, three trappers—Arnold Myers, Fred Forsberg and Ludwig Smaaslet—were waiting for the weather to clear before taking supplies up the Fox River to a cache.

> I was able to get information of the country to the north from them, and it was from what Myers said, in conjunction with intelligence given by the natives, that decided me to see if there was not a cut-off route, feasible for tractors, through from the Sifton Pass trail about 35 miles [55 km] north of Whitewater, almost directly east to Sheffield's upper cabin on the North Fork of the White. Months before, in Vancouver, studying a map of northern British Columbia, I had advised M. Bedaux that there might be such a route through the Wolverine Basin which would probably enable the expedition to avoid Whitewater altogether. Now, with the information obtained at Whitewater, I decided to see for myself.

Fortunately for Lamarque, there were two First Nations men at Whitewater who were able to provide valuable assistance. Joe Poole, from Whitewater, knew the area between Sifton Pass and the Kwadacha, while Jack Stone, from the Liard River area, knew the country north of Sifton Pass. After talking to these men on July 19, he hired both of them. Jack Stone would initially accompany Bill Blackman and the horses back to the North Fork of the Kwadacha where Lamarque intended to meet them. Joe Poole would go with Lamarque on the route that he wanted to explore.

There was more good news. The three trappers planned to leave for their cache in the Fox Pass on July 21. They invited Lamarque and Joe Poole to join them and offered to have their horses carry the two men's supplies.

Before the men left there was an unfortunate event that Lamarque recorded in his diary. "A young man arrived, just before we left Whitewater, to say his partner had been drowned crossing the White an hour or so earlier, the horse too. J. Ware and Indians leave immediately to search for signs of the body." (Thomas Granger was attempting to reach the Bedaux Expedition, hoping to obtain employment.)

From Fort Ware the group travelled up the Finlay River until it reached the Fox, which flowed south from the Sifton Pass area through the Rocky Mountain Trench. This was the traditional First Nations route, now known as the Davie Trail, that led to Lower Post on the Liard River. (During the Klondike gold rush some prospectors taking the overland route followed this trail through Sifton Pass.) The men stopped for the evening at 12 Mile Creek. "It was a fine night. The trappers did not bother to put up a tent, each man laying down on a few spruce boughs under the trees by the bank of the Fox River. Having sent my sleeping bag back with Blackman I had only a single light, woolen blanket and a piece of heavy canvas for bedding."

Lamarque and the other men reached the junction of the west and east forks of the Fox around noon. (Today the east fork is called the McCook River.) In his diary, Lamarque wrote:

> Cross the east branch of the Fox (the larger branch carrying twice as much water as the other) on a log jam—the horses fording above— and reach the trapper's cache at 12:45 on the east bank of the west branch of the Fox where there is an Indian cabin and a well-built cache in a big bend of the little 40 foot [12 m] stream.
>
> Joe Poole and I leave again at 4:15, Joe having a 45 lb pack [20 kg] and his rifle, I a 35 lb [16 kg] and Bounty, the yellow dog, a 20 lb [9 kg] one.

By 7:45 p.m. they reached McCook's cabins on the banks of the east branch of the Fox. "There was a rabbit sitting behind the little stove in the McCook's cabin in which we slept and this was Bounty's supper. The mosquitos were thick and sleep—with no bar—a minor quantity. Got up at 4:15 and were off at 6:30, crossing river on raft we found already made." By lunchtime they had reached a large lake (today known as Weissener Lake) and were about 3 km along its southern shore. Lamarque caught a large Dolly Varden, which he fed to Bounty. At the end of the day the men camped a few kilometres east of the lake by a large stream that flowed into it (today called Joe Poole Creek). Joe was following game trails. Most of the time they were on dry ground so the travelling was much better than on the Kwadacha.

Lamarque and Joe Poole. 1-30-r, Whyte Museum of the Canadian Rockies.

They started July 24 by cutting down a spruce tree to cross the creek. In his account Lamarque wrote: "There were blazes and cuttings along the easterly side of the stream made by a Whitewater Indian, Joe said, who fished at the lake and often came this way, through by the head of Twelve Mile Creek or over from the Warneford a few miles above its confluence with the White." They proceeded northeast for the first part of the day. "Just before we stopped for lunch Joe shot a grouse with his 30-30 carbine, and thus Bounty, getting all those parts of the bird we did not want, had, with some bannock and rice, a good meal." About 4:30 p.m. their route turned southeast and two hours later they stopped to camp by a small creek that flowed into the upper section of the Warneford River.

The next day, Lamarque and Joe went over a small pass. "From a point of vantage, where the ground falls away abruptly to a more densely forested region, we had a wonderful view to the east across the basin of the Wolverine Lakes to the distant Lloyd George range and those high mountains near the summit of the Rockies through which the North Fork of the White finds its way." Lamarque made a map sketch of the area. "Joe said that the country ahead was more difficult to pass through on account of the debris. He said,

Jack Stone. E.011074399, Library and Archives Canada.

too, with some bitterness, that a white trapper had been in from Hudson Hope, trapping and hunting in the basin below us, poaching on the preserve that he and his partner had had for so long." Around 11:30 a.m. the men reached the Warneford where they followed an old First Nations trail up the river for about a kilometre. "Leaving the side hill which this old trail traverses, we crossed a wide back channel on the crest of a beaver dam and made our way over an island and another channel to the bank of the main one where we lunched. The stream was fully a hundred feet wide [30 m] with a large gravel bar on the far side, extending to the mainland a hundred feet or so beyond." After lunch the men constructed a raft.

ACROSS THE WARNEFORD

From the top of the hill to the west of the Warneford River, we had a magnificent view over the basin of that stream and that of Chesterfield Creek, with, beyond, the high glaciated terrain of the Lloyd George Range, drained southerly by this British Columbia valley which lies in about 57½ N. and 125½ W.

Descending the steep, rugged hillside we crossed a small peninsula to the banks of the stream, where we cut down a dry spruce which we made into a three stick raft, cutting notches therein and inserting suitable cross pieces, into which, to make them fit tightly, we drove wedges.

Thus, with a strong raft, our dog and packs amidships, we crossed the rapid stream to the quiet eddy on the far side where a small stream entered the river, and along its valley in so densely timbered a terrain, mossy and damp, that the sun could hardly penetrate, we trudged along, coming, quite suddenly, to an open grassy area where was a small lake, the source of the stream we had followed.

For a moment after our passage from the river through the gloomy forest, it was like a glimpse of fairyland, so sudden was the transformation from the dim light of the deep woods. It was as if to tell us, "Behold, it is not always dark in the world, and this picture, which is now unfolded before you, is for your better understanding."

In memory, I see it all again, the sparkling, sunny lake; the dancing, light ridden grasses, the sunlit hills, with, on the far horizon, the massive peaks of the Lloyd George Range.

Lamarque made this card depicting the crossing of the Warneford River on the raft that he and Joe Poole made. Joe's dog, Bounty, accompanied the two men. M81-9-4, Whyte Museum of the Canadian Rockies.

I helped Joe place the logs side by side at the bank of the stream, and while he was binding them together by means of triangular cross pieces, which are so fitted into suitably shaped channels cut in the logs that, when tightened with wedges, the raft is held together with the utmost security, I made a couple of strong paddles out of a small dry spruce and we were ready to cross.

Before doing so, we cut the nearest sweepers that sprawled in the swift stream below us, and with fifty or sixty feet [15 to 18 m] of river bank thus cleared, we all three embarked, our packs in the middle and Bounty sitting solemnly in the midst.

Joe took the paddle in the stern and I the bow, kneeling at least six feet [1.8 m] back from the front of the raft. Even so, as we shoved vigorously off into the swirling stream, the water surged over the logs of our craft to within a few inches of my knees and we drifted nearly to the bend ere making the quiet waters of the eddy beyond, across which we paddled to tie our good craft to some bushes at the foot of the bar where a small stream enters from the east.

Continuing east, the men passed by three lakes. At the first one, "there was a cabin at the edge of the bush at the far end, built by a white man, Joe said, and I inferred from his tone that it was the fellow who had poached on his hunting grounds." Then they crossed Chesterfield Creek and camped by the stream. From this place they could see the high peaks to the north.

On July 26, they travelled up Chesterfield Creek, crossing it a couple of times and passing a trapper's cabin along the way. In the late afternoon, Lamarque and Poole reached Chesterfield Lake. They travelled for about four kilometres along its southern shore where they camped by a small stream. Lamarque noted that the north shore of the lake looked very rugged and that the lake had mountains on three sides. He could also see the low pass to the North Fork of the White that he had observed from Sheffield's upper cabin. "We could see the southerly slopes of the great Lloyd George range where, despite their favourable aspect, much snow lingered. We ate our evening meal in silence, impressed, almost awed, by the magnificence of our surroundings—the vast hush of the mountains, broken only and accentuated by the weird, plaintive, laughing cry of two loons far out on the water."

The next morning was clear. In his diary, Lamarque wrote: "Sunlight on green slides across lake, very fine. Goats on hills behind camp; caribou in those above the lake & Joe saw a moose swimming in the lake." It took the men two hours to reach the head of the lake. Then they crossed on a beaver dam and some

fallen trees to higher ground on the north side of the valley. There they found a pack trail, which they followed "easterly and southerly up the trail to a wet meadow and low summit and then descend[ed] easily for half a mile [800 m] to the White River. We pass[ed] up along near the creek bank but miss[ed] the cabin."

In his account, Lamarque described lunch. "Joe killed a young porcupine. He cooked this, roasted it on a pronged stick before the blaze after splitting it open, cleaning it and singeing the hair and quills off the pelt. The meat was edible enough and made a change. Bounty had a good feed of the entrails." Afterwards, Joe went downstream to the cabin and returned with food and a note from Bill Blackman, who had been there the previous day at four o'clock. Lamarque and Poole continued up over Bedaux Pass towards Fern Lake. "As we neared the lake where we had put out a signal for a plane we heard bells, and soon after, found Blackman and Stone in camp. It was eight in the evening. They had arrived four hours before and as they had killed a moose opposite Sheffield's cabin in the lick there, we had a change of diet for supper and Bounty a really generous meal." In his diary, Lamarque noted: "Had a good supper and my sleeping bag again."

The return trip was very successful. With Joe Poole's guidance, Lamarque had located a route to Sifton Pass that was shorter and had much easier terrain than going down the Kwadacha valley. Lamarque thought that this new route would be especially useful since the Bedaux Expedition was leaving Fort St. John at a later date than originally scheduled.

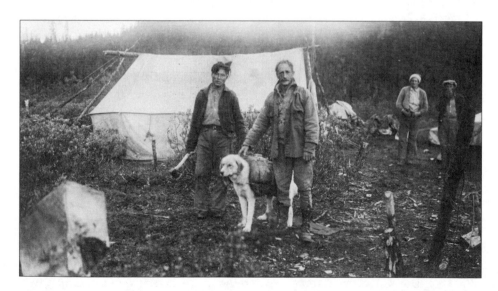

Joe Poole, his dog Bounty, and Lamarque at the end of their cross-country trip. 17-13, Whyte Museum of the Canadian Rockies.

On July 28, their first day back, Lamarque, along with Blackman, Poole and Stone, returned down the Muskwa valley to the main camp below the Big Bar. Along the way he saw that the crew had found a special location to cross the northeast fork of the Muskwa. "They had discovered an excellent natural bridge over the canyon where a slab of rock had fallen completely closing a narrow gap some ten feet [3 m] above the roaring torrent below. They had strengthened this natural bridge with one or two small props of timber, placing tree trunks on each side to form a low parapet. Moss and dirt thrown on the top of the rock slab completed a really good job."

It was dark when the men arrived at camp, where they found Henry Blackman and Art Paul. Cushing and Cecil Pickell had left three days previously to meet the freighting party and pick up more food. Lamarque also learned that the trail-cutting crew, consisting of three Lundquist brothers and Pickell, were a short distance down the Muskwa and that Lamarque now had these men to help him clear trail. In his account, Lamarque explained: "The situation, then, on my return to my party, was that whereas I had four men when starting for Whitewater, I now had, with Wilde's four and two Indians, ten... My horses had increased from thirteen to twenty."

July 29 was Sunday, so it was a day of rest and an opportunity to wash and do other chores. "We had brought mail from Whitewater which, as no news had

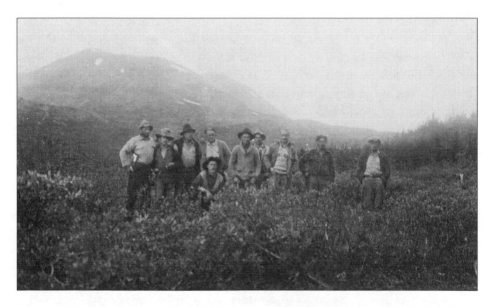

Lamarque's large crew in the upper Muskwa valley. Left to right: Henry Blackman, Willard Freer, the three Lundquist brothers (Bill, Bernard and Ingwald), Earl Cushing, Lamarque, Joe Poole and Jack Stone. Bill Blackman is in front, kneeling. 17-11, Whyte Museum of the Canadian Rockies.

been received since the end of April, created topics for conversation." The men resumed trail cutting the next day, but it rained all of the last day of July so they remained in camp. Joe Poole and Jack Stone went hunting and returned with a mountain goat, providing a large amount of fresh meat for the crew. On August 1, the men continued cutting trail, and the following day Cushing returned with two packhorses loaded with food along with Willard Freer, who had traded places with Cecil Pickell. Lamarque also met Nick Geake from the freighting outfit. It rained for the next two days. In his diary entry for August 4, Lamarque described their situation: "Poured all night and most of day. Creek got into tent at 2:30 [a.m.] so got all baggage out and remained round fire by cook fly till dawn. Moved stove into tent until the creek was falling and had breakfast therein." Lamarque noted that the temperature was only a few degrees above freezing all day.

The weather improved after this storm. During the following days, Lamarque's large crew worked to clear a route for the Citroens through the difficult terrain of the upper Muskwa. By August 10, the men were almost to the natural bridge and, by August 14, they reached Bedaux Pass. Jack Stone supplied the men with food by shooting a goat and two moose, one of which had been previously wounded by Henry Blackman. Lamarque and Bill Blackman located the trail from the summit down to the Kwadacha and on August 15 the trail crew began work on this section of the route. The next day, Lamarque and Bill Blackman rode back to Geake's freighting party to pick up supplies before heading down the Kwadacha.

August 17 was an important day for Lamarque. After working on the trail towards Kwadacha he returned to their camp on the summit to find Nick Geake and Jack Bocock there. In his diary, Bocock wrote: "Saw Lamarque. His outfit, men & horses are in the best of condition. He has found an excellent route to the Fox and says it will take his crew 2 weeks to cut a pack trail, the 70 miles [110 km]." Bocock had ridden up from the main party to inform Geake and Lamarque that Bedaux had abandoned the Citroens at the Halfway River and that the expedition was now proceeding on horseback.

After leaving Fort St. John, the Bedaux Expedition continued to have difficulty with the Citroen half-tracks, which continually got stuck in the mud. Progress was slow and the vehicles used double the amount of fuel planned. The expedition was still along a main trail in the settled area of the Halfway River valley when Bedaux decided to abandon the vehicles on August 9, only eighteen days after leaving Fort St. John.

Geake and his crew were going to return and join the main party. Lamarque's crew now needed only to clear a trail for horses and it was imperative for him to locate the final section of trail from Sifton Pass to Dease Lake as soon as possible.

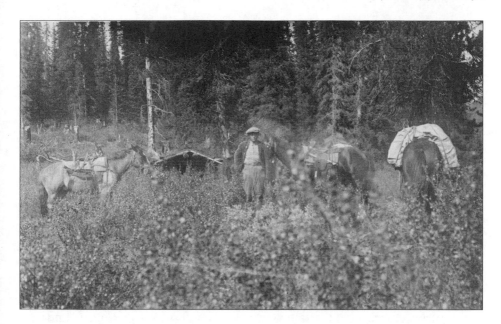

Jack Stone and horses by one of Sheffield's trap cabins at the start of their trip to Whitewater and Dease Lake. 2-58-r, Whyte Museum of the Canadian Rockies.

The next day was cold and rainy so the men stayed at camp. In the morning, Lamarque prepared his surveying notes for Bocock. After lunch, he and Bill Blackman went to Geake's camp to talk to Bocock again and get more supplies from Geake. On August 19, Lamarque and his crew completed the trail cutting to the Kwadacha River and moved camp to Sheffield's first cabin on the Kwadacha, where the expedition's route would leave the river and start up to the Wolverine Lakes.

In his account, Lamarque wrote:

> That evening I instructed William Blackman to take charge of my party during my absence or until the arrival of the main one. Indian Joe would be with them, so there would be no chance of them losing their way in the Wolverine Lake country through which they were to cut a trail along the route that Joe and I had followed to the cabins on the East Branch of the Fox. With my mind easy, therefore, regarding their welfare, I now arranged to leave with Jack Stone for Whitewater en route for Dease Lake the following day.

During the next two days, Lamarque and Stone covered over 30 km each day, making good progress down the Kwadacha River. Reaching the Warneford

around noon on the third day, they swam the horses across the river with their packs, then continued to the cabins a short distance below, where they built a fire to dry out and had lunch. On August 23, Lamarque and Stone reached Whitewater around noon.

Lamarque spent four days at Whitewater preparing for the trip to Dease Lake. In his account he described how the radio had changed the way of life in remote settlements.

> In the evening Ware [the Hudson's Bay Company factor] and I strolled over to the trader's store (run by Arnold Towers who was away at the time, up river at the camp of some white trappers) to listen in on his radio. Ware's was out of commission.
>
> The path from the post of the Hudson's Bay Company to that of the trader's lies along the bank of the Finlay, by the Indian graveyard and the few native cabins; the Company's post being at the extreme upper end of the settlement, the trader's at the lower, half a mile [800 m] away. We were entertained from Canadian stations at Calgary and Vancouver and from San Francisco, Hollywood and Salt Lake in the United States, hearing, incidentally, that the Bedaux Expedition had definitely abandoned its tractors and hoped to reach Dease Lake early in October with horses.

Lamarque listened to the radio a couple of evenings while he was at Whitewater.

On Monday, August 27, Lamarque and Stone left Whitewater. Following the Davie trail north through the Rocky Mountain Trench, the men reached Sifton Pass, a low divide between the Peace and Liard watersheds, on the afternoon of August 29. Along the way, Lamarque hiked to the top of a knoll to get a view of the Trench.

> It was a wonderful prospect. On the west the mountains were high and rugged, broken only by the gap known as Fox Pass. To the east, however, they were neither so continuous nor high in the immediate neighbourhood of the Trench. There are at least three gaps or passes—that of Twelve Mile Creek; that by which Joe and I entered the Wolverine Basin; and another to the north. The general trench-like feature is, however, maintained to a remarkable degree.

The two men stopped for the night at Sifton Pass where Lamarque received some unexpected news. In his diary he wrote: "Jack doesn't know trail from

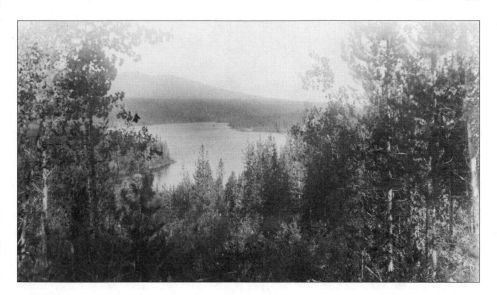

Fox Lake. 2-20, Whyte Museum of the Canadian Rockies.

here to... Frog River. I thought he did. He knows where it branches off though from Sifton Pass trail and that is where we are camped."

In his account, Lamarque explained the situation in more detail.

> Jack seemed thoughtful that afternoon, even troubled, and when he told me there was good trail down the Kechika which would eventually take us to the Dease River at McDame, I knew what the matter was. It was the thought of going into an unknown part of the country, for we were at the parting of the ways. The trail down the Trench to the northwest, was, he said, easy to follow and known to him; the other, a very faint old Indian trail, leading to the west right from where we were in camp, was another matter, and I could see he hoped that, at the last moment, I might decide to follow the one he knew.

Lamarque also commented that Jack "did know, realizing it far better than I, that we might be snow bound in the midst of the mountains for it was getting late in the season and this, I feel sure, was the chief reason why he would have liked to keep to the lower country in the valley of the Kechika."

Since the Bedaux Expedition was now travelling by horse and it was late summer, Lamarque hoped to find a route that would lead more directly to Dease Lake, similar to the one that he had located between Bedaux and Sifton Pass with Joe Poole's guidance. Lamarque knew the latitude and longitude of Whitewater and Dease Lake so he could calculate the approximate direction

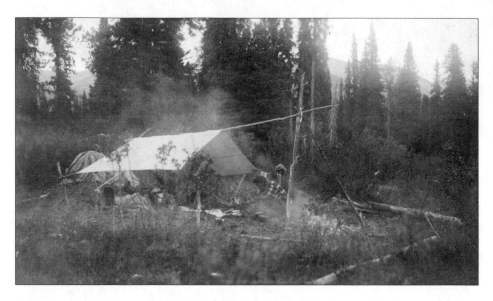

Camp in Sifton Pass. 17-12, Whyte Museum of the Canadian Rockies.

that they should follow. He would also plot the distance and direction that they followed each day. He was fortunate that Joseph Mandy, a BC government mining engineer, had made a map of his trip into the area east of Dease Lake the previous year. It covered about 100 km to the east of the lake so Lamarque could use the map for the last portion of the trip. In addition, Stone had talked to an old First Nations woman at Whitewater who had travelled to Dease Lake many years before, following the route Lamarque wanted to travel. She had provided directions and some landmarks for Stone.

The route that Lamarque hoped to locate would take him through the rugged Cassiar Mountains. Although First Nations people journeyed through the region, there was no well-used direct trail along the route that Lamarque intended to follow. In addition, the BC government had done little mapping or surveying of the area so the geography of the Cassiar Mountains was not well understood.

The next morning was cold but clear and Lamarque noted that Stone was quite willing to proceed. The first part of the journey took the two men northwest to the drainage of the Frog River, which flowed into the Kechika (also known as the Big Muddy).

> Before leaving, we put up a signal and a note for my advance party, telling them we were going through to Dease Lake by the shortest possible route and, as we traversed the dim trail through the spruces just to the north of our camp, we tied pieces of tri-coloured bunting to trees on either side of the old path, a procedure we maintained for

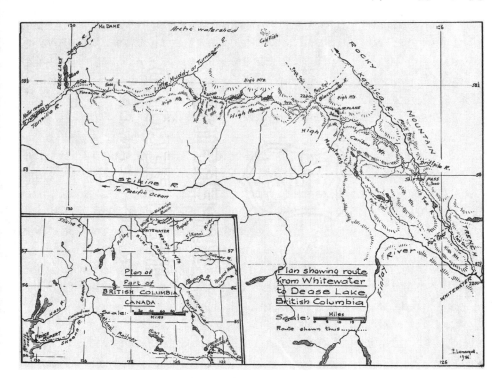

This is Lamarque's map of the route that he followed from Whitewater to Dease Lake. 81-4, Whyte Museum of the Canadian Rockies.

the next four days, besides making numerous blazes as we passed on our way. In the open or at some critical point, the coloured bunting; in the bush, blazes. It was a trail, then, that generally any woodsman might follow with ease and speed.

The trail climbed to a plateau where Lamarque and Stone had a view of the surrounding countryside. They continued northwesterly towards Cariboo Mountain (today Flat Top Mountain) passing "many old Indian encampments and stages on which they had dried meat." At the base of the mountain, the men had to choose whether to go over the mountain, follow a valley that went around the south, or one that went to the north. They decided to turn north and leave the trail. Continuing for a few more hours, the men camped by a small stream with feed for the horses nearby.

They awoke the next morning to a light cold rain with fresh snow on the mountains. In his diary, Lamarque wrote: "Leave at 7:30 and lunch near junction of two creeks at 11:15... Some swamp but generally fair going through jackpine following an old trail part of time." At lunch the rain stopped and the

weather cleared. Lamarque had good fortune that afternoon. Just after lunch he met Ludwig Smaaslet again and a trapper named Lindquist, who were on their way back to their cabin on the Driftpile River about 8 km north of Sifton Pass. "They had 2 dogs packing for them but carried nothing themselves but rifles. Chatted a few minutes." See image LaE.05.01, page 99, bottom.

The men told Lamarque and Stone that they would soon cross an open prairie and at the end they should leave the creek and go over a plateau. This corresponded with information Stone had gathered from the woman at Whitewater. In his account, Lamarque wrote: "As the afternoon waned we had much swamp to negotiate and I was glad to see a fine little prairie of excellent bunch grass at the highest point on the plateau we reached. We camped there, a splendid place, with commanding views in all directions. These are the sort of places that are dear to the heart of an explorer, where he may note the type of country to expect on the morrow or, possibly, for two or more days in advance." Lamarque could see that they were on the lower slopes of Cariboo Mountain and in his diary he noted: "saw 28 goats from our camp."

On September 1, Lamarque and Stone continued their journey. After travelling across the plateau for two hours, they started down the valley of a large creek through jackpine and open flats. The men saw many blazes and signs of old camps. In the afternoon, they encountered a "grizzly bear feeding on carcass of moose on our trail. Make a detour to avoid him and he runs away over swamp to the south." In the late afternoon, Lamarque and Stone reached the Blackwater (Frog) River trail, followed it to Airplane Lake, and stopped to camp at a small lake just beyond. Jack knew the area, for he had been on this trail during the previous fall.

The next morning, after about three hours of travelling, Lamarque and Stone reached Big George's cabins on the Frog River. Lamarque wrote about him: "Big George, an Indian from the Liard country, has three or four cabins where the trail crosses to the westerly side of the river. He was not at home and the windows were boarded up... Arnold Towers, the trader at Whitewater, had occupied one or more of these buildings of Big George's during the past winter, using the place as a trading post."

The men forded the Frog and continued near the river for an hour until lunch. Lamarque plotted his plan and calculated that they were about 160 km due east of Dease Lake, or about 200 km by trail. Stone told Lamarque that the trail divided here, with one branch going down the Frog to its junction with the Kechika, and the other heading out of the valley towards Cold Fish Lake. On the trail towards Cold Fish Lake there was a big creek coming down the valley to the southwest. According to the elderly woman at Whitewater, there was an old

trail that led in the direction of Dease Lake through this route. In his account, Lamarque wrote:

> We sat around and talked, that beautiful day, in the glorious sunlight. I brought out my government map and showed him on it just where I thought we were, plotting, very approximately, our position from my notes of the way we had come... It was a critical point in our journey. However, finally in agreement, we turned to the southwest and all that afternoon, as we made our way up the valley, Jack worked very hard on the old trail, to which we came about an hour after starting.

Lamarque noted that the old trail was well blazed as they followed the large creek up the valley. They continued until late afternoon when they found a good location for camping.

On September 3, the men continued their journey, stopping for lunch at an animal lick. Soon afterwards, Lamarque and Stone crossed a large creek flowing into the main valley. They tied the horses while Stone went up the main valley and Lamarque explored the one leading up the creek they had just crossed. Although neither man located a trail, Lamarque found a well-used game trail. Looking across the main valley he could not see an obvious pass through the mountains above them. "My mind was made up. We would try the gap to the north." Lamarque rejoined Stone, who had not found a trail, "so we turn up valley of creek and cross to big moose trail I had found and so to camp in good feed at 5 pm."

Big George's cabin on the Frog River. E011074390, Library and Archives Canada.

The next morning was a beautiful day and the men got an early start. "There were no high mountains to the northwest, the direction in which we were going, and when we got to a turn in the valley so that we could see to the west, I was relieved to note that there were no high mountains ahead, only a broad plateau or pass between the moderately high hills to the north and the rugged range on the south... Ahead, leading up to the plateau before us, we could see a wide game trail along the crest of a gravelly ridge." By 9:45 a.m. the two men were in the pass that is today named for Lamarque. "Before us, to the west, the ground rose gradually in a broad, undulating, grass-covered U-shaped valley; a true pass, indeed, across which we rode that beautiful morning with the wind blowing briskly in our faces, a bitter wind that, despite the sunshine, forced us to button our coats more closely around us." They travelled through the pass for about an hour and a half before stopping for lunch.

At the west end there was a small lake, then Lamarque and Stone followed game trails down to a large valley with a sizeable creek (today Jack Stone Creek). They proceeded northwest up this valley. Lamarque was surprised to find that the creek flowed southeast. "I was astonished at this, for I had expected to find it running in the opposite direction, away from those high mountains... It could only mean one thing—that there is a pass through the range which I had scanned so critically from the lick the day before." The men crossed a little valley that came from the southwest and nearby found a place that had been a hunting camp, probably for people who had come into the area from the Stikine River.

On September 5, the men travelled west over a low height of land that was the divide between the Frog River drainage and the Stikine River watershed.

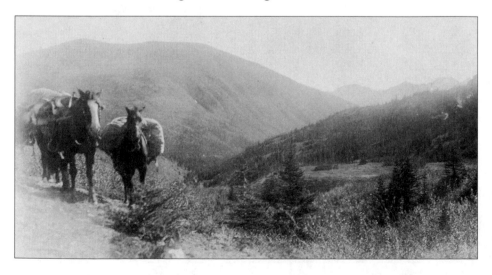

Looking east from the east end of Lamarque Pass. 2-31, Whyte Museum of the Canadian Rockies.

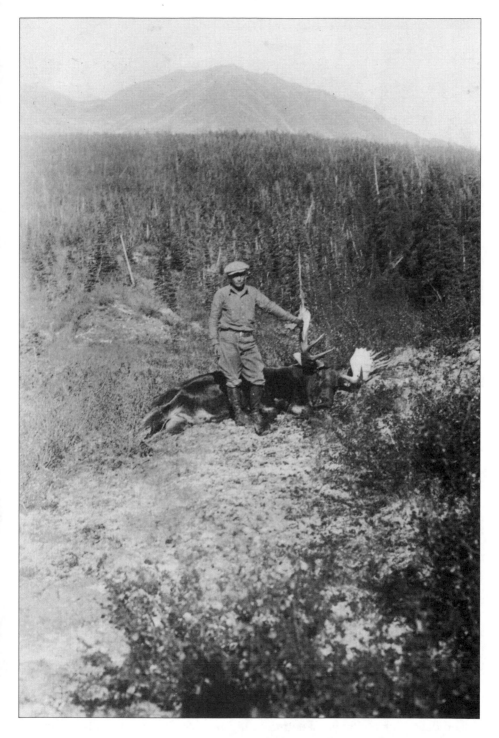

Jack Stone and the moose that he shot. 2-34, Whyte Museum of the Canadian Rockies.

Approaching Tucho Lake, which is in the background. 2-38, Whyte Museum of the Canadian Rockies.

They passed Tucho Lake along the south shore where numerous moraine boulders made the terrain difficult for the horses.

Crossing the creek at the outlet, they continued for an hour and stopped for lunch. There was a large valley from the north but Jack could find no sign of a trail in that direction, "so with the knowledge that there was a great wide valley ahead of us and a well-defined gap in the hills to the north, we saddled up and started off once more." During the afternoon, they passed an old abandoned sled leaning against a tree. Their route headed mainly west along the Tucho River valley since there was no apparent route through the mountains to the north. In the late afternoon, the men turned to the west and reached a low jack-pine-covered ridge where they stopped for the night.

Soon after leaving on September 6, Lamarque and Stone passed a First Nations winter camp. "Many trees had been cut down and there was old stove piping lying in the bushes." An hour and a half after their departure, the two men reached Hottah Lake. In his diary, Lamarque wrote: "Made for north side and found narrow arm extending northeasterly for half a mile or more [1 km]. Went up same and crossed by rough bluff with stream and bottom 30 feet [9 m] wide. Saw small lake to north in valley surrounded by high mountains. Continued down north side of lake until 11 to lunch at NW corner of lake." In the afternoon the two men followed a route west through a valley with mountains

on both the north and south side. They saw many old blazes and a "grassy area where someone had put up hay for we saw remains of stack."

The next day the men continued in a generally westward direction and began emerging from the rugged mountains. In his diary, Lamarque wrote: "Don't know where we are except that we are on Little Muddy [Turnagain] water. Shall keep going westerly and a trifle northerly. Country open and good." Lamarque realized that as long as he continued west he would be getting closer to Dease Lake and soon would be in the area covered in the copy of Mandy's map that he had. From the direction that the creeks flowed, Lamarque knew that he had passed back from the Stikine drainage to the headwaters of the Turnagain (Little Muddy) River. The Turnagain, a sizeable watershed with many branches, flowed northeast into the Kechika River north of the Frog River.

By the afternoon, Lamarque recognized his location.

> At the easterly edge of his map Mandy showed the Turnagain making a great bend from the west to the north and with a branch from the south coming in near this bend. He showed that the westerly branch forked, and a lake called Wolverine Lake [was] about two miles [3.2 km] above this fork on the northerly of the two branches.
>
> I showed the plan again to Jack who looked rather serious and shook his head. I told him that we would take the valley to the northwest, that I thought these streams were the Turnagain, and that if we came to a lake in about an hour there would be no question as to our position and that we should, by the evening, be on a regular pack trail.

They reached Wolverine Lake as described on the map. Lamarque knew that "we were now no longer exploring and it only remained for us to follow a generally well-beaten trail to the southerly end of Dease Lake as quickly as might be." The men continued past Wolverine Lake and camped at a small lake farther west. From the rim of the basin above it, Lamarque could see the Turnagain valley to the west and, to the east, the high mountains in the Tucho Lake area.

The next afternoon, they reached the Turnagain River where they found a good trail. Lamarque noticed that a man with dogs and some horses had passed by recently. They followed the river upstream and crossed the Turnagain on a bridge that had been constructed the previous year. Lamarque described it: "The bridge is about 120 feet [37 m] long and 6 feet [1.8 m] wide and is carried by four simple piers to wooden abutments at both ends. It is built of the trunks of trees, extending from pier to pier and is of sufficient strength for any purpose for which it may be needed at present." Shortly after

crossing the bridge, the men found a location to camp along one of the lake extensions of the Turnagain.

They continued along the trail to Dease Lake on September 9. "Early in the afternoon we passed a small cabin and a tent, the latter belonging to George Ball of Telegraph Creek who acts as guide to hunters of big game in these regions. We left the vicinity of the river there, cutting across the great bend which it makes to the south, on a well-defined trail." Their camp that night was in sparse timber at an elevation about 200 m above the river. The trail continued at a high elevation the next day and they saw several caribou. The men crossed Cariboo Pass in the afternoon and moved into the Tanzilla River drainage on the Stikine watershed. On Tuesday, September 11, Lamarque and Stone left at seven in the morning. At lunchtime they could see Dease Lake, and by 5:15 they had arrived at the Hudson's Bay Company post. Lamarque wrote: "We had come through from the Finlay by a route known only to a few natives, by so straight a one, indeed, from Sifton Pass, that one can but marvel at the favourable topography in that sea of mountains which had enabled us to do so."

At Dease Lake, Fleming, the HBC factor, provided supper for Lamarque and Stone and offered the two men accommodation for the night. Lamarque wanted to go on to Telegraph Creek as soon as possible to send a message to the Bedaux Expedition and let them know that he had located and marked a route to Dease Lake since the main part of the Expedition was probably somewhere in the area between Whitewater and Sifton Pass.

That evening a truck with two men arrived, delivering some gasoline for a mining company down the Dease River. "They said they were starting back to Telegraph Creek as soon as they had unloaded. Their employer, a man named Morrison, carried on a freighting business on this road besides running a hotel at Telegraph Creek which he leased from the Hudson's Bay Company. As the men were evidently determined to start back right away and it was impossible to say when the next opportunity would occur, there was nothing for it but to accompany them."

The men left about 9 p.m. and drove until about 1 a.m., when they stopped for the night about halfway to Telegraph Creek. The next morning the two men returned to Dease Lake and about fifteen minutes later Morrison, Albert Dease and another man arrived. Morrison had been following the progress of the Bedaux Expedition. After lunch, Dease left to go hunting while Lamarque went with the other two men to Telegraph Creek, arriving at 5:30. Lamarque sent a telegram to his wife, Winifred; had supper at Morrison's hotel; and spent the evening visiting the schoolmaster, Indian agent and telegraph operator.

While Lamarque located a route to Dease Lake, the Bedaux Expedition

Lamarque at Dease Lake. 5-5, Whyte Museum of the Canadian Rockies.

continued on horseback. On September 4, the group reached Fern Lake near the Muskwa summit where they remained until September 7. The previous day, at Geake's cache, not far below the lake, Bocock found a note from Bill Blackman saying that he expected it would take ten to fifteen days to get a trail through to the Davie trail. He wrote in his diary, "This is serious as he should have been there before this." The next day, after consulting with Bedaux, "it was decided that I shall have tomorrow to take charge of Lamarque's party and speed up the trail cutting." Bocock left on September 5 and caught up to the trail-cutting crew the following afternoon. "They are cutting a much too elaborate trail. Decided to swing down the Warneford and then down the White to Whitewater." Although it was getting late in the summer, Bedaux probably wanted to go to Whitewater to pick up supplies and rest. He also knew that some of the horses were developing hoof rot and this was slowing down the expedition. The Bedaux Expedition reached Whitewater on September 13 and spent a week there.

Lamarque remained for three more days at Telegraph Creek. "I sent off a wire to Vancouver, a message I wished to have broadcast so that the wireless receivers at Whitewater might pick it up and inform the main party of the expedition that a short route was available through the mountains to Dease Lake." Unfortunately that message was not forwarded so the Bedaux Expedition did not hear about Lamarque's success while they were at Whitewater. Lamarque purchased some supplies and was busy with correspondence. He also had a long visit with George Ball.

On Saturday, September 15, the boat arrived from Wrangell in the morning. Lamarque noted that the boat came about every ten days to Telegraph Creek and its arrival brought much excitement to the community. The Hudson's Bay Company store was busy selling goods. It also had the post office and most people were picking up their mail. Around four o'clock in the afternoon, Lamarque, Col. F.C. Weems of the Princeton Club from New York City and a third person left in a vehicle for Dease Lake. Weems and Lamarque spent much time in conversation and they arrived at Dease Lake at three in the morning.

Around noon, Lamarque went to visit Jack Stone, who had set up a comfortable camp at the edge of Dease Lake. Stone used some of his wages to purchase articles at the HBC store, while Lamarque bought some provisions for the return trip. Lamarque moved into Stone's camp for he intended to start on the return trip on Monday, but it was a "cold, poor weather day. NE wind. Waves breaking on beach of Dease Lake. Rain and snow higher up. Bah!" In his account, Lamarque wrote: "We really had a very snug bivouac, our somewhat small canvas covering replaced by an ample one loaned me by George Ball, one within which there was room to move about and at the same time store all our supplies."

On September 18, it was -10°C at 5 a.m. Lamarque and Stone spent the morning searching for the horses so they didn't depart until 1 p.m. At their campsite that night there was about 10 cm of snow and the temperature in the evening was again -10°C. The next day the two men crossed Cariboo Pass where they saw grizzlies and caribou. On September 20, Lamarque and Stone awoke to find that it had snowed about 10 cm that night and there was about 30 cm of snow on the ground at their campsite. "Rather an unpleasant day. Snowing most of time but wind, after ten days in the northeast has, I am glad to say, moved to the west. Am afraid of the snow in the passes and am now thinking of going down the Little Muddy [Turnagain] to the Forks [the Kechika River] and thence back to the Finlay... Not a very cheerful position." Lamarque was anxious to rejoin the Bedaux Expedition as soon as possible and he did not want to take an alternative route and possibly miss them. However, he had to be sure that the two men returned safely. If they needed to take a route that stayed in the river valleys, even if it was a significantly longer distance, he would do so.

SEE PLATE LaE.05.05, PAGE 112, BOTTOM.

Fortunately, the weather improved and the temperature became warmer so Lamarque and Stone decided to continue on the same return route. The men left early in the morning and had a full day on the trail. Since they knew the route, they were able to make good time. They had lunch near the bridge over the Turnagain on September 21, and on the evening of the twenty-third they camped just before Hottah Lake. They reached Tucho Lake on the morning of September 25 and this time went along the north shore of the lake. They camped that evening en route to Lamarque Pass. During the day it had warmed up to +11°C. They reached Lamarque Pass the next morning. There was a strong west wind and rain so they hurried through. The men camped that night by the animal lick they had passed around noon on September 3. "No snow at lick, the first time we have been out of snow for 8 days. Very agreeable to be away from it. High westerly wind and storming on the summit." On the morning of September 28, they crossed the Frog River at Big George's cabins and had lunch at their campsite at Airplane Lake. Lamarque decided that he was going to return following a shorter and better route that went to Fox Pass and on to the Davie Trail south of Sifton Pass. He had not yet seen either his trail-cutting crew or the main Bedaux party. Before leaving the lake, "I cut a great blaze on a nearby pine and wrote thereon a message to the effect that we were ten days out from Dease Lake and returning through Fox Pass. We tied streamers of tri-coloured bunting round the tree so that no passers by could fail to see the message."

In the mid-afternoon, they reached the junction of their old trail and the Blackwater trail. Lamarque again left a marker and message. About an hour

south, the men camped for the night. September 29 was a sunny day for cross-
ing Cariboo Mountain, and Lamarque and Stone had an excellent view of the
entire area. They spent most of the day on the large mountain, which at an
elevation of almost 1700 m had only a few small trees. That night they camped
on its southern rim in some timber. "It was late when we stopped to camp and
quite dark before we were settled for the night. The temperature was 38 [+3°C],
the sky overcast, and we had hardly put our shelter up when, with a rising wind
from the northwest, snow commenced to fall."

> We were up at three the next morning. The wind had dropped and
> the snow ceased to fall. Our shelter, however, sagged with its weight
> and some had drifted far inside over the lower part of our bedding. I
> was anxious about our horses... We finished breakfast before it was
> daylight, before even the dawn stole over the mountains to the east.
> Jack got the horses without trouble and we were away before seven,
> stumbling and sliding down the steep, snow covered hillside leading
> to the valley below.

A couple of hours after leaving camp, Lamarque and Stone passed one of
Big George's trapping cabins. The sun came out, the temperature warmed, and
they had an early lunch just beyond the south end of Porcupine Lake. In the
middle of the afternoon they reached the Wilson trail. "It is really an old Indi-
an trail improved by the Wilsons, a well-known British Columbia mining family,

Camp on Cariboo Mountain. 17-10, Whyte Museum of the Canadian Rockies.

who did so, quite recently, in order to investigate mineral prospects in the valley of Porcupine Creek." Lamarque and Stone stopped early that night in a meadow along the trail.

October 1 was another sunny day. The men passed Wilson Lake and then Candy Lake, and followed Ruby Creek south, camping along the creek that night. By nightfall of the next day Lamarque and Stone reached the western end of Fox Pass. There were some cabins belonging to Jack Abou and another person from Whitewater, and they were there with their families. "Jack Abou and another Indian were soon down to see us, saying that the main party of the expedition had left Whitewater two weeks before, going north towards Sifton Pass." Lamarque was now unsure about the location of the Bedaux Expedition. "However, whatever was ahead of us, I decided to go through Fox Pass rather than continue on the Wilson trail... Jack Abou had intimated that he thought we should find the main party before we had gone very far. Why he thought that I did not know and could not determine."

Lamarque described the scene at Fox Pass the next morning.

> The view, as the traveler approaches them [the cabins] along the trail from the west is wonderful and from where we were camped in the lowlands by the stream, these cabins, strung out along the light, gravel coloured ridge, the termination of a shoulder that springs from the hills to the north, made a remarkable foreground to a fine picture; with a deep and but partly visible basin in the right, middle distance; the blue-grey mottled masses of the high range which flanks the Rocky Mountain Trench on the west, in the background.

The men departed at 7:30 a.m. on October 3 and in about twenty minutes left the Wilson trail to head east through Fox Pass. They took the more northern of the two trails through the pass. About four hours later they were at the eastern end of the pass. "As I led my saddle horse up a steep hill I heard Jack, who had just topped the ridge, give a shout and I saw him pointing into the great valley below. He had pulled up his horse and I quickly joined him. There, below us, barely a mile away, was a large encampment and many horses. I looked at Jack. There could be little doubt who they were. So, in this rather dramatically sudden fashion, my conjectures were set at rest and thus, for the first time, came in touch with the main party of the expedition."

In Bedaux's diary, he recounted the arrival of the two men. "Freer calls, 'Here is Jack Stone with Lamarque.' I think I am dreaming, but soon learn that a heavy weight has been taken off my heart. He has come through Fox Pass... From what he says I gather rescue party is safe and will soon be with us.

Telegraph Creek has been reached... At dusk we shoot whole camp scene with flares. Josephine [Bedaux's maid] slips too much smoke. Offer Lamarque a hot bath. He accepts. Josephine will give it!" Swannell wrote: "Lamarque & Indian Jack Stone arrive dramatically about noon just after staging of a motion picture in which horses were supposed to be playing out."

Lamarque learned that the Bedaux Expedition had left Whitewater and reached Sifton Pass where they found his message at the junction of the trail heading west. A couple of men followed the trail for a distance and found that the trail gained elevation and they encountered deep snow. Bedaux, in consultation with others, decided to continue trying to reach Dease Lake by following the Davie Trail north through the Rocky Mountain Trench to the Turnagain River. They proceeded only a short distance before camping. When two new cases of hoof rot were found the next morning, Bedaux cancelled the expedition and began returning to Whitewater.

On September 28, Bill and Charlie Blackman and Edgar Dopp went to search for Lamarque and Stone. They travelled out to the place where Lamarque's return route branched off, then followed it back through Fox Pass to Whitewater. Carl Davidson picked the men up at Fort Ware after the main group had started down the Finlay, and the two Blackman brothers and Edgar Dopp rejoined the expedition at Deserter's Canyon.

On the return trip to Whitewater, the Bedaux Expedition spent some time filming scenes for the movie that Bedaux planned to make of the adventure. October 4 was a rainy day and Lamarque relaxed around camp. He visited Bedaux and showed him the sketches he had made during the expedition. The next day, before the expedition moved south, Jack Stone used his wages for a grubstake from Bedaux, along with six pack saddles and a horse, and headed north on his way to Chee House at the junction of the Kechika and Turnagain rivers.

By October 6, the expedition was back at Whitewater where Bedaux made arrangements for boat transportation down the Finlay and Peace to Rocky Mountain Portage west of Hudson's Hope. In his diary entry for October 7, Lamarque recalled that it was thirty years ago that day that he had arrived at Hudson's Hope as factor for the post. Lamarque partook of an unusual activity that day. "Bruce Bocock and I cross river in Eskimo kayak type of canoe brought out from Austria by Bedaux." In his account, Lamarque noted that Bedaux transported it to British Columbia and had it "shipped to Whitewater for possible use by the expedition. This fine little craft about 15 feet [4.5 m] long, three feet [90 cm] wide and weighing considerably less than 100 pounds [45 kg], could easily be taken apart and reassembled, and yet was so strongly made that it could

withstand many hard knocks and the vicissitudes of voyages in rough waters." Bedaux gave this portable craft to Jim Ware.

By October 18, Lamarque had returned to Hudson's Hope where he stayed at the home of the Hudson's Bay Company factor and his wife. "Hardly recognize the old place—don't in fact, though terrain is just the same except for denudation of local forest." After Bedaux hosted a banquet at Hudson's Hope on October 19, Lamarque began his return trip on October 20.

Lamarque's success in locating a route through the Rockies at Bedaux Pass; finding the shortest and best trail from there to Sifton Pass; and then establishing a direct route to Dease Lake was probably the greatest accomplishment of the Bedaux Expedition. Lamarque had several fortunate circumstances and a good relationship with Joe Poole and Jack Stone, who shared their knowledge of the geography of the area. He was the only member of the Bedaux Expedition to traverse the entire route from Fort St. John to Telegraph Creek and this makes his visual record particularly important. The half-track Citroens had been a failure in crossing the terrain of northern BC, but Bedaux liked to trumpet the fact that his expedition had located, as intended, a new navigable route across the mountainous landscape between the Peace River area and the Pacific coastal region.

Unfortunately, the Bedaux Expedition did not utilize much of the information that Lamarque gathered. He believed that the expedition would have likely been successful if the route location had been done the year before the journey began. Lamarque's and Swannell's maps provided more detail about an area of British Columbia that was not well known, and Lamarque's sketches, paintings and photographs give an excellent depiction of this strange, unique adventure in northern British Columbia's history.

1935 | 37 CENTRAL COAST

> The 1930s were what is known as Depression times, when work was scarce and many were on relief. To ease this situation, the federal and provincial governments co-operated in creating various public works, one of which was the improvement of old, or the creation of new trails in various parts of the country, and in '35, '36, and '37 I examined and reported on various trails on the lower mainland, Vancouver Island, and in the Bella Coola area.

In his memoirs, Lamarque described some of the BC government's Department of Public Works projects with which he was involved.

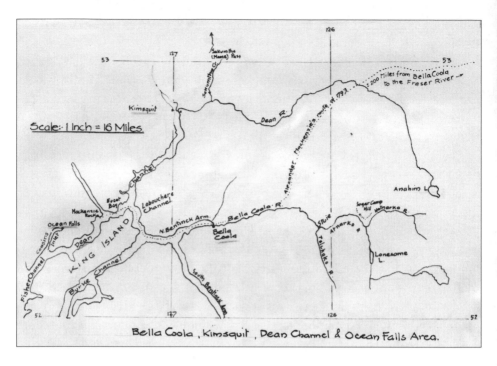

Bella Coola, Kimsquit, Dean Channel & Ocean Falls Area.

A map of the BC Central Coast region, showing the locations where Lamarque surveyed from 1935 to 1937. Map-81-1-memoirs, Whyte Museum of the Canadian Rockies.

One of these was from the upper end of Harrison Lake and up the Lillooet River. This was one of the routes that had been followed by the gold seekers of the 1860s... When we were there, Robert Pontifex and I, the place, with the exception of one or more native families, was entirely deserted. Our inspection of the trail took us as far as the Indian village of Skookumchuck [on the Lillooet River], where there was a church and a large cherry orchard fairly laden with fruit.

Lamarque wrote about his surveys on Vancouver Island.

I also traversed many old trails in the southwesterly part of Vancouver Island, where the rainfall is heavy and the forest more or less a jungle. One of these was from Ucluelet, near the entrance to the Alberni Canal, by way of Kennedy Lake and river to Sproat Lake and so to the town of Alberni at the head of the canal... It was while I was engaged on this survey that I became acquainted with Sidney S. Ells, a member of the Geological Survey of Canada.

Ells had made the initial surveys and reports on the tar sands in the vicinity of Fort McMurray in 1913. He and Lamarque established a lifelong friendship and Lamarque's correspondence with Ells is preserved at Library and Archives Canada.

> Another very old trail which I examined was from Cowichan Lake via the upper Nitinat and Cameron rivers to the Nanaimo–Alberni highway near the town of Alberni. This trail was not too easy to follow, and for long distances was completely obliterated by fallen timber and the debris of the forest.

Lamarque and his companion took four days to make the journey of approximately 100 km.

> This was indeed an old trail. Here and there we could see the rotten remains of old bridges across small creeks, or of old corduroyed timbers in swamps. Many, many years before there had been some mining excitement in this part of the island, which, I believe, was the reason for the trail.

Much of Lamarque's surveying during these three years was in the Central Coast region, especially the upper Bella Coola valley.

> When I went there, quite a good motor road traversed the valley for some 40 miles [64 km] from the sea, and beyond that, a good pack trail led over the hills to Anahim Lake and the Cariboo country. The road ended near the confluence of the Talchako and Atnarko rivers which together form the Bella Coola, and it was there, at Stuie, that a young Englishman, T.A. Walker, had an attractive hunting lodge.

Tommy Walker, the famous guide who later established a lodge at Cold Fish Lake in northern BC, and Lamarque formed a lifelong friendship. Lamarque's correspondence to Walker is held at the BC Archives.

> My work lay up the valley of the Atnarko and its tributaries, particularly in the vicinity of the steep escarpment called Sugar Camp Hill, where the trail climbed laboriously over an ancient rock slide. Beyond this hill, and on up the valley of the Hotnarko towards Anahim Lake the region is somewhat desolate and unattractive; a rugged undulating, partly rocky terrain, the timber generally small, scrubby...

I rode over some of this country with old Squinas, who was then the chief of the natives who inhabited that area.

Lamarque noted the impact of the telephone in this remote area.

There was one modern amenity which they all, more or less, enjoyed—a telephone line from Bella Coola to the Cariboo. Many of them, therefore, could talk to one another and listen in to what others were saying.

Lamarque came to the Bella Coola valley in September 1935 and spent a couple of months surveying for the Department of Public Works. His main objective was "to relocate the Belarko–Hotnarko pack trail on Sugar Camp Hill." There were also some improvements to the automobile road at the upper end of the valley.

In his government report, he provided the rationale for the new trail.

I did not commence the construction of this new trail on Sugar Camp Hill without due deliberation, for I was not immediately convinced that it was desirable to climb about 1500 feet [460 m] around and beyond this hill to descend 300 feet [90 m] or so again to the level of the trail along the Hotnarko above the "zig-zags" at the canyon thereon. There was, moreover, the telegraph line to consider for, eventually, if the trail up the lower Hotnarko is not maintained, this part of the telegraph line will, in all probability, have to be diverted up Sugar Camp Hill...

As travel in the deep valley of the lower Hotnarko below the canyon is both difficult and dangerous during the winter (this part of the Hotnarko route is practically sunless for six months of the year)... I came to the conclusion that the new trail would be a distinct benefit to the district and acted accordingly.

Lamarque made a sketch and described the new trail, noting that, "rock slides were avoided wherever possible. Where crossed by the trail, they are indicated on the sketch." He remarked that he examined the Palmer trail, made by the Royal Engineers in the 1860s, which passed through the same area. "I found the trail generally unsuitable, however, though I am of the opinion that, if considered advisable, a good location could be found."

In his report, Lamarque also mentioned the idea of constructing a road to complete the route from Williams Lake to the ocean. "While the pack trail

between Stuie and Anahim Lake forms an easy way for travellers to reach the interior from the coast or vice versa, the fact remains that there are but 40 miles [64 km] of road construction necessary to join up the Bella Coola–Stuie road with that which extends from Williams Lake to Anahim, most of which, certainly would not be expensive to construct. I am of the opinion, moreover, from my observations there, that a suitable road could be built on Sugar Camp Hill." The road was not completed for automobiles until the early 1950s.

In May 1936, Lamarque returned to Bella Coola. He and Maxie Hickman located and blazed a 4 km cutoff at the bottom section of the descent to the Hotnarko River that had a much more even grade and was shorter. He made a reconnaissance for a potential new trail in the Precipice portion of the trail, the steepest section. At the end of May, Lamarque made a survey near Ratcliffe's farm where the Bella Coola River was eroding the bank near the road and making it dangerous for travellers.

Following this work Lamarque went to Kimsquit at the head of Dean Channel, further north along the Pacific coast.

> From the upper end of Dean Channel, at a place called Kimsquit, where there were two salmon canneries, one on either side of the narrowing waterway, a pack trail follows up the valley of the lower Dean River and that of Sakumtha Creek, a small tributary coming in from the north. Creswell, an Englishman and an old-timer in the country, had a cabin some miles up this valley, and accompanied by him, one of his pack horses, and a settler named Young, I traversed part of this trail up the Dean... Leaving Creswell and his horse at his cabin, Young and I, carrying light packs, went to the pass at the head of the east fork of the Sakumtha, for the trail, at that time, was not suitable for pack animals. We camped at the pass and for a short distance, examined the trail leading down a creek which then drained to the Nechako River [watershed]. See image LaE.05.61, page 103, bottom.

The trail from Kimsquit over the Sakumtha divide into Eutsuk Lake on the headwaters of the Nechako watershed was an old First Nations trail. It had been considered as a potential route for the Canadian Pacific Railway in the 1870s. In 1926, during his survey of central British Columbia, Frank Swannell visited the area around the pass. In his government report, he wrote: "Last year about 12 miles [20 km] was opened up and built from Kimsquit to the mouth of the Dean [River], to a bridge a couple of miles up the Sakumtha." See image LaE.05.20, page 97.

The Department of Public Works was considering further development of this trail as part of increasing tourism in the area that was soon to become Tweedsmuir Provincial Park. The Canadian National Railway and the BC government wanted to promote a tourist route that would go from Burns Lake to Ootsa Lake where guides could take clients on a variety of trips around the chain of lakes in the area. The return trip could go from Eutsuk Lake over the Sakumtha trail to Kimsquit where the tourists could go to Vancouver or Prince Rupert by boat.

In his memoir, Lamarque wrote:

> On our return journey we sighted a black bear which Young shot at and missed. Saying that he would try for another shot, I went ahead to make lunch just across a low, narrow canyon through which the creek pursued its tumultuous way. This canyon, some 25 ft [8 m] wide, was crossed by a single cedar log of quite 30 inches [75 cm] diameter. I was just taking off my pack and preparing to make a fire, when a slight sound caused me to look back, and there was the bear, half way across the log. He saw me at that moment and paused there, a most comical expression of indecision on his face. Now, not wanting to see the bear come to harm, and knowing that Young could not be far away on the trail above, I encouraged the bear by gestures and voice to go downstream, which the animal, returning to the shore from which he was coming, happily did. A few minutes later, Young arrived saying he had seen nothing more of the bear. He never knew that I had.

Plans to develop the Sakumtha trail never proceeded.

In late May 1937, Lamarque returned to the Bella Coola valley. There had been a flood the previous fall that had caused considerable damage. Initially Lamarque went to Atnarko. "At Atnarko I arranged over the phone for Chief Thomas Squinas to meet me the following evening [May 29] at the Precipice Camp and proceeded there on foot with M. Hickman in order to look over the proposed cutoff." Lamarque found a few places where he could improve the trail location. "On the 30th M. Hickman returned to Atnarko and I proceeded with Chief Squinas to look over the country from the forks of the Hotnarko River to Pelican Lake. Lester Dorsey believed that an excellent trail could be made through this area to Anahim Lake. I spent two days riding over this region with Chief Squinas of Anahim Lake." Dorsey was away at the time and Squinas was the most knowledgeable person available. There was still snow on the ground in some sections so it was hard for Lamarque to fully examine the area.

In his report, Lamarque wrote:

> The trail between Belarko and Atnarko is, on the whole, in good condition despite the destructive consequences of the super flood of last November. Unfortunately the new bridges across Mosher and Young Creeks were carried out by the recent high water, but when these have been replaced and a new bridge constructed across a small creek just west of Atnarko, the trail will be easily negotiable by travelers except for a few hundred feet at Raspberry Flats, about a mile [1.6 km] east of the end of the road, where the Atnarko River, deflected by a slide on the southerly side, when high, now flows across the trail to the base of the hill. A new piece of trail should here be constructed along the side hill for the general convenience of the public, and the Governor-General's party later in the summer. [Lord Tweedsmuir, the Governor General of Canada, was coming to visit the newly created provincial park named for him, and his itinerary took him through the Bella Coola valley.]

On his way back to Bella Coola, Lamarque made two surveys. One was to divert a creek, whose flow had been changed by the flood, away from the pasture of a settler. The second, and more important survey, was at the Bella Coola River at the mouth of the Store Branch. Lamarque noted that the river had changed course considerably since he was there the previous summer "and threatens, should as much erosion occur again at this end of the island as that during the past year, to send a considerable part of its main stream down the School Branch with disastrous effects to the highway and the settlements below." Lamarque presented his recommendations for remediation of the road and the surrounding area.

1938 | MANSON CREEK

In 1938, Lamarque spent most of the summer relocating the northern part of the 250-km road between Fort St. James and the Omineca River at Germansen Landing. His assistant was Earl Cushing, who had worked on his crew during the Bedaux Expedition. Initially there had been a gold rush into the Omineca region in the early 1870s and there was a renewal of mining activity in the region in the 1930s. In 1938, there were two outfits mining on Germansen Creek, one on Manson Creek and the Consolidated Mining and Smelting Company on Slate Creek.

Beginning in 1934, the Department of Public Works reconstructed almost all of the road from Fort St. James to Germansen. In 1937, the department spent

The road to Manson Creek near Baldy Mountain. 4-7, Whyte Museum of the Canadian Rockies.

over $150,000 on this project, and in 1938 about $110,000. Its goal was to have a gravel-surfaced road that trucks could use to haul capacity loads the entire distance. This was needed to keep up with the mining activity in the region.

The section of road that Lamarque worked on was in the area south of Manson Creek and was the highest and most difficult part.

> [It] went over the easterly shoulder of Baldy Mountain where... the snow lay deep in winter. There were some very steep gradients over this shoulder, particularly on the northerly slope down to Manson Creek. Cushing and I cruised through the country with packs on our backs, and later, with the aid of a native, Jean Marie, and his pack horse, went even further afield, finally deciding on a new location for the road well to the east, in a lower country where the snowfall was less and the grades comparatively easy...

Tractor hauling truck across Baldy Mountain summit, July 4, 1938. 4-8, Whyte Museum of the Canadian Rockies.

One of our camps on the old road, near the southerly base of Baldy Mountain by the waters of Gillis Creek, was close to the grave of Hugh Gillis, a native of Souris, Prince Edward Island, who died there on August 19, 1872. As the words engraved on the board at the head of the grave were quite legible it is probable that the original board had been replaced...

One Sunday we stayed in camp near the grave. The log fence around the grave was broken and in decay, so I spent part of the afternoon replacing it with pine logs which I cut from the nearby bush. It is a pleasant locality; a parklike area with an abundance of good pasture. The rounded treeless dome of Baldy Mountain is but a few miles to the northwest, while the little creek, in its gravelly bed nearby, passes merrily along on its way down the valley...

In September we went up the Omineca River from Germansen to look at the country to the north of that stream, towards Aiken Lake [another area of mining activity]. We went up in a scow driven by three 9 H.P. [horsepower] motors. At a place where the current ran swiftly over a shallow gravelly bed, I slipped while attempting to push

Gillis' grave. E011074409, Library and Archives Canada.

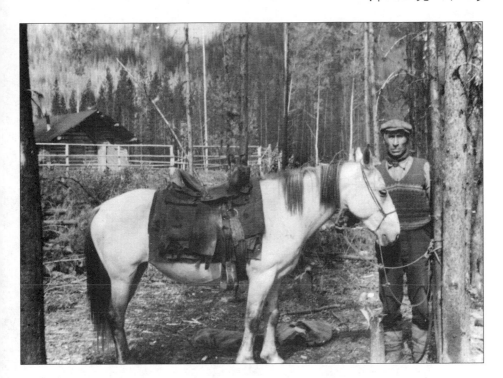

Jean Marie, 4-30, Whyte Museum of the Canadian Rockies.

a log out of the way of the scow, missed my target and fell overboard. Landing on my back, I endeavoured to catch hold of the square bow, failed, and receiving a violent blow on the left side of my head, was swept under by the current... I struggled to the side of the scow, at right angles to the boards. I came out with a rush, and fortunately Cushing was there to grab me.

The *Prince George Citizen* published a newspaper article on September 22 describing Lamarque's rescue.

Surveyor Falls from Scow on Omineca River

Falling off the forward deck of a 40 foot [12 m] freighting scow Tuesday afternoon on the Omineca River where there was barely enough water to float the craft, Ernest Lamarque, 58-year-old surveyor of Vancouver, was rolled over and over for some two minutes while the scow passed over him. Lamarque was rescued by fellow passengers at the stern of the scow when he popped up from under the craft.

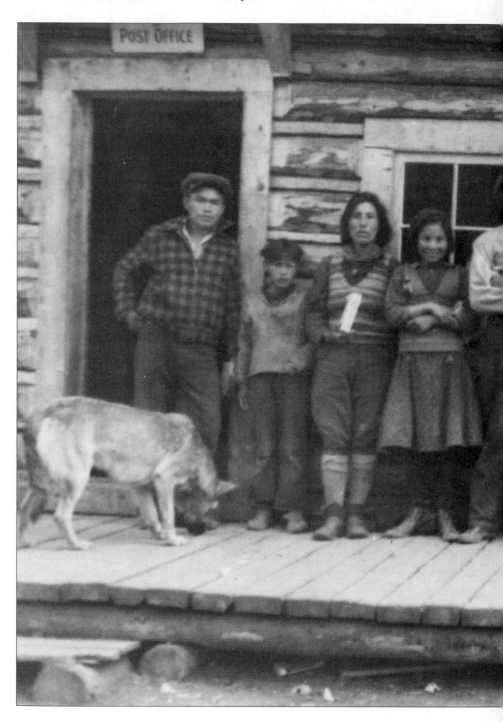

Sikanni at the HBC store and post office at Manson Creek. 4-10, Whyte Museum of the Canadian Rockies.

Taken on down the river to Germansen Landing a radio message was sent to Canadian Airways at Fort St. James bringing Pilot Russ Baker north to transport Mr. Lamarque to the Prince George hospital. The plane bucked fog and rain and had considerable difficulty in finding the Germansen seaplane to land, and on the trip south was in the air looking for a way through for one and a half hours in which a distance of only 30 miles [48 km] in a straight line was covered the fog was so thick. Landing was made at Prince George in semi-darkness and the pilot classes the trip as one of the toughest of the season.

Mr. Lamarque has been employed on the provincial public works road construction project from Old Hogem to Aitken Lake some 160 miles [260 km] northwest of Prince George. Along with others he was making the trip down the Omineca River from Old Hogem to Germansen Landing when the accident occurred.

Dr. C. Ewert reports from the hospital that Mr. Lamarque's injuries are no more serious than severe body bruises and shock and he expects him to be out again in a few days.

Lamarque returned to Germansen but was unable to resume working and since it was almost the end of the field season, he returned to Vancouver. In 1939, the Department of Public Works reconstructed the road south of Manson Creek, moving it off Baldy Mountain and following the route that Lamarque located.

1939 | THE ALASKA HIGHWAY SURVEY

In 1939, the threat of another world war became more imminent following Germany's occupation of the Sudetenland and the Nazi government's demands against Poland. Although British Columbia seemed far away from events in Europe, the province occupied a prominent link between the United States and its territory in Alaska. If there was a war, the United States would want a road connection to Alaska through British Columbia.

The idea of an Alaska Highway had started in the late 1920s, and in 1930 the BC government had made a major survey for a route that largely followed present-day Highway 37 (Stewart–Cassiar Highway). British Columbia's Surveyor General, F.C. Green, was a strong advocate for an Alaska Highway, but the Depression in the 1930s prevented much development. In 1939, with economic conditions improving and a world war seeming more likely, the British Columbia government hired several crews to survey a preliminary highway. Although there were a couple of possible routes through

northern British Columbia, Green favoured a highway through the Rocky Mountain Trench as the shortest and easiest to construct, and this was the main focus of the work.

Two triangulation surveying crews worked in the Rocky Mountain Trench from Finlay Forks through the Kechika River valley north of Sifton Pass. (Frank Swannell headed the survey south of Sifton Pass and Hugh Pattinson the one to the north.) Philip Monckton was in charge of the third crew working from the BC–Yukon boundary near Lower Post over to the Kechika River. The Survey Branch also had four photo topographic survey crews mapping the area. The Forestry Branch assigned Gerry Andrews, in charge of aerial photography for the province, to make a set of aerial photographs of the Rocky Mountain Trench from Finlay Forks to Sifton Pass. The Department of Public Works hired two surveyors to conduct reconnaissance work, examining the potential route for the highway and noting any possible difficulties. Col. J.M. Rolston, who had been on the 1930 Alaska Highway survey and done reconnaissance work for many years, was to examine the potential route from the end of the highway at

Lamarque's survey crew. Lamarque is second from right, while Earl Cushing is third from right. 3-35, Whyte Museum of the Canadian Rockies.

Summit Lake, north of Prince George, to Sifton Pass. Lamarque, appropriately, was selected to cover the remote section from Sifton Pass to Lower Post on the Liard River near the BC–Yukon boundary. The route that he was assigned to follow was not far north of the area that he had traversed between Sifton Pass and Dease Lake during the Bedaux Expedition.

Earl Cushing joined his crew once more, along with Kenneth Ford, who had a degree in civil engineering from the University of Alberta, and C. King, a young man who was studying at UBC. Lamarque described his experiences in his memoir but included more specific details in his government report, which is the primary basis for this chapter.

Lamarque and his crew departed Vancouver on June 3, travelling on the CPR steamship *Princess Louise*. They arrived at Wrangell at 2 a.m. on June 6, and left that afternoon on the riverboat, *Hazel B,* going up the Stikine River. Two days later they reached Telegraph Creek.

Since Lamarque's main method of transportation that summer was going to be by horse, he hired Walter Loudecker and Harry Carlick, local First

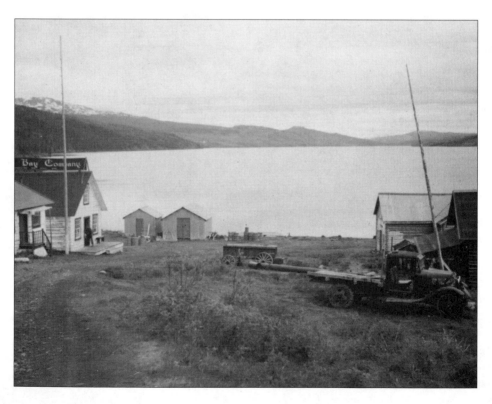

The HBC post at Dease Lake. 3-7, Whyte Museum of the Canadian Rockies.

Nations men, and used an outfit provided by the government. In his memoir, Lamarque wrote:

> We left Telegraph Creek on the 11th with 4 saddle and 10 pack animals with a local Indian in charge of the horses and another as cook. At Dease Lake we camped in the meadows where Jack Stone and I had, five years before. On the 17th, Ford, Cushing and the two Indians with all the horses went off on the trail to Chee House at the confluence of the Turnagain River with the Kechika, where they were to establish a cache of provisions, and on the 22nd King and I left by boat, across the lake and down the Dease River, stopping for the night at the Hudson's Bay Company post of [McDame] and reaching Lower Post late the next evening at the confluence of the Dease River with the Liard...
>
> King and I stayed for two weeks at the Lower Post, awaiting the arrival of Cushing and Ford with the pack train from Chee House.

HBC's McDame post on the Dease River. 3-9, Whyte Museum of the Canadian Rockies.

During that time we examined the lower canyon of the Liard for possible bridge crossings, and the Dease River, near its confluence, for the same purpose. This lower canyon is about 3 miles [4.8 km] long and 6 miles [9.6 km] above the trading post. The 60th parallel, which is the boundary between British Columbia and Yukon Territory, bisects the river in the canyon at, or very close to, the lower end. [This section of the BC–Yukon boundary had not yet been surveyed.] SEE IMAGE LaE.09.03, PAGE 102, TOP.

While Lamarque was at Lower Post he met Philip Monckton, a surveyor who had spent many years on triangulation surveys in northern British Columbia. Monckton was following the same route as Lamarque, but his surveying took him to the mountain peaks. Art Swannell, the son of Frank Swannell, was on Monckton's crew and he accompanied Lamarque on a reconnaissance down the Liard River from Lower Post for about 30 km. Jim Ware, the HBC factor at Whitewater during the Bedaux Expedition, had left the company and was now living at Lower Post. Lamarque used Ware's motorboat during his work on the Liard River.

CF-ABM at Lower Post. This airplane was a Fairchild 71. Built in 1929, it was originally used by Cominco for mining explorations in northern Canada. Other owners included McConachie Air Transport, Mackenzie Air Services, and Northern Airways. The plane crashed during an emergency landing near Carcross on November 29, 1940. 3-15, Whyte Museum of the Canadian Rockies.

In the government report, Lamarque described his method of surveying.

> A rapid chain compass traverse was made of our route from the confluence of the Dease River with the Liard to that of the Gataga with the Kechika, about 130 miles [210 km], where we tied into signals established by H. Pattinson... From the Gataga to Sifton Pass, our distances were estimated on a time basis and controlled by Mr. Pattinson's survey. At the Lower Post we tied on to the base line established by Mr. Monckton prior to the commencement of his triangulation southward; our distances from the post northward to the provincial boundary being estimated by time.

Lamarque was using a compass and a chain to measure and map the distances and direction along the route that he was following. Since it was a reconnaissance survey, Lamarque did not need the degree of accuracy that the triangulation survey had. However, he connected the beginning of his survey to Monckton's work so that he had a known starting point. (He also surveyed an estimated distance to the BC–Yukon boundary since it was not far away.)

Jack Stone (right) and family near Lower Post. 3-14, Whyte Museum of the Canadian Rockies.

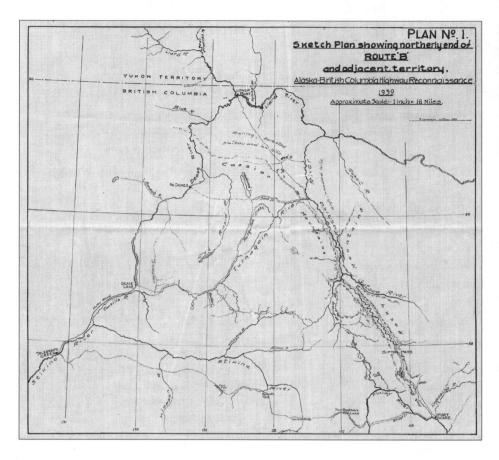

This is a sketch map of the area that Lamarque surveyed during his 1939 reconnaissance of the most northerly section of the proposed Alaska Highway in BC. Accn1286 map, Whyte Museum of the Canadian Rockies.

Later in the summer, as they reached the upper stretches of the Kechika River, Lamarque and his crew were working in the area being covered by Pattinson's survey, and he tied his survey into Pattinson's stations wherever possible. Since Lamarque knew his location at the beginning and conclusion of his survey, he would be able to adjust the remainder of his survey. To improve his work, "observations for latitude were taken at several points between the Dease and Gataga rivers and, in order to determine the magnetic variation, occasionally for azimuth." Lamarque would make comparisons between these observations and his compass and chain measurements to check his work. Along the traverse, Lamarque blazed and marked a tree every mile. Since he was experienced in this type of surveying, he was able to make an accurate map using these techniques. To assist in locating the route, he occasionally climbed

to viewpoints above the valley. "Excursions on either side of our route were made where necessary, and several hills and mountain slopes ascended for the purpose of general reconnaissance."

Lamarque commented on a new technology that was improving communication on work projects in remote regions of the province.

> The party was well-equipped in every way, and the radio, which with batteries complete, in a strong case suitable for a side pack on a horse, only 70 pounds [32 kg], was of great value. A recent model, built for the Forestry Department of the Province, it proved remarkably efficient, and from the middle of July we were in frequent communication with Colonel Rolston's party on the southerly end of route B, initially contacting them when quite 300 air miles [480 km] distant and, latterly, the forestry station at Prince George when over 400 air miles [640 km] therefrom.

The remains of Chee House, a trading post that was constructed in the Kechika River valley during the gold rush into the Cassiar region in the 1870s. 3-28r, Whyte Museum of the Canadian Rockies.

Jack Stone (front) and his nephew. 3-28, Whyte Museum of the Canadian Rockies.

The radio was also used to keep crews in the field informed about current events in Europe.

After the pack train arrived, Lamarque's crew left Lower Post on July 10, following the First Nations Davie Trail. They reached the junction of the Turnagain (Little Muddy) and Kechika (Big Muddy) rivers fifteen days later. There they saw the remains of Chee House, a trading post established in the latter part of the 19th century during a period of mining activity in the region. Lamarque noted that the route did not present any major difficulties and had only a few large streams to cross.

> On the 11th of August, Jack Stone and his nephew arrived in our camp with mail. I had met Jack again at the Lower Post and had engaged him to bring on any mail that might have arrived after our departure. Jack's hunting grounds and indeed, his home, was to the east of the Kechika River. The previous winter had been a hard one for him, for game and food had been scarce and he no longer

Views SE and NW in the Rocky Mountain Trench showing the Kechika River and Cassiar Mountains 20 miles [32 km] below the Gataga River. 3-29, Whyte Museum of the Canadian Rockies.

possessed that sturdy, vigorous appearance which he had when, five years before, he and I had traveled together...

He seemed surprised and pleased that we had found so good a line of country, saying that, nearer to the river, there was much swamp and a more difficult terrain. He stayed overnight in our camp and the next morning left cheerily on his return journey to Chee House where, no doubt, he had left his family...

The valley through which we were passing was, on the whole, an easy one through which to construct a highway with few, if any, major difficulties to contend with, and even the crossings of the Frog and Driftpile rivers which, together with the Gataga that comes in from the east some distance below their confluence to form the Kechika, were not expensive to bridge. We camped on the easterly side of the Driftpile on the 25th of August and reached Sifton Pass at noon on the 3rd of September to be informed by our wireless net that another war in Europe had started...

Britain and France had declared war on Germany that day in response to Germany's invasion of Poland two days earlier. In 1914, Lamarque had not learned about the start of World War I until over a month later. With the portable radio he heard about the start of World War II on the day of the event. "Before leaving Sifton Pass, Colonel Rolston and Del Miller had arrived from the south; a happy meeting and the practical completion of the season's work."

Lamarque and his crew reached Whitewater on September 8. Swannell, who had arrived the previous day, recorded in his diary that Jimmy Ware had arrived in a boat just a few hours before Lamarque. Lamarque noted that Chief Davie, who was in his late eighties or early nineties, died around the time of their arrival. The following day a plane arrived, bringing newspapers announcing the start of World War II. That afternoon, Ford and King, along with four of Swannell's crew members, left by boat for Summit Lake and then on to Prince George.

On September 10, Loudecker and Carlick started the return trip with the horses from Whitewater, and Cushing accompanied them. They "left for Telegraph Creek via Two Brothers Lake and Hyland's Post. Delayed by stormy, inclement weather, and having to abandon one horse en route, they reached Telegraph Creek on the 2nd of October where the Indians were paid off and the outfit, other than that brought out by Mr. Cushing or Mr. Ford, stored with the Government Agent there. Delayed by lack of transportation on the Stikine, Mr. Cushing did not leave Telegraph Creek until the 9th. He arrived in Vancouver on the 14th."

A mail plane arrived from Prince George the same day, so Lamarque flew to Prince George. From there he travelled to Quesnel, took the PGE railway to Squamish, and then went by boat to Vancouver.

In the government report, Lamarque discussed the proposed route. He stated that: "The reconnaissance shows that a good, generally economical route for a motor highway exists from the crossing of the Liard River at the lower canon on the northerly boundary of British Columbia to Sifton Pass, along, or very close to, our line of traverse." The distance of this route would be about 300 km.

The major item for consideration was the crossing of the Liard River. Lamarque noted that the river was over 200 m wide between the Yukon boundary and the Dease River. Almost immediately below the junction with this river, the Liard expanded to over 800 m with many islands. "Two possible bridge sites were measured on the Liard and two on the Dease. It is evidently more economical to cross the Dease and the Liard, than to cross the Liard below the Dease where the length of span required would considerably exceed the combined crossings."

Lamarque's survey only covered the Liard to the Yukon boundary. "Regarding the Liard River, it must be pointed out that it may not be advisable to cross this at the Lower Canon at the 60th parallel; it may prove economical to keep on the southerly side of the stream far into Yukon Territory [which was a federal jurisdiction], but as the southerly boundary of that territory was the northerly limit of our reconnaissance, we have no observed data on this question." The crossing of the Liard would need to be examined in more detail if plans for the Alaska Highway to follow this route proceeded.

Lamarque observed that: "the country in the general vicinity of the Lower Post is of an undulating, densely forested nature of somewhat low relief" and this largely continued along the route to the Kechika River.

> Throughout this wooded, undulating country there are many small ponds, lakes, swamps and streams. The swamps on either side of the Davie Trail which... pursues a remarkably straight course from the Lower Post to near the confluence of the Turnagain River with the Kechika, are rarely of any great extent and so situated in relation to gravel ridges and benches that they could be either entirely avoided or narrowly crossed by a highway located in the general vicinity of this trail. The swamps through which the trail passes usually have a firm bottom of gravel or small boulders about a foot below the surface.

"The Red River itself is the only stream between the Dease and the Turnagain that could be called a river," Lamarque commented. "From the Red River to the Kechika the location of the highway would, in all probability, be very close to the pack trail, swinging easily down on light grades round the northeasterly side of the southerly ridge to the low jack pine benches along the Kechika which it would follow to the Turnagain."

The Turnagain, flowing from the west, is the largest tributary of the Kechika. At this location the second important decision had to be made regarding the route of the highway. Lamarque noted that the Davie Trail crossed the Kechika about 8 km below the Turnagain and continued south up the east side of the river valley, "the trails on the westerly side of the river being but little used and more or less obliterated by windfalls and forest debris." He examined the Kechika between the Davie Trail and the Turnagain and found that it was between 150 and 210 m wide in this area. "On account of the formidable crossing of the Kechika, however, we examined the westerly side of the valley to above the confluence of the Frog with the Kechika, for about 60 miles [96 km]." Lamarque located a good crossing of the Turnagain about 200 m upstream, where the river was about 75 m wide.

In discussing whether to cross the Kechika, Lamarque wrote: "The country on the easterly side of the Kechika is probably as favourable, or even more so, than on the west, but it would hardly make up for the extra cost necessitated by bridging it below the Turnagain, and the crossing of the Gataga—at least 175 feet [55 m] would about balance the crossing of the Frog and the Kechika above it.

Lamarque wrote about another factor of the highway that was particularly important at a northern latitude. "It is more sunny on the easterly side of the

valley, but as the location on the west side of the river will be more in mid-valley than close to the slopes of the Cassiar range, the difference in this respect should not be great. In any case, this section will get more sunshine and less snow than that above, where the valley is narrower and the snowfall greater."

Lamarque noted the scenic beauty of this area where the Rocky Mountains on the east and the Cassiar Mountains on the west came closer. "The scenery along this section of the route is bold and beautiful and should be a great source of attraction to motorists. Moreover, the topography of the valley is such as to allow long tangents, easy grades and easy curves... The route we blazed through this section of the valley is never far from the probable location of a highway and usually in its approximate position. On the whole, the country is more open than that in the north and the clearing would be lighter." Lamarque observed two large creeks between the Turnagain and the Frog rivers, and thought that only the Denetiah would need to be carefully examined.

There was one more area to consider, but it wasn't nearly as important as crossing the Liard or the Kechika farther downstream. "It seems probable that it will be more economical to cross the Frog and Kechika rivers separately than the combined stream below the former, as the Kechika is there broken into many channels and no suitable bridge site was observed. Before this is decided, however, a careful survey will have to be made of this area." If this site did not turn out to be suitable, he felt that there was also a possible crossing of the Kechika (today called Driftpile Creek above the Frog) at a canyon about 5 km upstream. Lamarque wrote that by 25 km upstream from the Frog "the easterly side of the river is undoubtedly the better, for on the west the country is often rocky and the topography considerably rougher."

Above the Frog and the Gataga valley, on the east side, Lamarque rejoined the Davie Trail. He observed that the terrain had a few difficult sections but no major obstacles. The trail went up to 100 m above the river valley following a series of low ridges and it became quite good farther up the valley. There was one final crossing of the Driftpile about 8 km below Sifton Pass.

Although the BC government's focus and finances were mainly directed at the war effort after 1939, surveying the northern Rocky Mountain Trench continued in 1940 and 1941. After Japan bombed Pearl Harbor and the United States entered World War II, the Alaska Highway became imperative, but the route finally selected was in a far different location despite the advantages of the Rocky Mountain Trench location. Lamarque's description of the Davie Trail and his photographs of the area are an excellent account of what this remote area was like over seventy-five years ago.

5 | World War II

In the spring of 1940, Lamarque returned to the upper Bella Coola valley where he surveyed some lots for the well-known guide, Tommy Walker, whom he had met during his previous surveys in the area.

Lamarque, like fellow surveyor Frank Swannell, spent much of World War II surveying landing fields for airplanes. In the late summer and fall of 1940, Lamarque went to Sandspit on Haida Gwaii (known as the Queen Charlotte Islands at that time) for the Department of Defence, Western Air Command. He took a steamship from Vancouver to Prince Rupert and then flew on an RCAF float plane to Alliford Bay. "I spent the next several weeks making those preliminary surveys necessary for the establishment of an important airfield and a connecting road to Alliford Bay." Lamarque commented: "Except for the frequent and heavy gales in the winter, the Sandspit is an excellent site for an airfield; on which it is possible to have three runways in the form of an equilateral triangle, ranging in length from four to five thousand feet [1.2 to 1.5 km], or more. The approaches, also, except for the hilly country to the southeast, are open and good." In a letter Lamarque commented that he was "billeted with a settler for most of the time with occasional visits to the mess of the Air Command there. Such a happy joyous crew they are, and the settlers wonderful people."

At the beginning of 1941, Lamarque went to Prince George "to make a survey of the small airfield to the southwest of the town and then to make preliminary surveys for the establishment of a much larger one on the other and easterly side of the Fraser River. Though it was mid-winter, the temperature was rarely below 0°F [-18°C] during the day, nor was the snow deep enough to necessitate the use of snowshoes." In a January 30 front page article titled "Dominion Government Starts Work at Airfield," the *Prince George Citizen* wrote: "Ernest Lamarque, DLS, arrived in Prince George on Tuesday from the coast, and for the next three weeks will be engaged in survey work at the local airfield on behalf of the federal government. The work being undertaken by Mr. Lamarque is understood to be the initial move of the Transportation Department of the Dominion government in the construction of an $80,000 range station on the airfield." The newspaper also noted that "Mr. Lamarque is well known in northern and central British Columbia, having conducted surveys at a number of points in districts both east and west of the Rockies for the past third of a century." Lamarque returned to Prince George in the spring and made additional surveys for the project.

In the summer, Lamarque worked at Smithers in the Bulkley Valley where he had been in 1907 and in the fall he was at Prince Rupert "to make surveys for the accommodation of the growing population there necessitated by sundry war time activities. It was interesting to visit and work in a locality I had known many years before when the town, indeed, was but a tiny, six month old settlement. The climate, however, had not changed, as the number of rainy days I experienced during my four week visit made certain."

In early November, Lamarque went to Whitehorse, going by steamer to Skagway, and then taking the White Pass Railway. He spent a month surveying at the airfield. On the return trip, "when we were passing through Wrangell Narrows, some distance south of Juneau, we heard of the Japanese attack on Pearl Harbor."

The attack on Pearl Harbor led to a declaration of war against Japan by both Canada and the United States. The opening of the Pacific theatre of World War II made the Alaska Highway a necessity for the United States. In February 1942, the American and Canadian governments approved its construction, and work on the Alaska Highway started the following month. The route selected began at Dawson Creek and went through the Peace River region instead of going north from Prince George through the Rocky Mountain Trench where the BC government had surveyed in 1939.

Lamarque went to Fort Nelson in early February to survey an airfield. In his memoir he described this experience.

> The Muskwa River enters the Fort Nelson River at Fort Nelson and forms part of the southerly boundary of the airfield, which is situated on a plateau some two miles [3.2 km] to the west. I was there about six weeks, defining its boundaries and some settlement lots about the post of the Hudson's Bay Company on the easterly bank of the river. The snow was about three feet [1 m] deep and we had to use snowshoes, but the weather was not cold and the days were generally sunny and fine...
>
> At that time a great number of planes were being flown northward; many of which were for the Russians. Just before I left, a group of U.S. Army officers arrived by snowmobile from Fort St. John... They came one Sunday afternoon and stayed for but a few hours—the first such vehicle ever to be at Fort Nelson. It had been decided to build a highway to Alaska on or near the route followed by the planes—the Northwest Air Staging Route, as it was afterwards called.

During the spring and summer of 1942, Lamarque surveyed airfields in BC for the federal Department of Defence, including one at Dog Creek west of Williams Lake, and one at Vanderhoof.

At the end of October I left by air for Whitehorse, stopped at Prince George for the night on account of bad weather, and making a belated start the next day for Fort St. John, we were diverted to Grande Prairie in Alberta for a similar reason. We were delayed for three days at this thriving and busy farm centre, and then, the skies clearing, made Fort St. John the next night and Whitehorse the following day, a most interesting journey in fine weather, especially perhaps over the valley of the Liard from Fort Nelson to Watson Lake by the northerly ramparts of the main range of the Rocky Mountains. Flying at not too great a height, the confluences of the Fort Nelson River, the Toad, the Smith, the Rabbit, the Coal, the Kechika, and the Hyland were clearly visible, and their courses too, for many miles, especially those coming in from the north across a vast undulating and broken plateau, and in the far distance, a range of snow-clad mountains.

It was somewhat less than a year since I had been at Whitehorse, and its usual small winter population had more than doubled. The place was full of American servicemen and others, and as it was not possible to get accommodation at the Inn, I was fortunate to find good quarters above the office of the Department of Transport. Busy in the town and on the airfield until the 18th, I had just boarded a plane to Vancouver—in fact it was just moving off—when I received a directive to make surveys at the Lower Post near Watson Lake. That plane, however, did not stop at Watson Lake, so I went on to Fort St. John, taking another back to the lake... There I stayed at the headquarters of the Department of Transport, enjoying excellent accommodation and wonderfully good meals...

Lower Post is about 15 miles [24 km] from Watson Lake, about half of which is on the Alaska Highway, and the other half along the connecting road to the lake. This remarkable highway was already carrying heavy traffic, and as it and the branch road were well-maintained and patrolled by snow plows, our journey to and from the lake to Lower Post, by ordinary motor car or truck, was easily made within the hour...

During 1943 and 1944 I made many surveys for the RCAF at various places along the coast and in the Interior of British Columbia. One of these included an aerial reconnaissance over Cape Scott, at

Lunch on the Liard River boundary of the
WATSON LAKE AIRPORT RESERVE

This Reserve, on the North-West Staging Route from Edmonton to Fairbanks, first established by famous 'Bush Pilots' thirty to forty years ago, is situated about ten miles north of the 60th parallel, longitude 128-50 west, in Yukon Territory. It has an undulating, wooded area of some 40,000 acres and is bounded on the south-west by the Liard River, to the east by the Alaska Highway and a meridian northerly therefrom for some 8 miles to the N.E. corner, thence nine miles to the N.W. corner and so southerly to the Liard River. The Lake, which lies well within the area, has an elevation of 2230 feet, the highest elevation on the Reserve is 3250 feet on the northerly boundary near the N.E. corner.

The run-ways are on the northerly side of the lake, about centrally located, the radio range station is close to the north boundary. The Liard River falls about 70 feet to an elevation of about 1830 feet at the S.E. corner where the Alaska Highway bridge crosses the river.

From Fort Nelson to Watson Lake the North West Staging Route follows above the West Branch or Current Fort of the Liard (so called by the old time voyageurs of the Hudson's Bay Company) around the northerly end of the Rocky Mountain Range in a series of formidable rapids that induced the Company to abandon this route to the Yukon.

In all probability, scarcely one of the thousands of Canadians, Russians and Americans flying over this section of the Route thought of the old voyageurs of a century ago, it is certain that, to these voyageurs the air travel would have been heavenly transport.

Lamarque created this Christmas card sketch of two men getting warm by a campfire during the survey of the Watson Lake airport reserve. 9-3, Whyte Museum of the Canadian Rockies.

the northerly end of Vancouver Island, and surveys near Bamfield, at the entrance to Barkley Sound, on the southwesterly coast of Vancouver Island, where we stayed at the [Pacific] Cable Station.

Among the places where Lamarque surveyed were Tofino and Comox; Masset at Haida Gwaii; and at Woodcock on the Skeena River.

I went north again to Watson Lake in November [1943] to define the boundaries of the airport. This reservation is bounded to the south by the Liard River and elsewhere by an undulating densely wooded terrain, the perimeter being about 35 miles [60 km] long. We stayed at the headquarters of the Department of Transport close to the runways, which, while very comfortable, often meant long walks through the snow to and from work...

In the early summer of 1944, Lamarque wrote to Frank Swannell.

McCusker [Knox McCusker, a Dominion land surveyor] is surveying the Alaska Highway in the Yukon. The completion of my work at Watson Lake depends on the width of this highway, and when I heard, this had not yet been decided upon. However, presumably Mac will have commenced work by this time...

You will be sorry to hear that Earl Cushing died at sea en route to Canada. His wife, who is really a charming Scotch girl, had only been in her mother-in-law's home for one hour when the telegram recording his death had arrived. It is very sad and quite a blow to me, as I had eagerly anticipated his arrival. [Cushing had enlisted in World War II and served in the Canadian Forestry Corps in Scotland. He developed Hodgkin's lymphoma and was returning on a hospital ship when he died.]

My friend, Jack Stone, the Tahltan Indian (really one of the Grand Lakers—Muncho Lake) with whom I traveled for many leagues ten years ago, died last fall, not long before I was at Watson Lake.

Lamarque returned to complete his survey at Watson Lake that October.

While once more we were able to do most of the work from the headquarters station, we found it convenient to form a camp for a few days near the northeastern part of the reservation. This time I had two of the late Frank Watson's—after whom the lake was named—sons in my

party, Bob and Esnor. They were well acquainted, of course, with the area, and were especially useful, on occasion, in taking short cuts back to the station at the end of the day. They lived by a creek some distance from the runways and I cut out a small area in the reservation to include their own holdings and to remain as their own property.

As the end of World War II approached in 1945, Lamarque returned to his own survey practice.

Epilogue

After World War II, Lamarque maintained a small surveying practice that provided occasional work.

In the spring of 1948, he and Winifred went to Bella Coola. They travelled to Tommy Walker's Tweedsmuir lodge at the upper end of the valley where he made a survey of the property before Walker sold it and moved to the Spatsizi Plateau in northern British Columbia. "We reached Bella Coola about dawn and Tommy drove us over the 40 mile [64 km] road to Stuie as the day was breaking, the rays of sunlight lighting the mountains in splendour, and then the valley, a never to be forgotten experience. Our return to the sea was made by the light of a full moon, a drive again, equally beautiful and to be remembered."

The same year, Lamarque went to Lake Louise to make the initial survey for the proposed ski development there. During that time he met and became friends with Lizzie Rummel. Rummel was a member of the Alpine Club of Canada and the Ski Club of the Canadian Rockies, who also operated Skoki Lodge and Sunburst Lodge in Mt. Assiniboine. When the Whyte Museum in Banff opened in 1968, she persuaded him to donate his material to its archives. Rummel also recorded an interview with Lamarque about his career.

Lamarque returned to Lake Louise in the spring of 1949. Because of flooding he and his friend, Albert Knox, had to travel through the United States to Montana, then north through Cranbrook, Radium Hot Springs and the Banff–Windermere Highway to reach their destination. "We were two weeks at Lake Louise and during that period located a route for the proposed ski lift to the top of Whitehorn Mountain... On the whole we had fine weather and the views from the slopes of Whitehorn Mountain are something to ponder, immense and all embracing." Lamarque also surveyed at Lake Louise in 1952.

In the 1950s, Lamarque made several surveys for the British Columbia Telephone Company. Some of these were for relay stations on hills and mountains around the province. In 1956, he surveyed the locations of some of the company's submarine cables.

During that summer, Lamarque, accompanied by his wife, returned to England for the first time since leaving sixty years before. They travelled by train across Canada to Montreal where they boarded the *Empress of France*, landing in Liverpool. Winifred and Ernest spent about a month in England. His brother had died, but his sister was still alive and he spent much of his time visiting her. He also went to the area of rural Kent where he grew up.

Lamarque retired from surveying in the late 1950s. His final years were spent taking some trips (mostly around British Columbia); writing and maintaining an active correspondence with several people; and painting. In January 1967, he was elected as a Life Member of the British Columbia Land Surveyors. His wife, Winifred, died in September. She had been in ill health for a few years and Lamarque spent much time caring for her.

On November 25, 1967, Lamarque wrote to Sidney Ells.

> I have sold my property and am thinking of living in the Okanagan, at Summerland, perhaps with the wife of an old friend, a land surveyor by the name of Russel. [Walter Bucknill's surveying partner in 1911 and 1912.] He died about two years ago and Mrs. Russel kindly asked me to stay for a while at her house right on Okanagan Lake, and to stay on if I like to as a paying guest. But I may not have to leave here until the end of the winter and may later go on to Oyama where the Smiths [Loren Smith was Lamarque's nephew] live. Really I do not know at present and am yet much disturbed by the loss of my wife...
>
> Incidentally, I had an old friend here at the beginning of this week who is interested in the Banff Archives to be established by a Mrs. Whyte, and I have arranged, or about arranged, to give them most of my stuff...
>
> I told you, I think, that I went to Winnipeg recently to place Winifred's ashes in the grave of her parents. A wonderful old cemetery, that at St. John's Cathedral, 157 years old and dating to the time of the Selkirk Settlers. The cemetery is adorned by many fine oaks and the cathedral and the river being close at hand, makes it a place of great serenity and charm. I can only hope that, ere long, I may be laid to rest there beside the ashes of my wife.

But Lamarque was still determined to be active. He closed his letter by quoting from Henry Longfellow's poem "A Psalm of Life": "Let us then be up and doing, with a heart for any fate, still achieving, still pursuing, learn to labor and to wait."

Lamarque left Vancouver in early 1968 and stayed with Mary Russel at Summerland. When the Whyte Museum opened in June, he travelled to Banff for the ceremony. During late summer, Lamarque made a final trip to northern Canada. In a letter to Ells in May, Lamarque wrote: "I expect to go to the Arctic this summer, fly to the mouth of the Mackenzie, a trip offered to me by the president of an airline [Pacific Western]. Thus I may see your old stomping ground once more, of Fort Chipewyan, [Fort] Smith... to which places I was conveyed

Ernest Lamarque at the official opening of the Whyte Museum. Pa133-27, Whyte Museum of the Canadian Rockies.

lying on a mattress on a wagon drawn by oxen [in 1902]." Lamarque wrote to Ells again in early September:

I have just returned from the north—McMurray, Yellowknife, Inuvik, Fort Smith and of course the great plant of the Tar Oil Sands near Fort McKay where I also went to find it deserted by the Company and the buildings, which I knew, gone.

From the prow of the DC6 I just glimpsed the Sans Sous rapids which, at the head of the Ramparts, urge the great river into its mighty but comparatively narrow canyon, to diverge, at its lower end where old Fort Good Hope stands at the mouth of the Snare River into its average width of some two to three miles [3.2-4.8 km], truly a mighty stream in an immense and lonely territory tree clad with many small and some big lakes and with a telephone land line running there through from Yellowknife to the delta, a land line build on a tripod of poles to prevent the moose from knocking the standards over... At Inuvik there are as many trees as at Yellowknife, where, for over twenty miles [32 km] we drove along a road largely paved by

tailings from the two or three mines which are running in the vicinity, drove to a resort lake which, to some extent, is used by tourists... Oil has been found in the Inuvik area and there is some in the Dismal Lakes. But more anon. I have many letters to write.

In another letter, he wrote that it was "truly a different country to that which I knew 60 years ago, some of the towns then non-existent."

In early 1969, Lamarque moved to the "log cabin," which his nephew had constructed on his property at Oyama, where he spent the final two years of his life. Lamarque died on December 24, 1970. His nephew noted that Lamarque remained active until his final days, living independently and contentedly in his cabin. In a letter to Tommy Walker on December 15, Lamarque had written about his failing eyesight and commented: "I am just a hanger on and should really not be here."

Lamarque's adventurous career covered the end of the 19th century and the first half of the 20th, and spanned across western Canada. During those years he was involved in several activities that had historical significance, and much of his work was in remote areas. He revelled in his adventures: the people that he met and the places that he saw. He recorded his experiences through writing, photography and art. Lamarque's legacy is a landscape that encompasses many areas of western Canada and events that affected its history. His record helps provide a sense of what it was like to live, work and travel in this part of the country in a different era.

Geographical Names

Lamarque's surveying did not provide opportunities to name geographical features in British Columbia, except during the Bedaux Expedition. The expedition's route traversed a remote area of the province where many geographical features had not yet been named on provincial government maps by 1934. During his years of topographic surveying for the government, Frank Swannell, the geographer for the Bedaux Expedition, had named many features in central and northern British Columbia. He also submitted names for places along the route up to Sifton Pass. Most of these features were named for members of the expedition.

Lamarque provided names for some features, most of them in the area between Sifton Pass and Dease Lake. At his request, Swannell named Mount Sheffield in the upper Muskwa valley for Bert Sheffield, who provided Lamarque with vital information about the geography of the upper Muskwa River and upper Kwadacha drainage. Lamarque named the creek east of Weissener Lake, which he and Joe Poole followed, for his guide. The surveyor commemorated Jack Stone with the name of the creek that flows through the valley around the pass that was later named for Lamarque.

At the western end of Lamarque Pass. 2-33, Whyte Museum of the Canadian Rockies.

One interesting name that Lamarque provided was Hottah Lake. He wrote that the lake has "a similar arm to that at the northeasterly end, leading off to the west from the southwesterly corner." Jack Stone called this lake "ottah," meaning alike at both ends. Lamarque named it Hottah which is almost a palindrome. Hottah Lake is the setting for the book *Wilderness Seasons*, written by Ian and Sally Wilson.

Some of the people who were associated with Lamarque in 1934 also have geographical features named for them by other surveyors. Ludwig Creek, a tributary of the Kechika River, and Forsberg Creek and Forsberg Ridge, also in the Kechika valley, are named for two of the trappers who assisted Lamarque.

The British Columbia government denoted geographical features for the province's soldiers who died during World Wars I and II. Mount Cushing, in the vicinity of the route that Earl Cushing followed on his trip to Telegraph Creek at the end of the 1939 season, is named for him.

The British Columbia government named Lamarque Pass for Ernest. He agreed to have his name on this feature for three reasons: 1) as far as he knew it had not been named by the First Nations people, 2) he was probably the first non-native person to travel through this pass, and 3) locating this pass was a crucial part of the success in his location of a route to Dease Lake.

Acknowledgements

Most of Ernest Lamarque's material is housed at the Whyte Museum in Banff and I would like to express my appreciation to staff there for their prompt and cheerful assistance during my three research trips. Particular thanks goes to Elizabeth Kundert-Cameron, Head Librarian, and Anne Ewen, Curator of Art and Heritage. I would also like to thank staff at Library and Archives Canada, Hudson's Bay Company Archives, BC Archives, University of British Columbia Archives, and the Glenbow Museum for their assistance.

Once again, Robert Allen and Ross Peck read sections of the manuscript and shared their knowledge and insights, and I appreciate their continuing involvement with my projects. Mary Andrews provided her father's copy of Lamarque's Bedaux Expedition manuscript and the BC–Yukon boundary survey report. Robin Phillips shared the diary of her father, Jack Bocock. Willis and Francis Blackman provided information about their father, Bill Blackman. My thanks goes to all of you.

My appreciation also goes to staff at the Ministry of Transportation and Infrastructure for locating the file documenting Lamarque's surveying on the Central Coast from 1935 to 1937, and to Colin McMillan and Doug Wilson, who made me aware of the file.

Uno Langmann and Cal Cameron provided information that enabled me to locate most of Lamarque's artwork that is not housed at the Whyte Museum. Laverne and Carol Norris willingly showed me their collection of Lamarque artwork. Staff at the Vancouver Art Gallery located records that established the connection the VAG had with Lamarque's art for twenty-five years. Thank you.

I am grateful to my wife, Linda, for her ongoing assistance with my book projects, and to Vici Johnstone of Caitlin Press for publishing this book.

Sources

Unpublished Manuscripts

Lamarque, Ernest. Memoirs of Ernest C.W. Lamarque
_____Travels and Explorations in Northern British Columbia, 1934

Archives

BC Archives
British Columbia. Attorney General—Inquiry #5930/12 Walter Birch Bucknill—
 GR1323
British Columbia Department of Highways 1926–1971, Alaska Highway Sur-
 veys—GR0709, Box 2
British Columbia Land Surveyors—MS2259
Department of Public Works. Summary survey of activities from 1934–35 to
 1941–42—GR1169
Frank Beaton diaries—MS0749
Frank Swannell collection—MS392
George Blanchard Dodge photograph album—PR0991
R.M. Patterson correspondence—MS2762
Tommy Walker correspondence—MS2784

Glenbow Archives
Ernest Lamarque art collection
Riveredge Foundation: M4843-61 Ernest Lamarque correspondence

Hudson's Bay Company Archives
Biographical sheets
English River District and Île à la Crosse reports—12895
Île à la Crosse and English River district accounts—12890
Post journals: Île à la Crosse 12884; Fort McKay—B.305/a/4

Library and Archives Canada
Charles Eugene Bedaux fonds—MG30-B169 R7591 0-7-E
Ernest C.W. Lamarque collection—MG30-B39 R7625-0-8-E
J.N. Wallace and party to Alaska—Microfilm reel T-14590
Office of the Surveyor General Registry Records—J.N. Wallace, DLS—Survey of
 Yukon BC Boundary—RG88-A-1-1-a

Sidney Clarke Ells fonds—MG30-A14
Yoho National Park—Administration of Lands RG84-A-2-a

Provincial Archives of Alberta
James Spencer correspondence—PR1977/0042

UBC Archives
University Research Forest fonds, Box 1

Vancouver Art Gallery Archives
"Vancouver Art Gallery: All-Canadian Exhibition, May to July, 1932." Vancouver: Vancouver Art Gallery, 1932
"Lamarque Exhibitions at VAG"

Whyte Museum—Ernest Lamarque collection M81/V343
"Across the Warneford"
"The Arrival of the Brigade"
"At the Big Bend of the Columbia"
"Diary of a Survey in the Cariboo Country, 1933"
"The Grizzly"
"An Outpost Manager Remembers"
"The Packhorse"
"The Passing of the Cranes"
"Reminiscences of the Upper Peace River"
"A Summer on the Lower Peace & Athabasca Rivers, 1914"
"Tête Noir"
1934 diary of the Bedaux Expedition
Photograph albums

GOVERNMENT AGENCIES

BC Ministry of Transportation and Infrastructure. Department of Public Works File #3839.
BC Surveyor General's Office. File O-20694.

BOOKS, REPORTS, THESES

Hoagland, Edward. *Notes from the Century Before: A Journal from British Columbia*. Vancouver: Douglas & McIntyre, 1969.
MacDougall, Brenda. *One of the Family: Metis Culture in Nineteenth-century Northwestern Saskatchewan*. Vancouver: UBC Press, 2010.

"Report of J.N. Wallace, DLS," Government of Canada, Sessional Papers No. 25b, Appendix 46, pp. 237–245. Second Session, 11th Parliament, 1910.

Report of the Commission Appointed to Delimit the Boundary Between the Province of British Columbia and the Yukon and Northwest Territories. Ottawa: Queen's Printer, 1966.

Shanks, Signa A.K. Daum. "Searching for Sakitawak: Place and People in Northern Saskatchewan's Île à la Crosse." Ph.D. thesis, University of Western Ontario, 2015.

Sullivan, Kristian. "The French Counts of St. Hubert." M.A. thesis, University of Saskatchewan, 2009.

NEWSPAPER ARTICLES

"Committed Suicide in Hastings Park," *Vancouver Daily Province*, June 10, 1912, p. 3.

"CPR Plans Survey for Double Tracks," *Vancouver Province*, June 12, 1912, p. 1.

"Dominion Government Starts Work at Airfield," *Prince George Daily Citizen*, January 30, 1941, p. 1.

"Highway Construction Has Been Slowed Down," *Prince George Citizen,* June 5, 1930, p. 2.

Lamarque, E.C.W. "Big Bend Country Caught in Giant Noose of New Columbia River Highway," *Vancouver Province,* n.d.

"Many More Millions Are to Be Spent," *Vancouver Daily World,* April 28, 1913, p. 1.

"Preparing for Panama Canal," *Vancouver Daily World*, June 12, 1912, p. 9.

"Surveyor Falls from Scow on Omineca River," *Prince George Daily Citizen*, September 22, 1938, p. 1.

"Three were Killed Outright in Wreck," *Vancouver Daily World*, June 15, 1909, p. 10.

"Tolmie Submits Relief Work for Consideration," *Prince George Citizen*, June 25, 1931, p. 1.

DIARIES

Jack Bocock diary—Bocock family collection

Index